PAINTINGS
that Changed the World

From Lascaux to Picasso

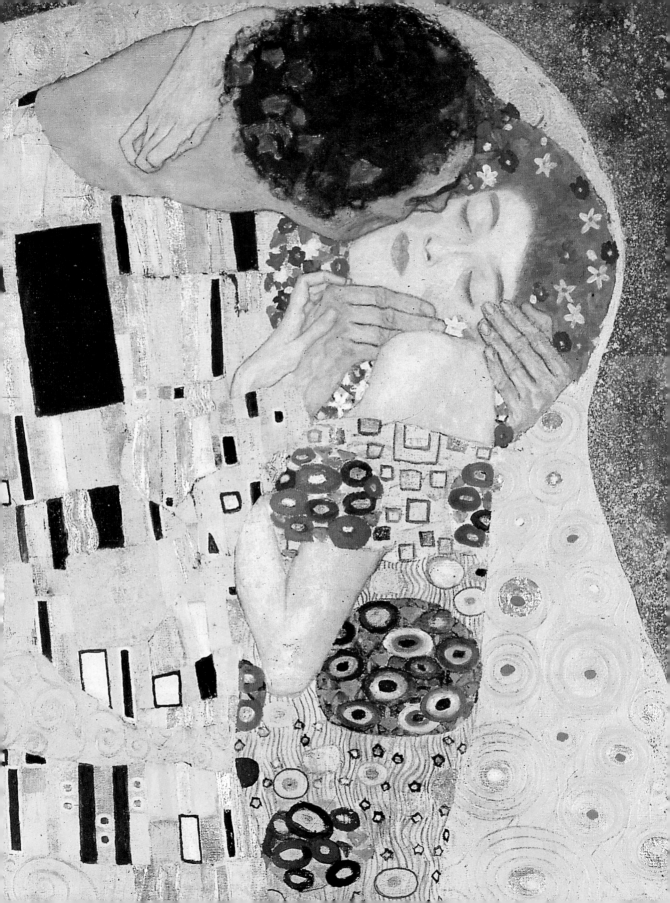

Klaus Reichold · Bernhard Graf

PAINTINGS
that Changed the World

From Lascaux to Picasso

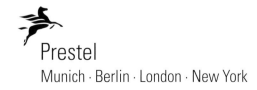

Prestel
Munich · Berlin · London · New York

Front cover:
Georges Seurat, *Bathers at Asnières* (detail), 1883–84,
The National Gallery, London

Frontispiece:
Gustav Klimt, *The Kiss*, 1907/08
Österreichische Galerie, Belvedere, Vienna

Pages 4/5:
Jacques-Louis David, *The Death of Marat*, 1793,
Musées Royaux des Beaux-Arts, Brussels

Page 7:
Jean-Auguste-Dominique Ingres, *Turkish Bath*, 1863,
Musée du Louvre, Paris

Photo credits: see page 192

Prestel Verlag
Königinstrasse 9 · 80539 Munich
Tel. +49 (89) 381709-0
Fax +49 (89) 381709-35

Prestel Publishing Ltd.
4 Bloomsbury Place, London WC1A 2QA
Tel. +44 (020) 7323-5004
Fax +44 (020) 7636-8004

Prestel Publishing
175 Fifth Avenue, Suite 402
New York, NY 10010
Tel. +1 (212) 995-2720
Fax +1 (212) 995-2733

www.prestel.com

Edited by Jane Milosch and Michele Schons

Designed by Cilly Klotz
Lithography by Ludwig, Zell am See
Printed and bound by Druckerei Uhl, Radolfzell

Printed in Germany on acid-free paper

ISBN 3-7913-2986-3

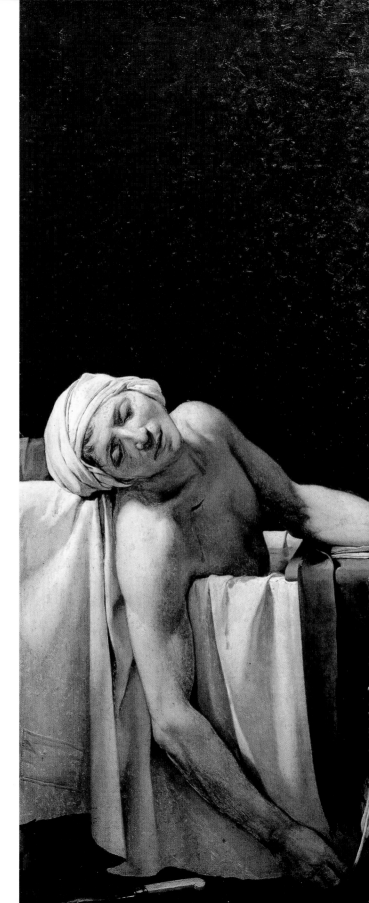

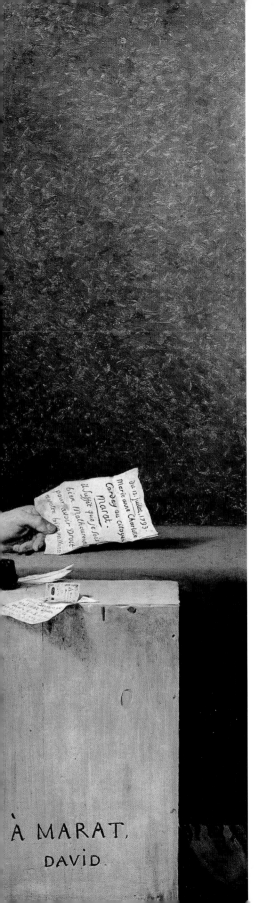

Supreme art is a traditional statement
of certain heroic and religious truth,
passed on from age to age, modified by
individual genius, but never abandoned.

Ars longa, Vita breve

Of course, no painting really changed the world! But who can question the influence of art? Who can deny that a painting can change the way we look at the world – or that artists have been influenced by world changes? An evolving world captured in paintings, and paintings that alter our view of the world: past and present, cause and effect.

The discovery of Tutankhamen's tomb, the signing of the United States of America's Declaration of Independence, the news of Marilyn Monroe's death: three very different subjects from three very different epochs in the history of humankind. Yet, however different their significance, these three occasions captured the attention of much of the world. They are moments in history when the eyes of many nations were focused on one particular spot, on one event or on one person. Since the invention of photography, such historical moments have been captured on celluloid, but to reveal the deep significance of an event after it has happened is an opportunity for the artist, frequently completing the painting long after the event. Historical occasions or figures, as well as their importance or fascination, have never ceased to provide artists of all nationalities with an abundance of inspirational material. The painting of Alexander the Great's

moment of triumph or of Martin Luther and his "Ninety-Five Theses" are masterpieces that mould our picture of history. Jacques-Louis David's depiction of the murdered French Revolutionary, Marat, lying dead in his bath, records an event after the decisive moment, the assassin having long fled. Even Vincent van Gogh painted his *Self-Portrait with Bandaged Ear* well after the blood had dried. These are all paintings that focus our thoughts on dramatic moments, capturing fateful situations on canvas.

It is not only brief moments or lengthy wars that have changed the world. Many people have left an indelible mark as a result of their exceptional life's work, their influence or genius – be it of a religious, moral, medical, heroic or artistic nature. Some have a timeless quality since they embody symbols of human existence, fear and hope, moods and passions that have never failed to keep the world in perpetual motion. The legendary unicorn represented virginal purity, and Medusa's countenance an expression of fear in the face of evil; the forlorn expression worn by Pierrot has long been used to show melancholy in humankind, in a similar way as the youthful Amor symbolises friendship or ardent passion.

A few paintings however do exist that, as works of art, have changed the world in their own way: for example, the cave paint-

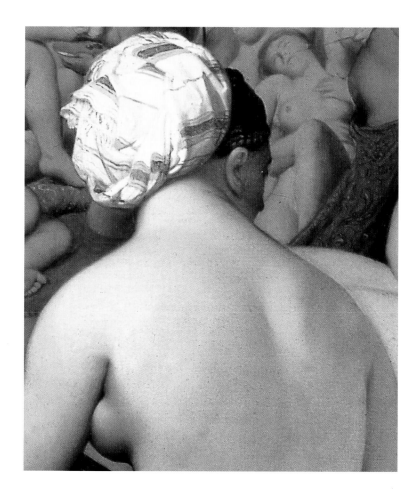

ings at Lascaux, which are a silent witness to Homo sapiens' early development and have changed our understanding and knowledge of prehistoric times; or the calendar pictures in the Duc de Berry's book of hours which provide the world with a unique glimpse at medieval court life, captured in exquisitely executed and richly coloured illustrations; or Pablo Picasso's *Les Demoiselles d'Avignon* which caused an uproar world-wide – here was a painter who, in a display of unparalleled disrespect, was proclaiming the expanse of artistic freedom.

All of these works of art are paintings which have changed the world either by making history visible or creating history themselves.

This volume is not an art-historical appraisal but an overview of great works of art from a cultural aspect. We are intent on peaking behind the scene and looking at the social conditions prevalent at the time a picture was painted, at an artist's milieu and lifestyle or at the historical importance of the event or subject depicted. Classical art-historical analyses have intentionally been avoided. In their place, anecdotes and short tales bring the paintings to life. The selection of works illustrated consciously addresses the Western European Christian tradition; this in no way means that the historical or artistic elements of other cultures or confessions are of lesser importance or interest.

This juxtaposition of world-famous and less familiar works of art underlines their significance in our world today. Sometimes this is subtle, with little obvious effect on our times, and for others no commentary is necessary.

The Authors

Prehistoric Art that Made the World Think Again
The first masterpieces of painting

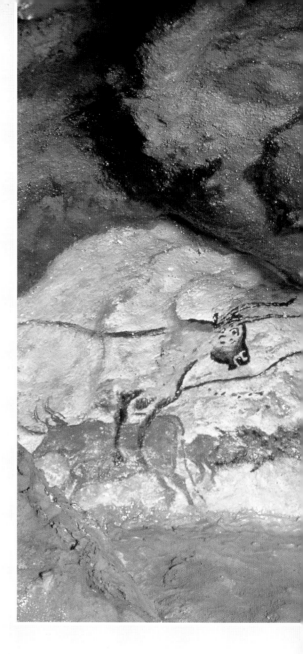

… suddenly we found a hole. We moved a few stones to make the opening wider. And, because I was the strongest, I was the first to climb down into the darkness. I was afraid to start with, because you never know what's lurking in a cave. But my burning curiosity overcame my fear of the unknown.

Still my heart was beating furiously. I slipped, tried to hold on to some stones but slid downwards several metres. And then, when I finally came to the bottom, I was amazed to see the strangest pictures on the walls.

Eyewitness report by one of the four boys who discovered the Lascaux Caves in 1940

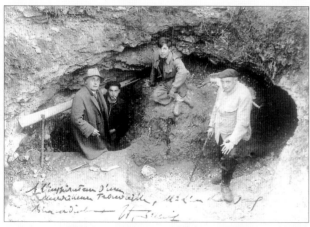

A journey into the past: The entrance to the Lascaux Caves, 1940. Marcel Ravidat and Jacques Marsal, two of the boys who discovered the caves, are pictured in the middle

The Lascaux Caves were discovered purely by chance. On 12 September 1940 four boys were roaming through the woods above Montignac in the Vézère Valley, when suddenly their little dog disappeared in front of them. Terrified, they ran to the spot where he had been and discovered a small crevice in the ground – thus began the adventure related above.

Caves were the first type of permanent housing for human beings, when they were still active as hunters and gatherers at the dawn of history. Around 15,000 BC, several groups seem to have settled near each other in the south-western region of Dordogne in France. In nearly 200 caves, prehistoric remains have been discovered. Due to the unusual atmospheric conditions present in these caves, an astonishing number of palaeolithic paintings have been preserved in excellent condition.

The discovery made by the four boys affected the history of art as nothing had ever done before. In the Lascaux Caves, which are about 100 metres long, more than 1,500 palaeolithic incised drawings and roughly 600 realistic paintings – of bison, stag, ox and other animals – were discovered. Nowhere else have so many prehistoric pictures been found preserved in one place. Researchers assume that for about 5,000 years people have

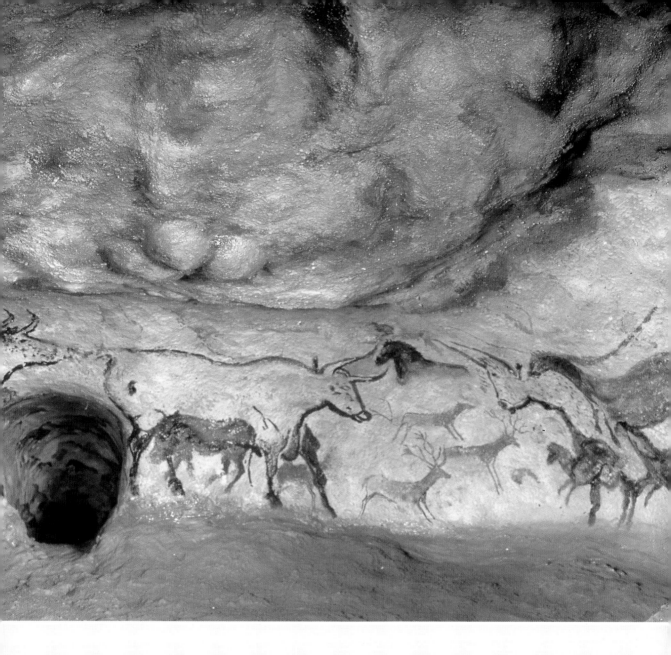

inhabited these caves, painting the walls over and over again — ultimately leaving behind a "prehistoric art museum".

Some of these pictures are extremely large: the walls of the biggest cavern (The Great Hall) is decorated with some bulls measuring five metres in length. Unique in their vitality and remarkable in the skill with which they were executed, these pictures dramatically changed our view of art history. Until well into the nineteenth century, it was thought that art had developed gradually and in stages over time, similar to the way a child's art develops — from awkward beginnings to more polished forms. In fact, when the first cave paintings were discovered in 1879 at Altamira in northern Spain, they were regarded as fakes. Further discoveries, above all the paintings at Lascaux, removed all doubts: as early as 15,000 BC painting was already a "fine art".

The Great Hall

c. 15,330—15,050 BC
Pigment on limestone
Length of longest bull: approx. 5 m
Lascaux Caves, France

The Pharaoh's Curse
Tutankhamen's tomb

**Have finally made a marvellous discovery
in the Valley – *stop* – Magnificent
grave with unbroken seals – *stop* –
Covered up again until you arrive – *stop* –
Congratulations!**

Telegram sent by Howard Carter to Lord Carnarvon,
6 November 1922

After six years of intense excavation work in the Valley of the Kings, the archaeologist Howard Carter had finally stumbled on the entrance to a tomb. The tomb of Tutankhamen? He did not know for certain, but he sent the above telegram to his patron, Lord George Edward Carnarvon, imploring him to come to Egypt as quickly as possible. Carter re-

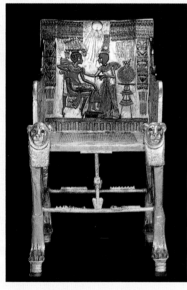

"The most beautiful thing that has ever been found in Egypt". The throne discovered in Tutankhamen's tomb

covered the tomb and awaited Lord Carnarvon's arrival – a period of almost three weeks in which Carter was sleepless with excitement.

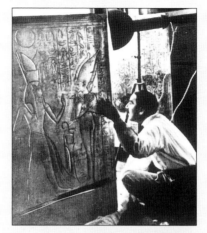

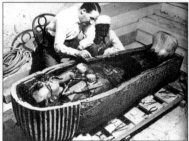

Howard Carter and an Egyptian assistant examine Tutankhamen's coffin (above)

A triumphant moment: Howard Carter opening the golden shrine, 1922 (top of page)

Carter and Carnarvon experienced one of the greatest triumphs in the history of archaeology: after they had cleared the last of the sixteen steps leading into the tomb, the two were standing in front of a walled-up entrance – bearing the royal emblem of Tutankhamen! This was only the beginning. When Carter and Carnarvon found a second walled-up entrance, they took a crowbar and knocked a hole in the 3,000 year-old masonry. Through it, they gazed at things that left them speechless. The flickering light of a candle illuminated the most important treasures ever discovered in Egypt. Among them was a gold

throne with a brilliantly coloured back – a present to the young Pharaoh from his wife. Carter described the chair as "the most beautiful thing that has ever been found in Egypt". These objects captured the world's attention and sparked a lasting interest in Egyptian art. It was as if a tale from *A Thousand and One Nights* had come true, and Carter summarised his find in this way: "The most remarkable thing Tutankhamen did in the eighteen years of his reign was to die and be buried."

The press gave the story extensive coverage. It also invented another story – on something it called the "Pharaoh's Curse", which was apparently deadly to anyone who disturbed the rest of the dead king. It is true that Lord Carnarvon and his wife died shortly after the tomb's discovery, as well as a number of others who had been present when it was opened. And by 1930 the only living member of the original excavation team was Howard Carter, who seemed indifferent to the rumour that these deaths were the result of an ancient malediction. After all, they had never encountered an inscription recording the "Pharaoh's Curse". Upon investigation into this series of deaths, it was discovered that quite a few were press swindles invented to keep newspaper circulation high. Yet there is something to the legend. Science has revealed that by opening these tombs, people are exposed to an infectious mould which is present in decaying bodies. This may have something to do with the mysterious series of deaths that followed the discovery of Tutankhamen's tomb.

Anonymous, Egyptian
Tutankhamen Anointed by His Wife

1355–1342 BC
Detail from the back of Tutankhamen's throne
Carved wood and gold, inlaid with Egyptian
faience, enamel, semiprecious, stones and silver
104 × 53 × 64.5 cm
From the tomb in the Valley of the Kings
Egyptian Museum, Cairo

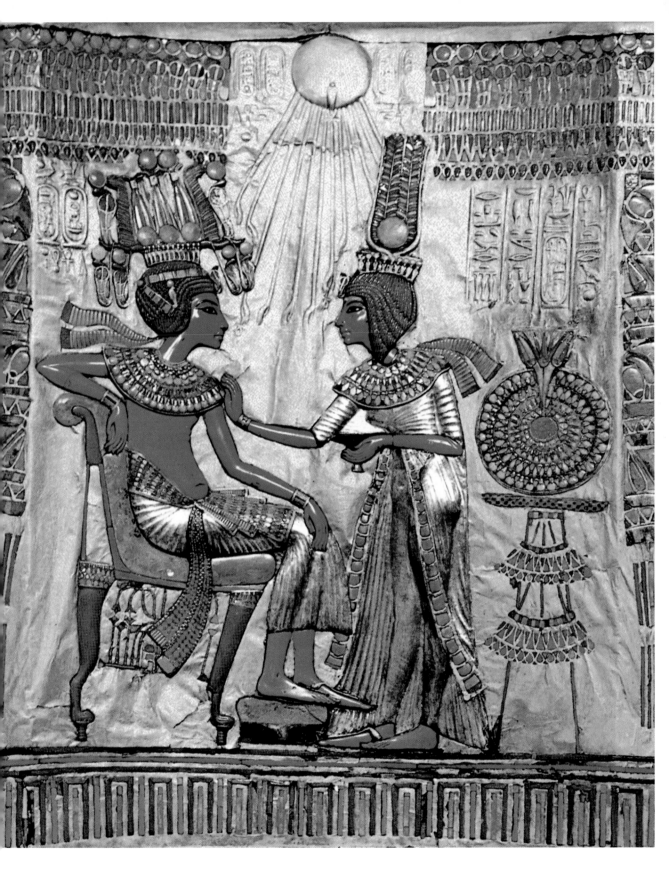

Fertile Beginnings
Europa and the Minotaur

Out in the dark blue sea there lies a land called Crete, a rich and lovely land, washed by the waves on every side, densely peopled and boasting ninety cities.... One of the ninety towns is a great city called Knossos, and there, for nine years, King Minos ruled and enjoyed the friendship of almighty Zeus.

Homer, *The Odyssey* 19, 172–174, 178–180

To speak of Crete is often to speak of bulls. An ancient tale concerns a young woman named Europa, who was so generous as to give her name to a continent. Europa was the daughter of a king who ruled over what is now the Mediterranean coast of Syria. When Zeus caught sight of beautiful Europa on the beach he fell in love, assumed the form of a

A test of strength and high spirits during the Fiesta de San Fermín on the Plaza de Toros in Pamplona, Spain

white bull and approached her. The maiden caressed him, and climbed onto his back — at which moment he carried her off to the island of Crete, where he revealed his true identity. As the ancient Greek writers said: "There they mingled in love", and Europa bore Zeus three

sons. One of them was the legendary Minos. There is another tale about Minos, who later became king of Crete. When Minos refused to sacrifice a white bull sent to him by Poseidon, the sea-god revenged himself by seducing Minos's wife Pasiphaë. Driven mad by strange desires, she is said to have hidden herself in a wooden cow. Poseidon assumed the form of a bull, prevailed over the cow and months later Minos's wife gave birth to the Minotaur: a monster with the head of a bull and the body of a man. Minos built a sub-terranean labyrinth, in which he concealed the Minotaur. Yet, it was necessary to placate the monster as he grew older; he demanded a tribute from the city of Athens: they had no choice but to regularly send the Minotaur seven youths and seven virgins – which the monster devoured.

Why did the bull play such an important role in mythology? Many cultures venerated the bull as a divine animal; he was, according to their myths, the first creature and a symbol of fertility. He was also associated with cattle raising and the first human settlements. The place where a bull stopped on its wanderings was considered a good place to settle – in fact the borders of many ancient settlements were marked by an ox drawing a plough. The bull also provided a standard of value and an

object of barter: Homer tells us that a woman skilled at domestic work was worth four bulls, while a beautiful slave was worth twenty.

The sport of bull-leaping was already known to Crete in Minoan times: it was an exercise for youths to measure themselves against the raw forces of nature and may also have had religious significance. One of the earliest depictions of bull-leaping can be seen in Knossos near Heraklion, where, since the beginning of the twentieth century, a vast palace complex has been under excavation. It has been suggested this magnificent structure belonged to King Minos and that its nearly 1,200 rooms were the origin of the myth of the Labyrinth that housed the Minotaur.

Anonymous, Greek
Bull-Leaping

c. 1500 BC
Fresco
Height: 86 cm
From the Palace of Knossos
Archaeological Museum, Heraklion

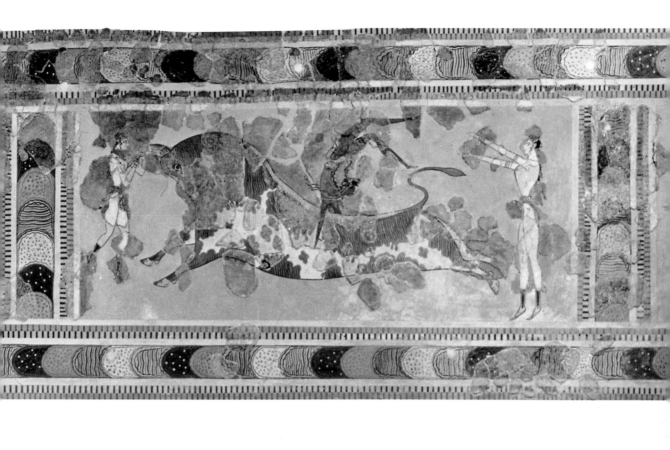

What Would Life Be Without Music?
The Etruscans and melodic beginnings

Europe's oldest depictions of musical instruments and its oldest written music were found in Greece, the home of antiquity's most famous writers on music: Plato (*c.* 428–348 BC), the founder of Western philosophy, and Aristotle (*c.* 384–322 BC), his no less distinguished pupil. In *The Republic*, Plato declared: "Education through music is extraordinarily important because rhythm and harmony penetrate to the depths of the soul, seize and ennoble it." This quality would only be brought out of the soul by "good" music:

which was traditional music. In matters of art, Plato was a conservative: "One should guard against anything novel in music, otherwise everything will be called into question. Nowhere are the laws of music broken without the law itself being broken!" The way his philosophy had it, disordered music produced disordered souls which produced a disordered society. The serious and sober philosopher despised the flute above all. To him it epitomised the orgiastic cult of Dionysus, and was therefore an instrument of evil (there are

"Platonists" today who say the same about Heavy Metal music). Aristotle agreed with his teacher in principle, but allowed the flute into his Ideal State, where it would be played only at such occasions "where listening aims more at cleansing than instructing".

And what did the Etruscans have to do with the flute? It was some time around the tenth century BC when this people emigrated from Turkey to Italy. There they established the first western European cities in the land to which they gave their name, Tuscany, and to which they brought Greek music and culture. Yet the Etruscan achievement is most convincingly attested to by their tombs, some of which are in superb condition. They are not only Europe's first domed buildings, but also contain its oldest frescoes. *Flute Players* is a superb example of works that were discovered in 1830 in a beautifully decorated tomb in Tarquinia, one of the largest Etruscan cities, situated about eighty kilometres north of Rome.

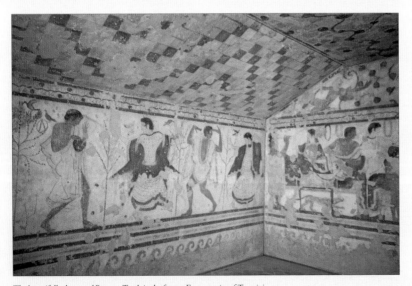

The beautifully decorated Banquet Tomb in the former Etruscan city of Tarquinia

Anonymous, probably Greek
Flute Players

480–450 BC
Fresco
From the Tomba del Triclinio
(Tomb of the Triclinium),
Museo Nazionale, Tarquinia, Italy

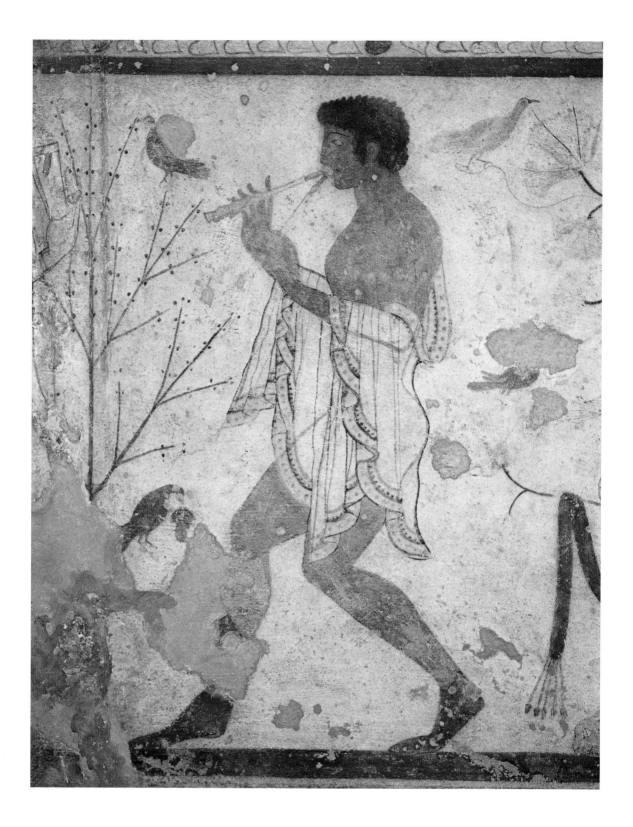

Everyday Life Freezes into Burning Darkness
The destruction of Pompeii

Make wine-must rolls as follows: moisten a bushel of wheat flour with wine-must, add aniseed, cumin, two pounds of suet, a pound of cheese and some grated bay twig; after you have shaped them, place them on bay leaves and bake.

Marcus Gavius Apitius, *De re coquinaria* (On cookery), first century AD

Buried for centuries under lava: The Via dell'Abbondanza in the excavated city of Pompeii

In the year AD 79, on the morning of August 24, people in Pompeii were going to market. Pompeii was a Roman city of 15,000 inhabitants, small but prosperous. People who did not feel like cooking were going to one of the many public kitchens where soups and stews were bubbling on the fire. In its shops fresh chickens, fish, eggs, olive oil, herbs and dates were being sold. A baker and his wife were selling bread and rolls fresh from their oven. They had done well and had shown it by having the walls of their house decorated with colourful frescoes. One of them was the double portrait *A Baker and His Wife*. The baker holds a scroll which may have borne the text of the couple's marriage contract, his "master baker's certificate" or perhaps a recipe. His wife is holding a stylus for writing and a wax tablet. Perhaps it signifies that she does the books for the bakery, perhaps she is proud of her literacy. The picture was probably intended to advertise the couple's success to future generations.

At ten o'clock in the morning of August 24, the fresco, the couple and the entire city were buried under a several-metre thick layer of ash, pumice and lava. Pompeii is situated at the foot of Mt Vesuvius, but the volcano had not stirred since the city was founded; nor was there any warning that it was about to erupt – much less that it was about to erupt in the way that it did. When Vesuvius blew the plug of its gigantic crater into the air, an apocalyptic hail of stones and millions of tons of hot ash made Pompeii as dark as night. People fled in panic into entries and cellars but there was no escape, the falling ash crushed buildings and burned through wooden floors. People passing through the forum were killed by falling columns. Sixty prisoners awaiting gladiatorial combat were suffocated where they were interned. The owner of the "Villa of Diomedes" died with the keys to his house in his hand. The lady of the "House of the Faun" was buried under the roof of her hall with the jewellery she had grabbed to take with her. The hot ash enveloped her neighbour's dog where he was chained up. Pompeii was lost under a mountain of ash within a few hours; only a handful of people escaped.

Pliny the Younger (*c.* 61–*c.* 113) witnessed the inferno from the Bay of Naples as an eighteen-year-old. He wrote that, of the people in the area, "most prayed to the gods. Others, however, explained that there were no more gods anywhere; the last night on earth had plunged the world in eternal darkness". There was no question of rebuilding Pompeii, the ash hardened into rock and it was not until 1748 that the rediscovered ruins – especially some well-preserved interior frescoes – created a sensation throughout Europe. Along with neighbouring Herculaneum, which suffered the same fate, Pompeii provides us with incomparable evidence of what daily life was like in ancient Rome.

Anonymous, Roman
A Baker and His Wife

1st century AD
Fresco
48.9 × 41 cm
Wall painting from Pompeii
Museo Archeologico Nazionale,
Naples

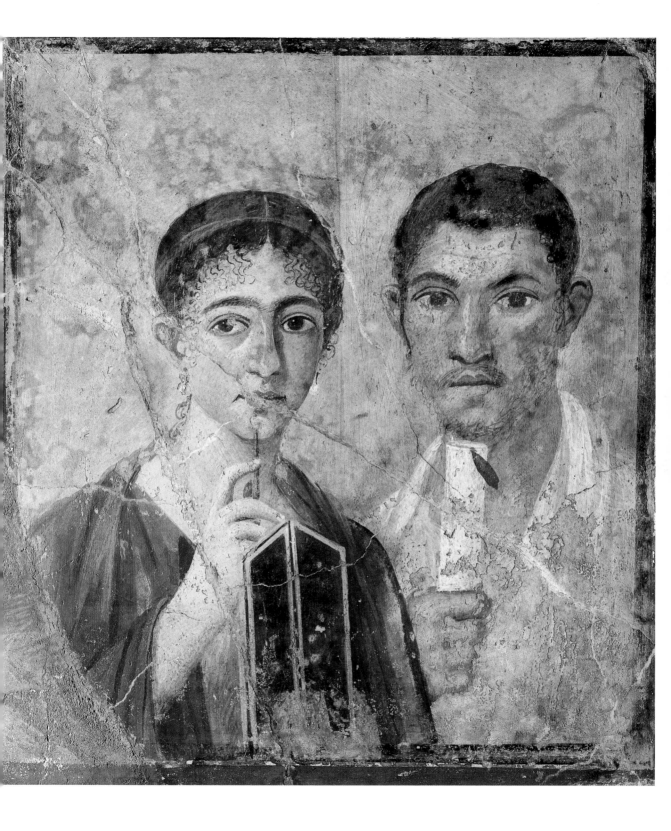

"Upon this Rock I Will Build My Church"
The birth of Christianity

Santa Costanza: Interior view

And I say also unto thee, that thou art Peter, and upon this rock I will build my Church; and the gates of hell shall not prevail against it. And I will give unto thee the keys of the kingdom of heaven: and whatsoever thou shalt bind upon earth shall be bound in heaven: and whatsoever thou shalt loose on earth shall be loosed in heaven.

Christ to Simon Peter, the Gospel of Matthew (16: 18–19)

He had indeed failed. Accused by Jewish scribes of blasphemy, Jesus Christ was crucified by Roman soldiers on the mount of Golgotha. To all appearances the son of a Jewish carpenter from Nazareth, he claimed to be the Son of God, and for this he died in dishonour on the Cross. But something unheard of happened: three days later, when some women went to his grave to anoint his body with oil, they met an angel who said to them: " … Fear not ye: for I know that ye seek Jesus, which was crucified. He is not here: for he is risen, as he said…" (Matthew 28: 5–6). Was Jesus Christ really the Son of God? Certainly his adherents grew in numbers so rapidly that there were soon several thousand of them.

The leader within this first Christian community was Simon, a fisherman from Capernaum. It was Simon whom Jesus Christ renamed the "rock" (Greek: Pétros) on which he would build his Church. Our picture shows this scene: Jesus Christ has just made Peter the head of his Church – the first Pope.

Yet Peter had much to overcome and undergo. Forced to flee Jerusalem in AD 42, he carried his missionary activities as far as Rome, where Christians were soon to be persecuted. They

The mosaics in Santa Costanza also depict secular scenes such as the harvesting of grapes and the making of wine

refused to practise the cult of worshipping the Emperor, and were therefore regarded as godless, which provoked the hatred of the pagans. Christians were accused of the most evil and shameful things: "When the Tiber rises to the city walls, when the Nile does not flood the fields, when there is famine and disease, the cry immediately goes up: 'the Christians to the lions'," wrote the Roman historian Tertullian. Peter himself was martyred – crucified upside-down – in 64 or 67, on the place where St Peter's Cathedral stands today.

Constantine the Great was the first Roman emperor to be baptised – presumably shortly before he died – and this made it possible for Christianity to become the state religion of the Empire. Early in the fourth century a mausoleum was built on the Via Nomentana, probably as a tomb for Constantine's daughters Costanza and Helena. Today known as Santa Costanza, this round structure is one of the oldest and most significant religious buildings in Rome: here mosaics depicting secular events, such as the grape harvest, can be viewed as well as the finest surviving examples of early Christian art, after the catacombs.

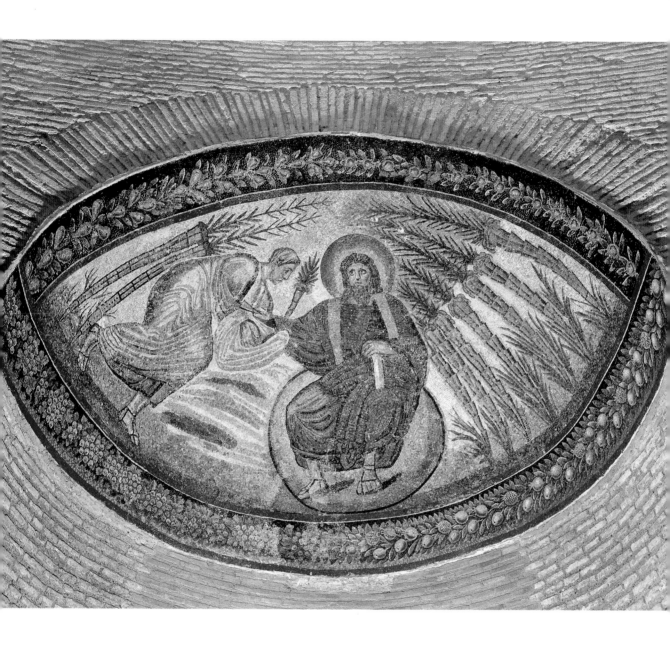

Anonymous, Late Roman
Christ and St Peter

4th century
Mosaic
Santa Costanza, Rome

From Brothel to Court
Masterpieces of art and architecture

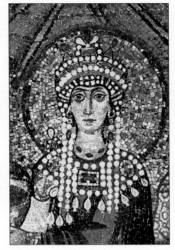

An exemplary career: Empress Theodora

Theodora's father was a bear-keeper at the Hippodrome of Constantinople, where the Roman crowd went to enjoy the spectacles of chariot and horse racing, circus performances and gladiatorial combats. Growing up among jugglers and gladiators, Theodora ran with a dubious crowd. When she was a girl she stood out among the capital's actresses, dancers and hetaerae (female companions and courtesans) for her wit, her charm, her beauty and her shamelessness. The Byzantine historian Procopius said of her: "She bared her body front and back, inviting men to look at charms that are supposed to remain unseen, and became an expert in the techniques of exciting lust so as to hold worldly men in her thrall." Among her admirers were judges, scholars and statesmen – and a young Senator named Justinian. Roman law forbade the marriage of a Senator to an actress, but the ardent aristocrat persuaded the Emperor Julian to revoke the law so that he could marry her. Justinian's mother is said to have died of grief.

Justinian became ruler of the Eastern Roman Empire in AD 527 and the one-time courtesan became an empress, reigning jointly with her husband. We hear that priests who did not bend to her will were persecuted and that she had a secret police which spied on and tortured the thousands of people whom she considered her enemies. Her ladies-in-waiting, with whom she is depicted in a mosaic in the church of San Vitale at Ravenna, which was then a Byzantine outpost in Italy, are all supposed to have been former courtesans. In the same church, Emperor Justinian is portrayed with his attendants in another mosaic on a wall directly opposite Theodora. The two rulers were to be seen analogously to Christ and the Virgin, symbolizing the union of earthly and spiritual authority and "divine kingship".

Procopius seems to have taken a leering delight in writing *Anecdota*, an historical exposé about an Emperor and Empress, whom he held in contempt. But others considered Theodora to be generous, compassionate towards the poor and a devout Christian. Together with the Emperor she had churches and monasteries built, most importantly Hagia Sophia (The Church of Holy Wisdom in Constantinople), 532–37, which remains the most important achievement of Byzantine architecture. Contemporary historians are kindly disposed towards Theodora. They admire her unusual erudition and intelligence and credit her with doing much to strengthen the will of her indecisive husband and inspiring him in the work of defending the Empire.

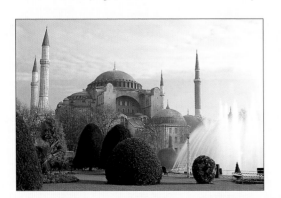

Hagia Sophia in Istanbul, erected by Empress Theodora and Emperor Justinian

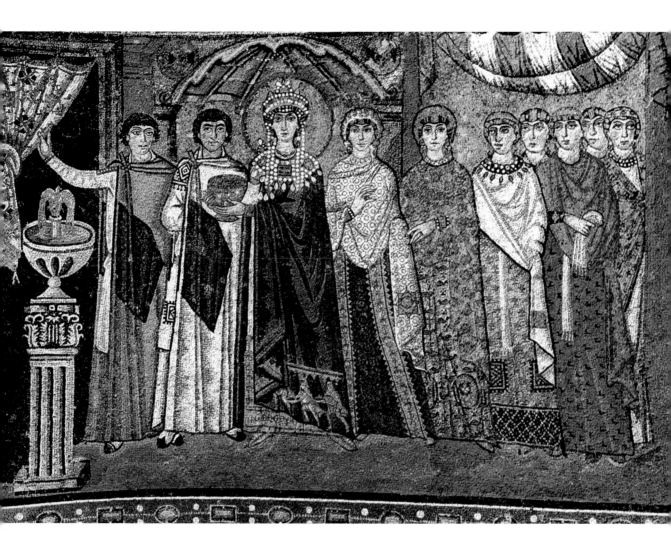

Anonymous, Byzantine
Empress Theodora and Her Attendants

c. AD 547
Mosaic
Detail from the apse of San Vitale, Ravenna

"Which Was, and Which Is, and Which Is to Come"

The end of the world and an artwork for posterity

And the first beast was like a lion, and the second beast like a calf, and the third beast had a face as a man, and the fourth beast was like a flying eagle. And the four beasts had each one of them six wings about him; and they were full of eyes within: and they rest not day and night, saying, Holy, holy, holy, Lord God Almighty, which was, and which is, and which is to come.

The Revelation of Saint John the Divine (4: 7–8)

Around AD 1000, the troops of Emperor Otto were surprised by an eclipse of the sun. These fearless warriors were terrified and thought that Armageddon – the end of the world – had come; they climbed into barrels and hid under carts. Calculations and prophesies setting a date for the end of the world has long been a fixation: Christopher Columbus

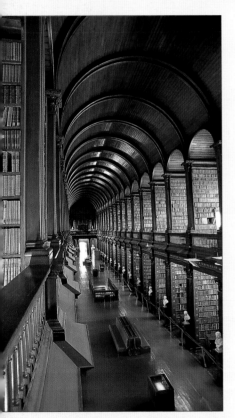

The Long Hall in Trinity College, Dublin, where the *Book of Kells* can be marvelled today

predicted it would happen in 1647, and the French astrologer Nostradamus (1503–1566) spoke of a "King of Terrors" who would

come down from heaven in the year 1999. Just as no man knows the hour of his death, so too is the end of the world a mystery: "The Lord of that servant shall come in a day, when he looketh not for him, and in an hour that he is not aware of ... ", according to the Gospel of Matthew (24: 50).

Though precisely *when* the last hour will be is not clear in the Bible, *how* it will happen is vividly described. St John the Divine writes in the book of Revelation that, at the end of time, God will come into the world and pronounce judgement upon mankind. His throne will be flanked by the Four Beasts of the Apocalypse: man, lion, bull and eagle. These beings are also interpreted as symbols of the earthly Creation, which is traditionally signified by the number four; hence the four elements, the four seasons and the four corners of the earth. The New Testament, which tells of the "new covenant" between God and man, opens with the gospels of the four Evangelists that form the majority of this work. Each Evangelist is represented by one of the Four Beasts of the Apocalypse: Matthew by the man, Mark by the lion, Luke by the bull and John by the eagle.

In reference to this evangelistic and apocalyptic imagery, these four beings appear in the *Book of Kells*. An illuminated manuscript from the eighth or ninth century, this work contains the four Gospels together with magnificently painted illustrations and intricate

embellishments with a mix of geometric and zoomorphic forms. The *Book of Kells* represents the climax of Irish manuscript illumination, an art influenced by the work of both the Celts and the Germanic peoples. A priceless legacy of the early Middle Ages, it is considered a supreme achievement of Western civilisation. It was probably created from around 800, but where it was made still remains a mystery: probably from a monastery library at Kells (sixty-five kilometres northwest of Dublin), in Northumbria, or perhaps even in eastern Scotland. This book is perceived as a "sacred relic of art", and so exquisite that it was once believed to be the work of angels. The first mention of the *Book of Kells* was in 1007, when it is recorded stolen – "impiously by night" – but, after "twenty nights and two months", it miraculously reappeared having been hidden underneath a small piece of turf.

Anonymous
Man, Lion, Bull and Eagle

c. 800
From the *Book of Kells*
Illuminated manuscript
3.3 × 2.5 cm
Trinity College, Dublin

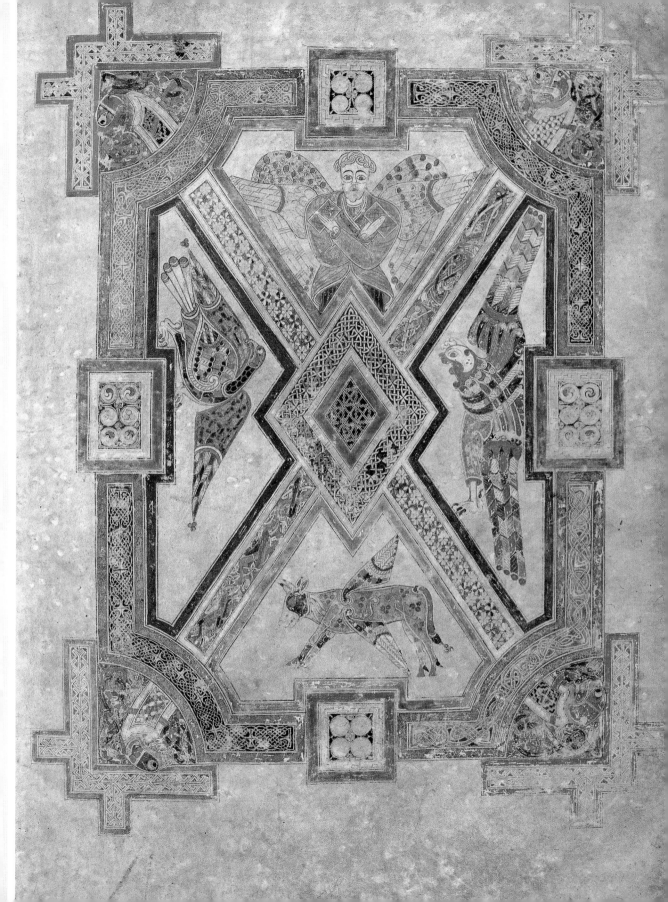

Idle Hands Are the Devil's Workshop
Ora et labora!

Idleness is the enemy of the soul. Therefore at certain hours the Brothers should busy themselves with crafts, at other hours in reading Holy Writ.

The Rule of St Benedict of Nursia, from chapter forty-eight

Pray and play: In the Bavarian monastey at Andechs the monks still observe the Rule of St Benedict. But this doesn't mean that they are not allowed to play the odd game of cards!

Two books were always displayed at the medieval bishops' synods and meetings of the Reicherat of the Holy Roman Empire: the Bible and the Rule of St Benedict. Promoted actively by Emperor Charlemagne (742–814), the Rule was accepted throughout Europe as a guide for Christian conduct, and still today committed Christians around the world use it as a guide to godly life. The Rule, comprising seventy-three chapters, was originally conceived as a code to govern the everyday lives of monks. Regulating monastic life in astonishing detail, it even admonishes monastery cellarers to serve their fellow monks "the proper amount of food and drink" without "treating them with condescension or keeping them waiting". The humanity which is apparent in every part of the Rule and its quiet, almost democratic, tone guaranteed its success. In fact, it became the model Rule of conduct for monks and monasteries in other Orders too – and, today, the Rule is still observed in a number of recently established Benedictine monasteries in the United States.

In Europe, the significance of the Rule and its fruit are far reaching. St Benedict's basic principle of *"ora et labora"* (prayer and work) represents a deliberate rejection of the other-worldly piety practised by the early ascetics of the deserts. The Rule, in contrast, requires the individual monk to pay more than lip-service to God by serving Him with his hands. Thus many Benedictine monasteries became the leading centres of culture in Europe, in which the art of manuscript illumination and the chronicling of history, the writing of poetry and music, the practice of agriculture and animal husbandry flourished. The best schools and the most modern hospitals of the early and high Middle Ages were run by sophisticated and highly educated monks who wore the habit of St Benedict.

What do we know about St Benedict himself, the "father of monks and educator of the West"? He was born in the Italian town of Nursia in *c.* 480, and later lived as a recluse in a forest east of Rome. Around 529, St Benedict founded Europe's first monastery at Monte Cassino near Naples, which became the fountain of European monasticism and, presumably, the place where the saint died in 547. Today, scholars question the veracity of the various details of his life which have come down to us; some even doubt whether there was a St Benedict at all. Yet, it is certain that the Rule, which bears the name of St Benedict, has powerfully formed European civilisation and culture.

Anonymous, Italian
The Death of St Benedict

11th century
Detail from Cod. Vat. Lat. 1202
Illuminated manuscript
Biblioteca Apostolica Vaticana, Rome

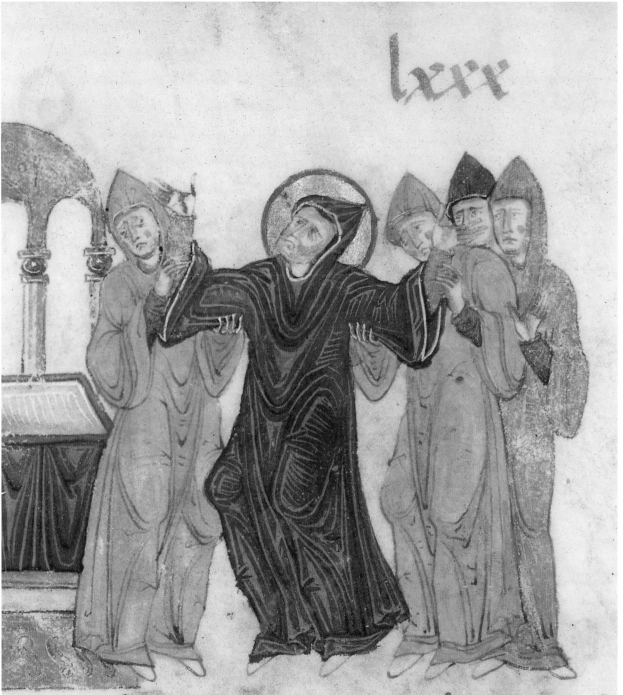

Vlnas depandrat hmur ulnars Afftrgz sca

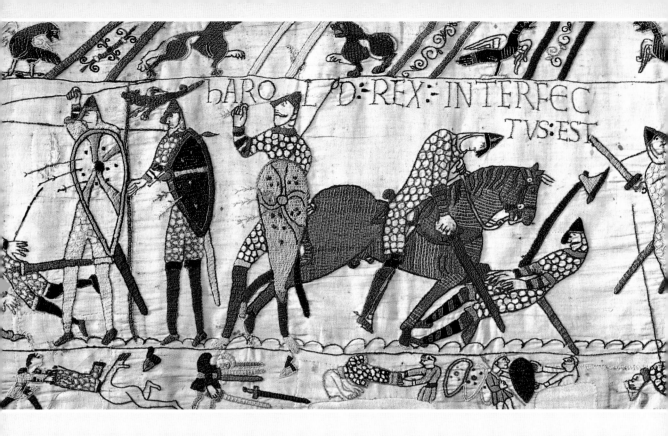

1066 and All That

"And the hooves of their horses trod down the corpses"

Now evening had come and the Anglo-Saxons knew that they could not withstand the Normans. They feared the implacable wrath of Duke William, who spared no one. They were routed and fled: on horses captured from their foes, on foot, some along the way, many across the open fields. Those who could stand no longer nor had the strength to flee writhed in their own blood. Many died in the depths of the wood. Although the region was unfamiliar to them, the Normans relentlessly pursued their adversaries and fought them to the death, and the hooves of their horses trod down the corpses as they galloped away.

William of Poitiers, *The Deeds of William, Duke of Normandy and King of the Anglo-Saxons*, 1073/74

The Vikings – the scourge of Europe. The West lived in terror of these men who came down from the Scandinavian north in their dragon-like ships. Their geographical location gave rise to another name, the "Nor(th)mans". From the eighth century they attacked the coasts of Great Britain and France and sailed up the great rivers right into the heart of Europe, arriving without warning at the gates of Cologne and Paris. Normandy, the first Viking kingdom in Western Europe, was founded at the mouth of the Seine in 911. The Vikings also persisted in their attempts to establish a strong foothold in England.

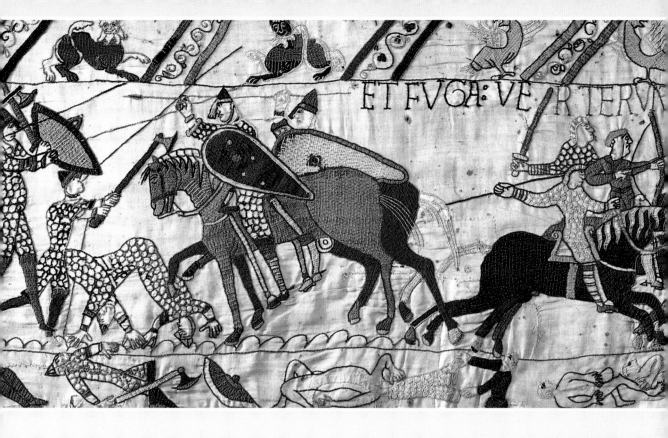

ET FVGA VE RTERV

Anonymous
The Bayeux Tapestry

———

c. 1066–1082
Detail
Canvas, embroidered in coloured wool
Overall: 50 cm × 73 m
Musée de la Tapisserie, Bayeux

William the Conqueror (c. 1028–1087), Duke of Normandy, finally secured Norman rule in England in 1066. On 27 September of that year, he sailed from the Norman coast under the cover of darkness. His ships carried 7,000 men, horses, weapons, provisions and even a dismantled wooden fortress which could be reassembled. Landing in the early morning, William rallied his troups and marched to Hastings. There, the decisive battle of the compaign was fought on 14 October 1066. The Anglo-Saxon forces, led by King Harold II, had been weakened by their hard-won victory over the Norwegian Vikings some days before as well as the subsequent

march to Hastings. They were defeated and Harold was killed by a Norman arrow. With Harold dead and his army routed, the fortified Normans were at leisure to hunt down the hapless Anglo-Saxon soldiers. A few weeks later, on Christmas Day 1066, William had himself crowned King of England in Westminster Abbey. For his victory, history has given him the epithet "The Conqueror".

The Bayeux Tapestry preserves the memory of his victorious campaign which linked England more closely to Latin culture and the West. The tapestry is seventy-three metres long and one of the most important pictorial records of medieval history. Rich in detail and

exquisitely made, it portrays clothing, armour, weapons, vehicles, ships and even banquets and celebrations from the eleventh century. Legend has it that the tapestry was woven by Matilda, the wife of William the Conqueror, but it is more likely that it was made by nuns. In any case, it is a masterpiece presumed to have been created by women in southern England, and was probably commissioned by Bishop Odo of Bayeux (1036?–1097), the half-brother of William the Conqueror. This particular detail of the tapestry shows the Anglo-Saxon soldiers fleeing and, presumably, King Harold being struck by an arrow in the head.

The Court and the Church: The Great Divide
An Emperor humbles himself

For three days he persevered, in pitiable attire, before the gate of the castle. He had divested himself of his royal robes and his shoes. In their stead he was clad in woollen dress. And he did not cease imploring the aid and consolation of Our Clemency with great lamentation … until we … persuaded by the duration of his penitence and the urgent intercession of those present, received him again in the lap of the Holy Mother Church.

Pope Gregory VII, on King Henry IV, 1077

Formerly an impregnable mountain fortress, Canossa loomed above the countryside like an eyrie, eighteen kilometres southwest of Reggio nell'Emilia. Here, where today geckoes can be found scurrying over its ruined walls in midday heat, an extraordinary chapter of European history was written in 1077. In this castle, which belonged to the pious and influential Countess Matilda of Tuscany, the most powerful ruler in the West fell on his knees before the Pope to beg for forgiveness. Nothing like this had ever happened before. Strife between temporal and spiritual authority had

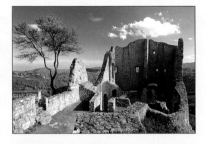

The ruins of Canossa, destroyed in 1255, and its rocky outcrop

never escalated to such a degree. At that time, Henry IV, who was both the Holy Roman emperor (crowned in 1084) and German King (1056–1106), was only twenty-seven years old

– half the age of his adversary, Pope Gregory VII (c. 1020–1085). These two men had heartily disliked each other for years and were locked in a power struggle, with the authority of each at stake.

Since his election in 1073, Pope Gregory VII had worked earnestly to reform the Church. He forbade priests to marry and prohibited the widespread practice of simony, the sale of lucrative ecclesiastical preferment to nobles without a vocation or theological background. In addition, Pope Gregory VII insisted that all temporal rulers were subject to him, Christ's deputy on earth, and that only he, the Pope, might determine who was to become an abbot or bishop and where such office should be held. From time immemorial, emperors, kings and dukes had appointed abbots and bishops, personally giving them their rings and croziers as the insignia of their ecclesiastical dignity. Things had progressed to such an extent that monasteries and bishoprics only existed because they had been endowed with land and wealth by the nobility. Abbots and bishops were required to place the possessions of their church at the disposal of their temporal rulers in time of war or economic necessity. As a result, the power of the rulers was based on the loyalty of their clergy. And now the pope was trying to create a clergy loyal to the ecclesiastical authorties! The enraged Emperor-King Henry IV proclaimed that Pope Gregory VII had been

deposed – and the investiture strife broke out. Investiture (from the Latin *investire*) means the clothing of abbots and bishops signifying that they are invested with their rank and office. The Pope excommunicated Henry IV, banishing him from the Church, and absolved his subjects from their oath of allegiance to their Emperor. The pontifical acts put Henry IV in checkmate.

This was an age in which belief meant life, and life meant faith. There was no doubt that anyone who had anything at all to do with an excommunicated person under the ban of the Church had made a pact with the devil. The only way Henry IV could free himself from this predicament was to travel to Canossa as a penitent and humbly beg the Pope to lift the ban. Before going, he cast about for powerful allies who might intercede for him. His godfather, Abbot Hugh of Cluny, and the Countess Matilda of Tuscany agreed to do so. Finally, on 27 January 1077, the Papal ban on Henry IV was lifted. The quarrel over investiture, however, dragged on until 1122.

Anonymous
King Henry IV Begging Countess Matilda of Tuscany and Abbot Hugh of Cluny to Intercede for Him with Pope Gregory VII

1111/1116
From the *Donizo* manuscript
Illuminated manuscript
Biblioteca Apostolica Vaticana, Rome

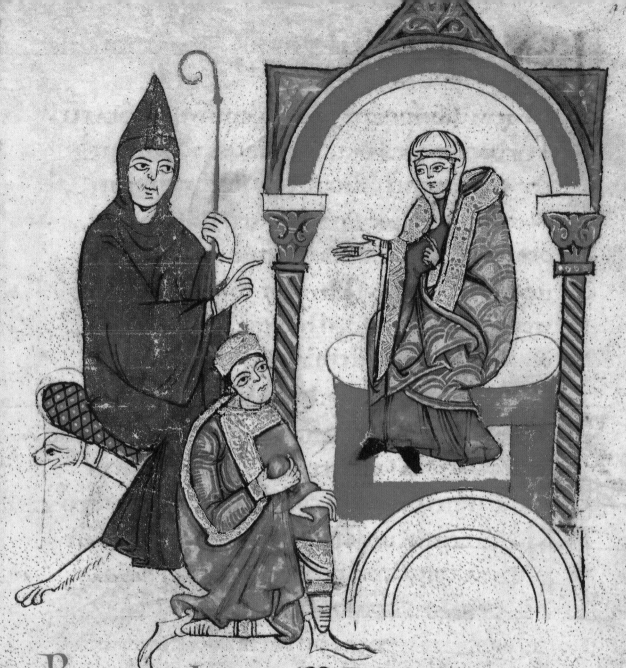

REX ROGAT ABBATEM MATHILDIM SUPPLICAT ATQ

Medieval Medical Matters
Healing with stones

God has endowed precious stones with miraculous
powers. They succour man in body and soul, banish
Satan and protect all living beings from his malice.
Therefore the devil shuns precious stones. They cause
him to shudder by day and night.

St Hildegard von Bingen, *Physica (The Healing Powers of Nature)*, c. 1151–1158

In Europe and America, the trade of precious stones is booming and exhibitions of common minerals attract more visitors every year. The sheer volume of advertising for alternative therapy alone is astonishing. Increased dissatisfaction with the results of scientific medicine is promoting a search for different treatments. This quest for healing has led to the rediscovery of all sorts of forgotten cures and remedies for disease, among them the therapeutic use of precious stones. The practice of healing through the use of such stones has a long tradition. Pliny the Elder, a Roman writer who perished at Pompeii when Vesuvius erupted in AD 79, wrote at length about the healing properties of gems and minerals in his *Historia naturalis*, an encyclopaedia of natural science. Later Pope Gregory the Great (c. 540–604) and the Benedictine monk known as the Venerable Bede (672/73–735), the founder of English historiography and author of *De natura rerum*, joined the circle of those "in the know" on the healing properties of precious stones. These two men drew their inspiration from the Revelation of St John the Divine, which mentions crystals and precious stones in connection with his vision of the Heavenly Jerusalem. During the Middle Ages, the first person to advance the practice of this type of

Early eighteenth-century pharmacy

alternative medicine was a woman: St Hildegard of Bingen (1098–1179), an abbess who was later canonized and is today regarded as the first German mystic and one of the great women of the Middle Ages. Her writings deal with the aetiology of disease and the treatment of patients, and she even corresponded with emperors, kings, popes and scholars on the subject. St Hildegard's natural remedies included herbal infusions and elixirs distilled from metals or precious stones dissolved in wine, and according to one: "A sufferer from gout should place a diamond in some wine for a whole day and then drink of it. The gout will depart from him." By the late Middle Ages, however, healing with precious stones was seen as witchcraft and black magic, and its practice seemed threatened into oblivion. In the fifteenth century, Paracelsus (1493–1541),

alchemist and the city physician to Salzburg and Basel, staunchly defended this form of alternative medicine, and encouraged the therapeutic use of mineral baths and minerals as medicine. Jakob Böhme (1575–1624), and his circle of mystic philosophers, also defended nature-based medicine – their teachings later exercised great influence on the German Romantics, especially the nineteenth-century poets who reawakened interest in alternative medicine.

Today, at the close of the twentieth century, St Hildegard of Bingen's remedies, the resurgence of nineteenth-century homeopathic medicine, together with the flower-essence therapy developed by English herbalist Edward Bach, form the basis of a type of medical treatment advocated by New Age circles. Furthermore, St Hildegard's knowledge of the psychological aspects of disease finds its resonance in modern psychosomatic medicine. In the work illustrated here, the saint and visionary is seen dictating a letter in her cell, whose columns symbolize the Old and the New Covenant, and above her is the five-tongued ray of divine inspiration.

Anonymous, German
**St Hildegard Dictating Her Letters
to Monk Volmar**

c. 1180
Detail from the *Liber Scivias*,
copy of the former Rupertsberg Codex
Illuminated manuscript
Abbey of St Hildegard, Eibingen

Herbal recipes prescribed by St Hildegard of Bingen have been used since the Middle Ages. Containers from the Carmelite Convent in Schongau, c. 1700

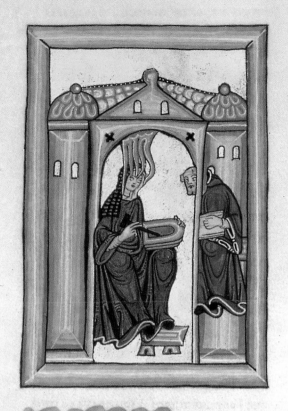

ad exponendum ⁊ indocta ad scriben
dum ea dic ⁊ scribe illa ñ sedm os homi
nis. nec sedm intellectum humane ad
inuentionis nec sedm uoluntate huma
ne compositionis s; sedm id quod ea in
celestib; desup in mirabilib; di uides ⁊ au
dis. ea sic edisserendo pferens. quemadmo
dum ⁊ auditor uerba pceptoris sui pcipi
ens. ea sedm tenore locutionis illi̇. ipso uo
lente. ostendente. ⁊ pcipiente ppalat. Sic
⁊ tu ó homo. dic ea q̈ uides ⁊ audis. ⁊ sc
be ea non sedm te. nec sedm aliu homi
nem s; secundu uoluntate scientis uiden
tis ⁊ disponentis omnia in secretis miste
riorum suorum. Et iteru audiui uoce
de celo michi dicente. Dic q̈ mirabilia
hec. ⁊ scribe ea. hoc modo edocta ⁊ dic.

Factum e̅ in millesimo centesimo
quadragesimo pmo filii di ihu x
incarnationis anno. cu q̈draginta duox
annox septe q; msiuim ee̅m maxtime co
tionis igneu lui̇ apto celo ueniens. totu
cerebru meu̅ tusfudit. ⁊ totu cor totuq;
pectus meu uelut flamma ñ tamn ar
dens s; calens ita inflammauit. ut sol
rem aliquam calefacit. sup quam radi
os suos ponit. Et repente intellectum
expositionis librox uidelicet. psalterii
euuangelii ⁊ aliox catholicox tam ue
teris quam noui testamenti uolumi
num sapiebam. ñ aute intpretatio
nem uerbox textus eox nec diuisione

Et ecce quadra
gesimo tercio
temporalis cur
sus mei anno
cum celesti uisi
oni magno ti
moze ⁊ tremu
la intentione inhererem uidi maxi
mu splendoze. in quo facta e̅ uox
de celo ad me dicens. O homo fragi
lis ⁊ cinis cineris ⁊ putredo putredi
nis. dic ⁊ scribe q̈ uides ⁊ audis. Sed
quia timida es ad loquendu ⁊ simplex

Fate and the Entire Cosmos of Medieval Life

Keeping the Wheel of Fortune turning

O Fortuna!
Like the Moon
Fickle in her state of being
Always waxing
Also waning
Fate thus unfettered
And so fearful
Wheel keeps rolling on and on
Evil state
In vain our fate

Wreaking our dissolution
Shadowed darkly
Veiled so thickly
Now on me you do descend
Now you play
On my bare back
Bent to you, I bear the brunt.

"Fortuna imperatrix mundi"
chorus from *Carmina Burana*

Drums pound as the choral music swells to a crescendo: "O Fortuna!" The first two words of Carl Orff's *Carmina Burana* are a cry of helplessness under the lash of destiny. The name of this powerful work, "Songs from Beuern", comes from Benediktbeuern, a

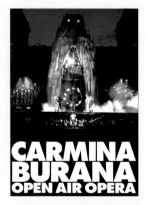

Fire and smoke: The mechanical wheel and the Wheel of Fortune in the open-air stage production of *Carmina Burana*, directed by Walter Haupt, 1996

Benedictine monastery in Upper Bavaria. It was there, in 1803, that a manuscript containing 318 medieval poems was found. Originating from the twelfth and early thirteenth centuries from South Tyrol or Austrian Styria, this manuscript proved to be the most important collection of medieval profane lyric poetry. Most of the texts were written in

medieval Latin by anonymous scholars and itinerant priests, but there are also works by major German poets, including Walther von der Vogelweide (*c.* 1170–*c.* 1230) and Neidhart von Reuenthal (*c.* 1180–*c.* 1250).

In sensuous, humorous, and graphic terms, this collection of poems offers us a candid picture of medieval life: one tells of a drunken abbot, carousing with cronies and dice players, while another of a roasted swan, complaining about its sufferings. Here, conventional morality rubs shoulders with mocking satire, virginal love with obscene songs to Venus. Verses on the Crusades, replete with mythological allusions, clerical games and tender poetic songs round off this fascinating poetic assemblage. Panoramic in scope, it unveils the entire cosmos of medieval life, and enthroned above it all is Fortuna, the goddess of fate.

For *Carmina Burana*, Carl Orff composed a musical score which synthesised twenty-four of these lyric poems, taking fate as the unifying theme: Fortuna, whose name derives from the Latin *Vortumna*. She turns the wheel of the seasons, bringing good and bad to kings and commoners alike: one day on top of the wheel (*regno*, I rule), the next at the bottom (*regnavi*, I have ruled). And yet, for those who ultimately end up at the bottom (*sum sine regno*, I am without rule), there is still hope (*regnabo*, I will rule). As with Tarot (another New Age

The opening bars of Carl Orff's manuscript for *Carmina Burana*, 1936

fad drawn from the Middle Ages), where the Wheel of Fortune adorns the card marked "X", the basic tenor of *Carmina Burana* is ambivalent; it can also be interpreted optimistically, for it is always possible to begin again.

The Wheel of Fortune is ubiquitous in medieval art and architecture. It appears in the form of a rose window in Gothic cathedrals, as a mechanical wheel in Fécamp monastery in Normandy, as a floor design in Siena Cathedral and as a motif in illuminated manuscripts. It is a wheel that will always turn: "O Fortuna! Like the Moon, fickle in her state of being, always waxing, also waning …"

Anonymous
Wheel of Fortune with Christ Enthroned in Judgement Instead of the Goddess Fortuna

12th–13th century
From the illuminated manuscript *Carmina Burana* (Clm 4660, fol. 91v), 112 leaves
Parchment
24.9 × 17.7 cm
Found in Benediktbeuern, Upper Bavaria
Bayerische Staatsbibliothek, Munich

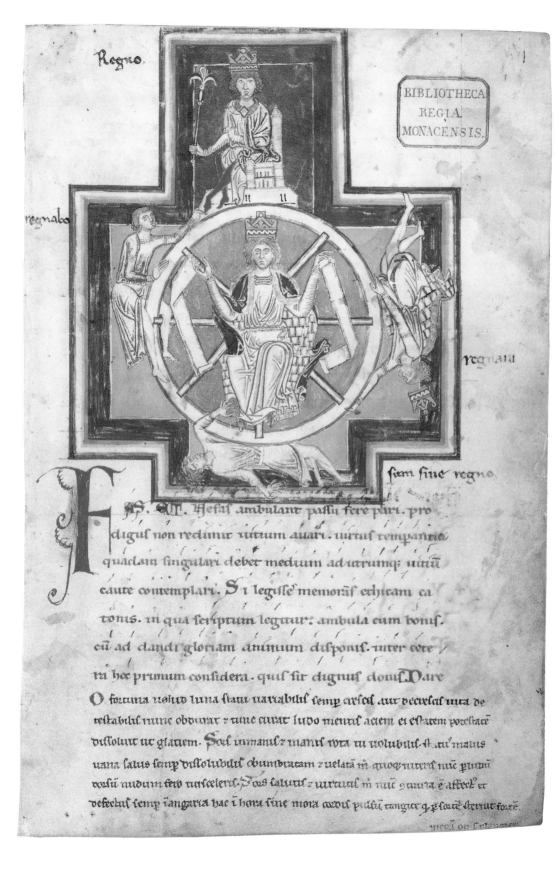

FIS. QT. Ysctas ambulant passu fere pari. pro
digus non reddut uitium auari. uirtus temparica
quadam singulari debet medium ad utrumqz uirtu
caute contemplari. Si legisse memoras ethicam ca
tonis. in qua scriptum legitur: ambula cum bonis.
cū ad dandi gloriam animum disponis. inter cete
ra hoc primum considera. quis sit dignius donis. Dare
O fortuna uelud luna statu uariabilis semp crescis aut decrescis uita de
testabilis nunc obdurat z tunc curat ludo mentis aciem et estatem potestate
dissoluit ut glaciem. Sors inmanis z inanis rota tu uolubilis statu malus
uana salus semp dissolubilis obumbratam z uelata m quoqz nitens nunc pmm
uorsū nudum fero turscelent. Sos salutis z uirtutis m nuc gratura e affect et
defectus semp angaria hac i hora sine mora cordis pulsu tangite qz statu sternut forte

The Art of Falconry
An Emperor's book of tricks

The noble and powerful of this world, who are burdened with the duties of ruling, can, through the practice of this art, find beneficial distraction from their cares. The poor and the less elegant can, on the other hand, earn their living from it, assisting at the hunt.

Emperor Frederick II, *De arte venandi cum avibus*
(On the art of hunting with falcons), before 1248

The margins of the so-called "Falcon Book" are like an aviary, teeming with pheasants and quail, red-legged partridges and swallows, turtledoves and plovers, oyster catchers and vultures. More than 500 representations of at least 80 different species of bird adorn one of the most famous medieval manuscripts, and the author of this work is no less a personage than Emperor Frederick II. According to the Arab chronicler Ibn al-Giawzi, the Emperor

Falconer at a medieval pageant in Landshut

was a bald-headed man, near-sighted and of reddish complexion and, had he been a slave, would have been worth little. Yet, to his admirers he was the "wonder of the world". Born in 1194 at Jesi near Ancona, Frederick II

was considered to be "the first modern ruler" by Jacob Burckhardt. He spoke not only "vulgar Latin", the Italian vernacular, but also mastered Latin, Greek, Hebrew, Arabic, French and a Provençal dialect. His court was the Western centre of science and art during the first half of the thirteenth century.

Frederick II was a patron of the arts, open to Judaic and Islamic culture, and interested in astrology and medicine. Driven by insatiable curiosity, he laid the ground work for Italian poetry, introduced – and this was of great controversy – experiments on human beings, and earned a reputation as a natural scientist. A great deal of his knowledge in this last field is contained in his "Falcon Book". In it he describes how falcons, eagles and hawks can be tamed and trained to hunt game birds and small animals. He is just as well-informed on the prey of his falcons. An inveterate polymath, the Emperor, in loving detail, describes their appearance, anatomy, habits, flight patterns and defensive strategies – so precisely that the "Falcon Book" is still used today as a basic textbook in the field of ornithology. He was the first to present evidence on the cuckoo bird's sneaky habit of laying its eggs in other birds' nests.

For all the admiration he receives, Frederick II owed his sole military defeat to his

passion for science and hunting. On 18 February 1248, the city of Parma went on the offensive against the Emperor's troops after he had besieged the city for months. The offensive succeeded and part of the imperial treasure was lost, including the original manuscript of the "Falcon Book". Frederick II was out hunting with his birds of prey when the surprise attack was mounted. Adding insult to injury, the biographer of Pope Gregory IX, who did not care much for the Emperor, implied that the Emperor had degraded the title of "His Imperial Highness" to that of a game-keeper.

Anonymous, Italian
Frederick II with a Falcon

1258–1366
From the Manfred Manuscript of
De arte venandi cum avibus, 111 leaves
Parchment
36 × 25 cm
Biblioteca Apostolica Vaticana, Rome

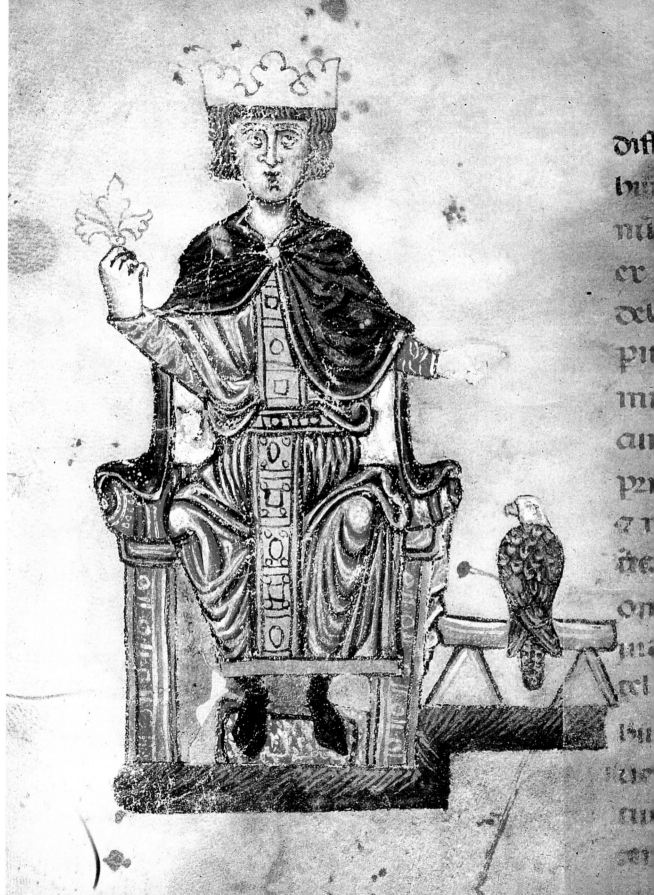

How a Poor Little Man Put the World Right
St Francis of Assisi and poverty

Praise to you, O Lord, and all your creatures, who, with our sister the Sun, give us the day and light. Lovely she is – and she shines with great glory. She reflects Your impress, Most High.

St Francis of Assisi, "The Hymn of the Sun", autumn 1225

He was certainly not a handsome man, the way his ears stuck out from his head, nor, with his thin, small figure and modest education, did he cut an impressive figure – at least this is what his contemporaries said about him. Yet no other name from the thirteenth century is so well-known and loved. In January 1206 Francis heard a mysterious voice commanding him to "go and repair my house, for it is falling down". He obeyed, and, not only did he repair the physical structure of a church, he also found himself leading a powerful

San Francesco in Assisi. The tomb of St Francis is a place of pilgrimage for millions

movement of religious renewal in the Church. At a time when lust for money and power had corrupted temporal and religious life, he set the example of an evangelical who cared nothing for possessions.

Born into a wealthy family, Francis had grown up living the life of a pleasure-seeker and enjoyed surrounding himself in luxury. He gave it all up so suddenly, so cheerfully

and willingly, that he drew thousands along with him, even some of the most distinguished scholars. The "poor little man," who had experienced the Impression of the Stigmata, the wounds of Christ, on 14 September 1224 on Mount Le Vema, lived only forty-four years. Yet after his death, 20,000 men from all over Europe were seeking to emulate his life, as well as thousands of women. Caring for the urban destitute, his mendicant Order, the Franciscans, grew by leaps and bounds. The advocate of the poor, St Francis of Assisi was the first to state publicly that work dignifies man, that its value is intrinsic and cannot be measured by the money it earns. He also loved animals and birds, seeing them as man's friends and his lovely "The Hymn of the Sun" was the first great poem in the Italian language. Dante remembered him with a reference to Assisi in the XI Canto (*Il Paradiso*), of *The Divine Comedy*: "There at the edge of the cliff a Sun was born to the world."

Another monument to St Francis is a fresco, *The Dream of Pope Innocent III,* from the cycle depicting the life of St Francis in the Upper Church of San Francesco in Assisi. It is frequently attributed to Giotto. Tradition has it that Pope Innocent III was dubious of Francis and his followers, and so had not given his approval to St Francis's *Regula Prima,* his Rule. The Pope's doubts vanished when he had a dream in which Francis of Assisi appeared to him as a pillar of the Church.

GIOTTO DI BONDONE, attributed to
(Italian, *c.* 1267–1337)
Francis as a Pillar of the Church (The Dream of Pope Innocent III)

c. 1296–98
Detail
Fresco
Upper Church of San Francesco, Assisi

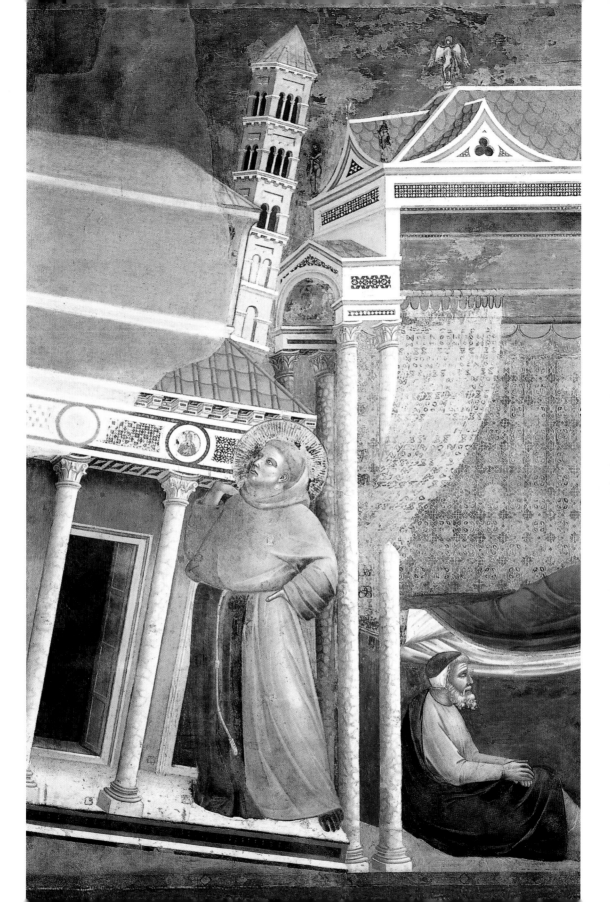

Thou Art Mine and I Am Thine
Knights and courtly love in the Middle Ages

I sat me on a stone, my
legs were crossed, alone.
Then rested I my elbow too,
with chin and cheek in hand.
Sorrowfully did I then
ponder, how one might
live in this world of ours.

Walther von der Vogelweide,
before 1230

Draughty corridors and icy stone chambers. Medieval castles were anything but cosy. It was a time when glass was still a luxury that few could afford. During winter months, pelts and animal skins, instead of glass, covered the openings, or they were simply boarded up altogether. Castle kitchens promised a fire, where the residents gathered out of necessity to warm themselves around its large hearth. At times chivalrous life may have been adventurous, but it certainly was not easy. The medieval German lyric poet and soldier, Oswald von Wolkenstein, whose castle was in South Tyrol, complained that he led a wretched life. He struggled for his daily bread and in the lives of those around him, he saw nothing but intense hardship: ungainly people, filthy goats and cattle, all blackened by the soot of fires; nor could he take pleasure in the sounds he heard around him: braying donkeys and screaming peacocks.

The bleak existence of daily life may explain the medieval passion for elaborate and lively banquets; these were frequent and certainly would have filled their dining halls with food and good cheer. Residents and guests at the Frohburg Castle (which literally translated means "happy castle") in Switzerland, for example, devoured "106 wild boar, 73 deer, 61 bear, 3 elk and 2 aurochs [now extinct]" during the

The singing troubadours (top to bottom):
Kraft von Toggenburg, Hartmann von Aue and Werner von Teufen in the Manesse illuminated manuscript

course of a long winter. These festivities also meant good business for the Teutonic troubadours or minnesingers. Most of these minnesingers were errant knights, meaning that they were "chansonniers". Their songs dealt with Platonic or chaste courtly love.

When chivalry was at its peak in the twelfth and thirteenth centuries, courage and loyalty were not the only virtues to be sung. Songs which praised a pure Christian life, defended the poor and, above all, paid homage to the ladies of the court, could also be heard. Although aristocratic ladies were always under the authority of their fathers, brothers or husbands, they enjoyed the status of goddesses in chivalric society. Courtly love, *Minne*, became an ideal because it exacted the patience, endurance and submission of its practitioners. Men courted the favour of ladies whose social status was often higher than their own. Consequently, they had to "earn" the favour they sought by winning tournaments or writing poetry, setting it to music and singing it.

The most important itinerant troubadour in central Europe was Walther von der Vogelweide. Born in about 1170 in Lower Austria, he lived at various courts until he received a fief from the Emperor Frederick II which ensured him a steady income. Some of his poetry has been preserved in the Manesse illuminated manuscript, which contains nearly 6,000 stanzas of verse written by 140 poets between 1160 and 1330. It is said to have been collated and illuminated at the court of Ruediger Manesse, who represented the knights' estate in the Zurich City Council from 1264. This magnificent codex, which includes sumptuous full-page portraits of the authors, is one of the most important medieval illuminated manuscripts in the world.

Anonymous
The Minnesinger Walther von der Vogelweide as a Knight Errant

1300–1340
From the Codex Manesse
(Cod. Pal. Germ. 848, fol. 124r), 426 leaves
Illuminated manuscript
35.5 × 25 cm
Heidelberg University Library, Heidelberg

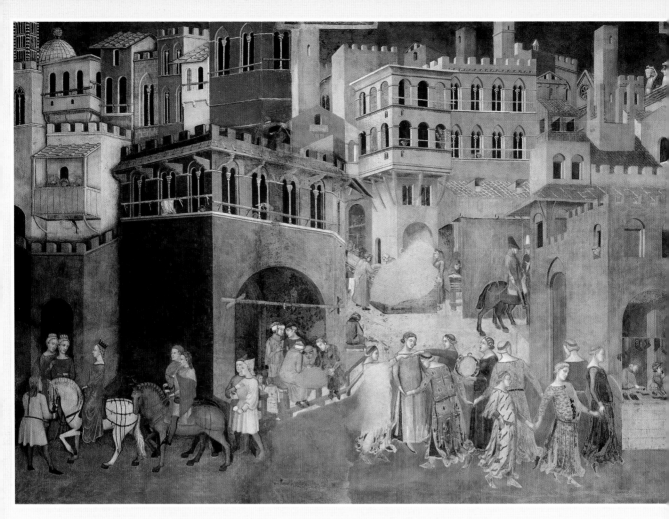

A Useful Thing, Peace!
Siena and the *Allegory of Good Government*

It is a great joy to see peace represented by Lorenzetti. I see merchants travelling from city to city, selling their wares without a care in the world. I see how houses are being built by men full of hope and how girls rejoice in dancing round dances. A useful thing, *pace* (peace)! The word falls so sweetly from one's lips, as compared to its antonym, *guerra* (war), which sounds rough, redolent – with so much crudeness that it twists the mouth.

Bernardino of Siena (1380–1444)
"Sermon on Good Government", 1427

In the evening when the sun is setting, Siena's brick patrician town houses glow in warm tones of brown and ochre: at the heart of the city is the Campo, a shell-shaped, cobblestoned square that slopes downward, where the shadow of the Torre del Mangia grows longer. After the sun has disappeared, young people, who gather in the square "to see and to be seen", continue to radiate the heat of the day. Time seems to have stood still in Siena. The Gothic cityscape has essentially survived intact with its striking silhouette of the cathedral, steep alleys and imposing city wall.

Today, major roads do not lead to Siena. However, during the late Middle Ages this was not the case: merchants, pilgrims, knights and emperors had to pass through the city on their way to and from Rome. This Frankish road, built by the Lombards, brought additional prosperity to the city, whose affluence was assured by the nearby silver mines. The Sienese banking houses were among the most powerful in Europe and the Sienese sought to express their prosperity through grand building projects. As evidence of their mercantile confidence and assertiveness, be-

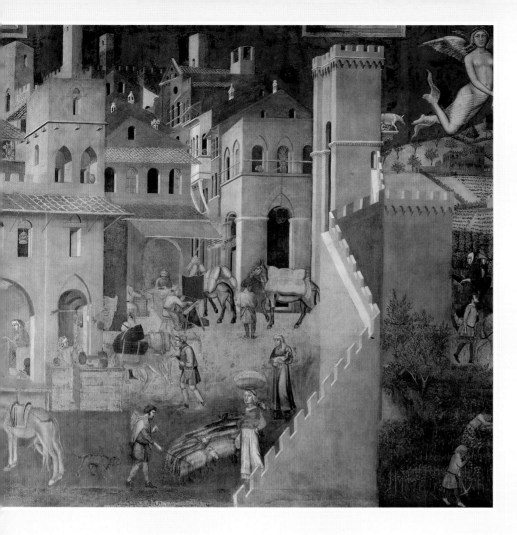

AMBROGIO LORENZETTI
(Italian, c. 1285–1347)
The Fruits of Good Government

1338–40
Detail from *Allegory of
Good Government*
Fresco
Length: 14 m
Palazzo Pubblico, Siena

tween 1288 and 1309, they built their town hall, the Palazzo Pubblico, in travertine and brick. To adorn the interior of the Palazzo, elaborate fresco cycles were commissioned, among them *Allegory of Good Government* and *Allegory of Bad Government*, painted by a native of Siena, the artist Ambrogio Lorenzetti. Masterpieces of medieval painting, these enormous works fill the room used by the governing Council of the city-state from 1292 until 1355. Panoramic in style and unusually profuse in detail for that time period, they are probably the first realistic townscapes in Western painting.

Promoting the consequences of good politics, *Allegory of Good Government* proclaims peacekeeping as the loftiest aim of a just governance. Peace is the only guarantor that trade and commerce will flourish and that life will bring serenity and joy. Although these are allegorical scenes, Lorenzetti chose to paint the people of his day, engaged in everyday activities. Dwellings, shops and palaces with towers and crenellations give us a realistic picture of how Siena must have looked in the first half of the fourteenth century. *Allegory of Bad Government*, located on the opposite wall,

depicts the same townscape scene, only devastated by war. Bernardino of Siena described it thus in a sermon: "Here I see no commerce, no dances. I see only death. No houses are being built, fields are no longer being cultivated and grapes are no longer being harvested." Only a few years after Lorenzetti had finished the frescoes, this bleak picture of Siena essentially became reality, although not by human contrivance. Siena lost more than two-thirds of her townspeople to the plague and among the victims was the painter himself, Ambrogio Lorenzetti.

God Moves in Mysterious Ways
Karlstein Castle and the medieval cult of relics

When the body of the dead Saint was lying on the bier, many of the faithful came to do it reverence. And, they cut off her fingernails and the nails of her feet, the tips of her breasts and even her thumbs to keep all these things as relics.

Caesarius of Heisterbach, *Notes on St Elizabeth, c. 1231*

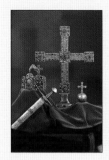

Imperial Jewels

Christians fought over them, for to many these relics were more valuable than gold or precious stones. Relics were earthly remains or objects and scraps of cloth which had come into contact with the living or dead body of a saint. Above all, the bones were the most precious. Since ancient times, it was believed that through them God very often continued to work in mysterious ways, and those who venerated them received special graces. Some medieval Christians, however, saw them as possessing magical powers, and so an illegal trade in relics grew up. Traders would do almost anything to get hold of these sacred objects. They robbed graves, skeletons were taken apart or stolen and limbs hacked off; the head of a saint was particularly sought after. The trade was so grotesque that St Francis gave Perugia a wide berth on his last journey from Siena to Assisi; he was afraid the traders would tear him apart. And it is said, though we cannot know for certain, that Bishop Hugh of Lincoln shocked the monks at Fécamp monastery in France by gnawing "like a dog" on a bone, reputedly that of Mary Magdalene's arm, in order to ensure protection from all harm.

The monasteries and secular princes were the chief collectors of relics, as well as the precious reliquaries which housed them. Assembled between 1347 and 1378, the most important collection of this kind was owned by the Holy Roman Emperor Charles IV. The relics and reliquaries amassed by this inveterate collector represented all the countries he ruled. His collection included bones from the skeletons of St Palmatius (Italy), St Sigismund (Burgundy) and Wenceslas (Bohemia). The Emperor never tired of praising the "empire-preserving powers" inherent in his relics.

He also owned treasures which signified his omnipotence: crown, sceptre, orb and the Imperial sword. These symbols of the temporal power of the Holy Roman Empire were regarded as relics of Charlemagne, who was then venerated as a saint, and who, according to legend, commissioned and first used these objects. Even more sacred were the sacred lance and nails thought to be from the True Cross. The lance itself was believed to be the very one with which the soldier Longinus pierced the side of Christ on Mount Calvary.

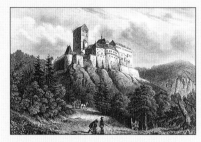

Karlstein Castle near Prague, built in 1348–57

Utterly convinced that his relics were genuine, Charles IV had Karlstein Castle built near Prague to house these sacred treasures. It became a gathering place for knights of the Grail and was the spiritual centre of his reign. Today, the Imperial Jewels are kept in Vienna. However, Karlstein Castle is still a delight to visit due to its magnificent frescoes, and it is *the* Bohemian national monument.

Sacred treasures from the Middle Ages: Reliquaries from across the Continent

NIKOLAUS WURMSER
**The Emperor Charles IV
Consigning Relics to a Reliquary**

1356
Fresco
Chapel of Our Lady,
Karlstein Castle, Prague

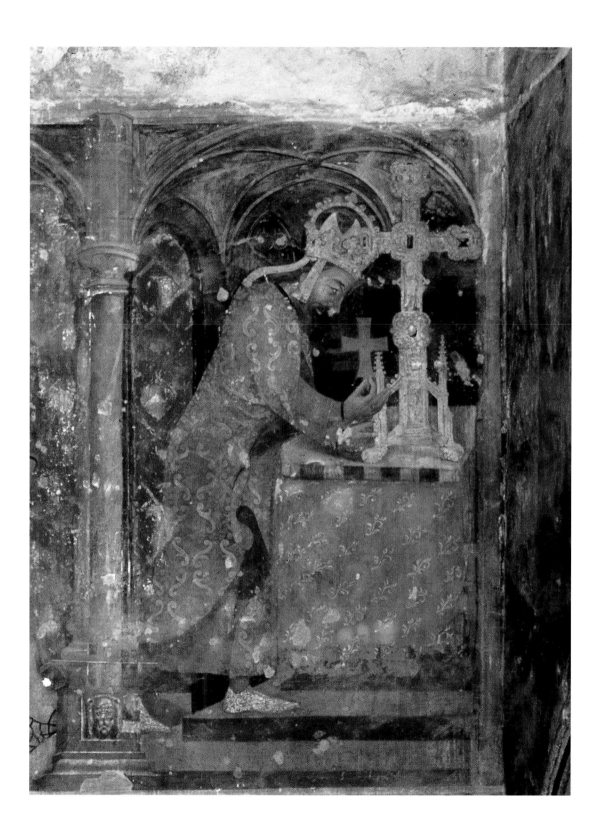

Miniature Kings and Peasants
The Duc de Berry's Book of Hours

**Others may amass riches of glittering gold,
or have as much farmland as they desire!
I wish only for modest possessions and to
have a peaceful life; if only the fire keeps
burning on my own hearth.**

Tibullus, "Happiness in the Country" from the *Elegies,*
first century BC

The Duc de Berry collected only precious things: jewels, Italian cloth woven from gold, valuable musical instruments, porcelain, timepieces, embroidered tapestries and reliquaries. He owned seventeen castles, a zoo with ostriches, camels, chamois, a tooth of Charlemagne's and the finest ruby collection of his day. But books were his first love. His library contained Roman classics, chronicles, *chansons de geste* and an edition of *The Travels of Marco Polo.* A true connoisseur, the Duc de Berry never missed a chance to indulge in pomp and luxury. The Duc de Berry, or Jean de France, was the son of the French King Jean II, so he could afford such expensive taste. And when his money ran low, he could simply raise the taxes in central France, an area which fell mostly under his rule.

The Duke was not just a consumer of extravagant things, but also an active patron of the arts, commissioning countless artists and artisans. Some of his most famous commissions were Books of Hours. These illuminated manuscripts contained prayers which the laity recited in their personal devotions, so-called because the prayers were to be said at particular times of the day.

The Duc de Berry owned several Books of Hours, and, in 1413, he commissioned the Limbourg brothers to execute *Les Très Riches Heures,* which became his most valuable example. The preliminary work for this book was actually completed by another artist who died shortly after receiving the commission. When the three brothers from Nijmegen in the Netherlands started to work on this book, they were all in their thirties and must have realised that this would be the work of a lifetime. In 1416, all three brothers died, as did their patron, probably from one of the many epidemics rampant at that time throughout Europe.

Les Très Riches Heures, with its 206 leaves, was actually never finished. Despite this, it is regarded as one of the greatest works of European medieval art: the finest fifteenth-century illuminated manuscript and a supreme example of painting in the International Gothic style. Here, for the first time in the history of manuscript illumination, idealistic landscapes were replaced by real landscapes, in this case depicting the regions belonging to the Duc de Berry. *The Month of August* shows the Château d'Etampes, a massive twelfth-century castle which still looms above the countryside today. In this calendar cycle, *August* is the only one to depict courtiers and peasants together in the same scene. The court, however, does not come into contact with the peasants, who labour in the hot fields and bathe in a stream, while the court solemnly passes by on horseback in the foreground. How different peasant existence must have been from that of the Duc de Berry's: oatmeal instead of capons, water instead of wine and straw mattresses instead of featherbeds.

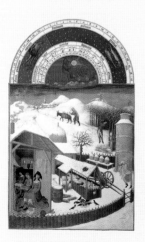 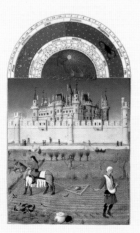 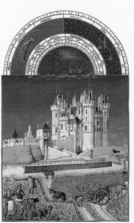

The changing seasons:
Winter in the village;
sowing the seeds on the banks of the Seine;
grape-picking below Saumur Castle

HERMAN, JEAN AND PAUL LIMBOURG
(*c.* 1385/1390–*c.* 1416)
The Month of August

1413–16
From *Les Très Riches Heures du Duc de Berry*
206 leaves
Illuminated manuscript
21.6 × 14 cm
Musée Condé, Chantilly

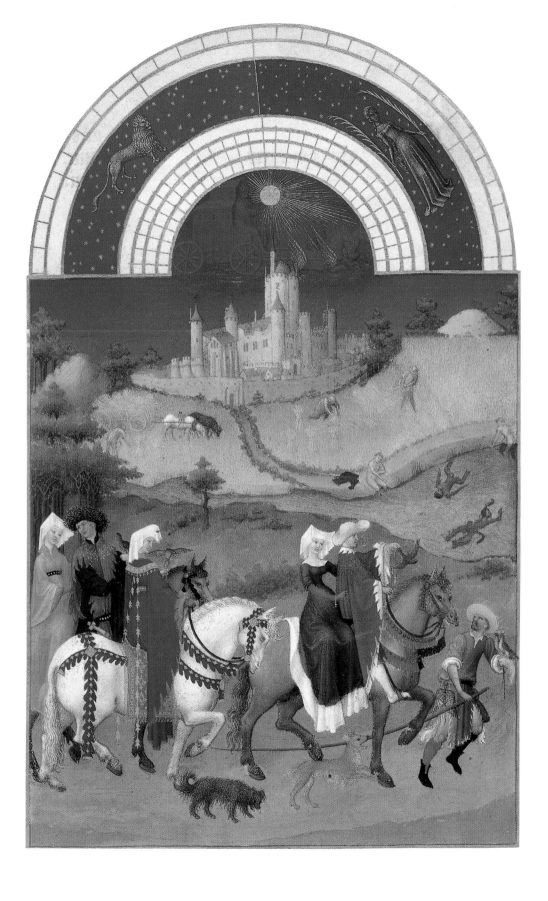

To You Have I Given Myself
Nuptials and marriage in the Middle Ages

**My dearest, of you alone I think day and night.
Your red lips take all that is sad from me.
To you have I given myself. Your own will I be,
with you to live in joy until my ending.**

Hans Leo Hassler, taken from a new German madrigal
in the Gallic mode, late sixteenth century

In the Middle Ages, banquets were particularly sumptuous, and above all those for a wedding's celebration: partridges and woodcock, cheese and pastries, nuts and dried fruits – banqueting boards piled high groaned under the weight of such delicacies. In fact, governing authorities were often forced to counteract the excesses of such festivities with ordinances regulating how many guests might be invited and how many courses served. The ordinances, however, were not always effective. It was difficult to forbid lavish spreads and

"The beginning was sweet and good …"
Blessing the Bridal Bed, Bernard Picard (1673–1733)

excessive drinking, or to prevent guests from dancing after a banquet. By the end of such wedding festivities, the men were often so drunk that brawls were the order of the day.

A wedding has always been one of life's great events. And, in fact, most people had little choice about whom they married at that time since marriages were usually arranged by families. The needs of the family and the desire to advance its position in society dictated the terms, and as a result influence, money and power were what counted. Naturally, there were always those who advocated marriages for love and not money or influence, though even love matches could not guarantee future happiness, as a fifteenth-century Flemish song shows: "The beginning was sweet and good when I was courting my wife. Now heart, mind and soul have turned. I regret the first steps I took, poor man that I am. She rules the roost and I am like the chickens." In those days people often married very young and a Church ceremony was not the norm. Nuptials, at which marriage vows were exchanged in the presence of two witnesses, were a purely secular matter. They often took place at home, in larger rooms or even in bedchambers, but the ceremonies were seldom recorded in paintings for posterity.

However, the wedding portrait *The Arnolfini Marriage*, by the Early Netherlandish painter Jan van Eyck, is a notable exception. Michele Arnolfini, the scion of an Italian mercantile family from Lucca who had settled in Bruges, is depicted with his bride Elizabeth. This pictorial marriage certificate, however, could never guarantee that the couple would stay together. Divorce was possible even then: "Since it is known that we cannot remain together – the devil has wrought this and God does not want us to be together – it is best that we dissolve our marriage ties." Thus a Merovingian divorce formula that was in use for a long time. Nevertheless, divorced people, like the unmarried, were socially ostracised. In Flanders an ultimatum was issued to a man of thirty, if he was still a bachelor. He was given a time limit within which he had to marry or he would have to endure the humiliation of being recorded in what was known as the "Book of Disgrace". If he didn't marry after all, he may well have done what old maids, priests, monks and nuns of necessity did, and sought comfort in St Augustine's words: "Those who die unmarried, shine like stars in Heaven."

JAN VAN EYCK
(Flemish, *c.* 1390–1441)
The Arnolfini Marriage

1434
Oil on panel
82 × 60 cm
National Gallery, London

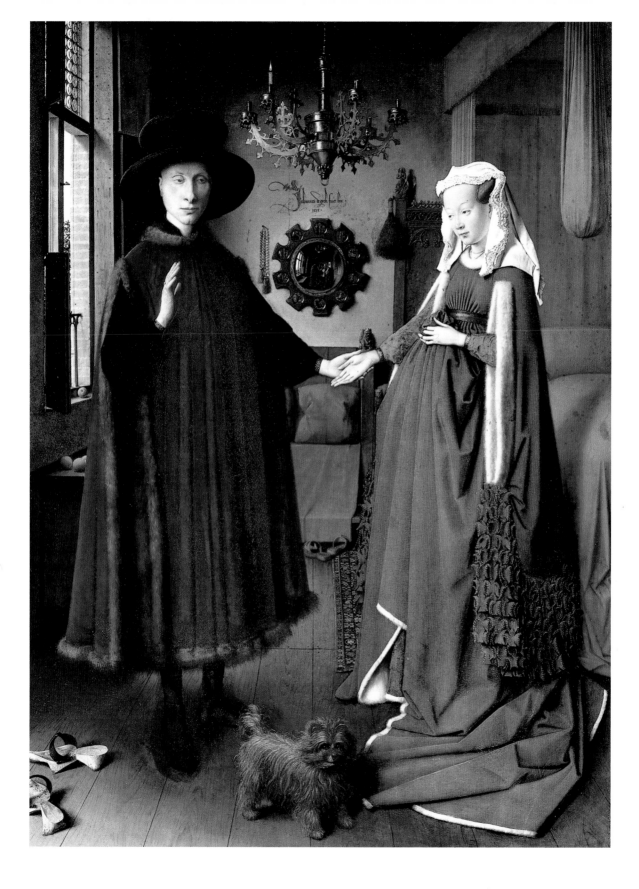

"In this Sign Thou Shalt Conquer"
Emperor Constantine and the Cross

Constantine was a merciless Roman emperor. Not only did he see to the execution of his coruler, Licinus, he also condemned close relatives to death, among them his son Crispus and his second wife Fausta. Despite his ruthlessness, however, Constantine the Great supposedly secured a place in Heaven, a saint who is still venerated in the Greek Orthodox Church. Although Constantine tended to sacrifice morals to expediency, he later became a key figure in the development of Christianity as a world religion. Legend has it that it all started with a dream.

When Emperor Constantius died in AD 311, there were two claimants to the throne: Constantine and Maxentius. On 28 October 312, at the Milvian Bridge, which spanned the Tiber north of Rome, these men fought the decisive battle over the succession. Constantine is said to have told the Church historian Eusebius of Caesarea that, on the day before the battle, a Cross of light appeared to him in

The choir in the church of San Francesco, Arezzo, showing the fresco cycle by Piero della Francesca

the heavens, bearing the inscription: "In this sign thou shalt conquer!" Yet according to Jacobus de Voragine, the leading medieval compiler and specialist on the lives of the saints, Constantine had his vision at night in a dream. It was based on this report that the Italian Renaissance painter Piero della Francesca depicted the vision of Constantine at night, rather than by day. The artist was commissioned by the wealthiest family of Arezzo to paint a fresco cycle depicting the Legend of the True Cross for the choir in the church of San Francesco, and *The Dream of Constantine* is one scene in this cycle.

After the vision, it is said that Constantine had the symbol of the Cross painted on his soldiers' shields, which led them into their victorious battle. It is impossible to know whether his vision and the victory really led Constantine to convert to Christianity, but, during his reign, Christianity was legally established as a religion, enjoying the same status as the ancient pagan belief in the gods. From 312,

Constantine also made impressive donations to the Church and had the first important Christian churches built. Among them were Old St Peter's in Rome, the Church of the Holy Sepulchre in Jerusalem and the Church of the Apostles in Constantinople, the foundation of which today supports Hagia Sophia. Constantine also introduced Sunday as a day set aside for church services and promoted the Christianising of public life by appointing Christians to high office in Rome. In fact, some of his legal reforms further suggest a Christian influence: criminals were no longer permitted to be branded on the face and the corporal punishment of slaves as well as the selling of children was restricted. In 325, in what is now the western Turkish city of Iznik, Constantine convened the first synod of bishops: the "Council of Nicaea", which stands out in ecclesiastical history. For all that though, the Emperor did not consent to baptism until he was on his deathbed.

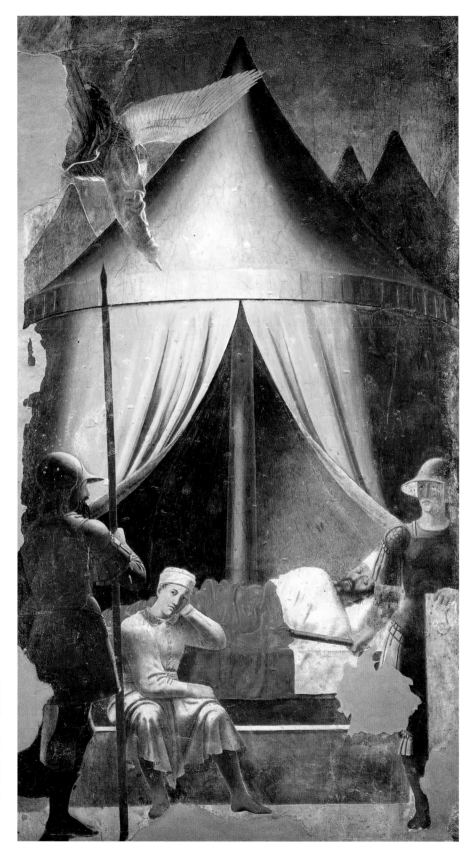

PIERO DELLA FRANCESCA
(Italian, *c.* 1412–1492)
**The Dream
of Constantine**

1452–1466
Detail from
Legend of the True Cross
Fresco
335 × 750 cm
Choir of San Francesco, Arezzo

The Pagan Dragon
An evil beast

George mounted his steed, made the sign of the cross and charged the dragon that was advancing towards him; he brandished his lance mightily, commended himself to God and struck the dragon with such force that it fell to the ground.

Jacobus de Voragine, Legenda aurea (Golden legend), 1265–66

According to legend, in the second century BC there lived a dragon in a lake near the city of Silene in the land of Libya. It often crawled from its wet home "to beneath the city walls" – or so it was claimed in the *Legenda Aurea* – translated into English by William Caxton in 1483 as the *Golden Legend* – the most frequently read book in the Middle Ages with the exception of the Bible. There, the beast was said to have poisoned with its breath all those who came near it. To appease the dragon, a lamb and one human victim were sacrificed every day. A lot was drawn to determine "which man or which woman should be offered to the dragon". One day the lot fell to the king's daughter, Sabra, who bravely accepted her fate for the benefit of the city. However, just as she was ready to make her way to the lake, her altruistic intensions were dampened when "Saint George came riding up as if by chance" and asked her why she was so sad: Suddenly, the dragon appeared. George valiantly pierced it with his lance – though he did not kill it. As legend has it, George proceeded to wrap the princess's girdle round the wounded beast's neck and to lead the dragon triumphantly like a tame dog into the city, where he slaw it with a single blow of his sword. George was subsequently celebrated as a hero and the dragon was never to be seen again.

In antiquity the scaly, fire-spitting beast was thought to possess demonic, primordial powers. It was said that the gods had to fight and kill the monster before the world could emerge from the animal's dead body. In Christianity the legendary winged creature came to symbolise sin and paganism. Described in

Still with Paul Richter as the dragon-slayer Siegfried in Fritz Lang's *Nibelungen*, 1924

Revelation as a symbol of the devil and elsewhere in the Bible as a demon of temptation, the dragon still flits like a ghost through the pages of the Old and New Testaments. Likened to a diabolical serpent by the biblical scholar Origen in the third century AD, the legendary green monster was not met with

sympathy in Europe or in the Near East, but was repeatedly depicted as being "trample[d] under feet" (Revelation). Yet there were others besides St George who were renowned dragon-slayers: St Michael, St Margaret, the prophet Daniel of the Old Testament as well as Siegfried, the legendary hero of the *Nibelungenlied*, who bathed in the blood of the vigilant dragon, presumably to render himself immune from injury.

Indeed, no one seemed to show mercy on the tormented animal – except Paolo Uccello. A Florentine painter who staged the present scene like a romantic fairy-tale with an ironic undertone. Kept on a short lead by the princess, the fearsome beast is made a pitiful, almost amusing spectacle; with its curled tail and contorted stance, it looks more like a caricature than a monster. Here, the unfortunate animal appears to be having a tooth extracted, which, according to other sources, never occurred.

Despite the widespread feelings of fear and disgust towards the dragon in Europe and the Near East, in the Far East it was held to be a beneficent creature that brought good luck.

PAOLO UCCELLO
(Italian, before 1396/97–1475)
Saint George and the Dragon

c. 1450
Oil on canvas
57 × 73 cm
The National Gallery, London

A Lesson in Perspectives
The sepulchre of Christ

This man [Joseph of Arimathaea] went unto Pilate, and begged the body of Jesus. And he took it down, and wrapped it in linen, and laid it in a sepulchre that was hewn in stone, wherein never man before was laid…. And the women also, which came with him from Galilee, followed after, and beheld the sepulchre, and how his body was laid.

The Gospel of Luke (23: 52–53, 55)

According to scripture, Jesus Christ probably died soon after three o'clock in the afternoon, and one might think, as far as the authorities were concerned, "the case was closed". However, for the family of a person executed in Roman times, disgrace did not end with death. Roman law provided a harsh accompaniment to crucifixion: the loss of the right to honour the dead. It was only through an act of pardon that the body of an executed person was returned for proper burial. In this respect the narrative contained in the Gospel of Luke is highly plausible. The Jerusalem councilman, Joseph of Arimathaea, who revealed himself to be a follower of Jesus at the Crucifixion, had to bow to convention and beg Pilate, the Roman governor of Palestine, for the body of Christ. Pilate granted this request only after a Roman officer, who had been present at the Crucifixion, verified that the man from Nazareth was indeed dead. What then happened to the body of Jesus is

Looking towards the open heavens: Andrea Mantegna – one of the great masters of perspective techniques, ceiling fresco, Palazzo Ducale, Mantua, 1475

described in the Gospel of John (19: 39–41): "And there came also Nicodemus, which at first came to Jesus by night, and brought a mixture of myrrh and aloes, about an hundred pound weight. Then took they the body of Jesus, and wound it in linen clothes with the spices, as the manner of the Jews is to bury. Now in the place where he was crucified there was a garden; and in the garden a new sepulchre, wherein was never man yet laid." But where was this garden? The gardens of Jerusalem were north of the second city wall, and their presence was indicated by a nearby garden gate. Here were also the quarries, and during Jesus' lifetime, chamber graves were hewn from the rock of these steep slopes. In one of these chamber graves, not far from Golgotha, the "Place of Skulls", Joseph and those with him buried Jesus.

This sepulchre is the setting for Andrea Mantegna's *The Entombment*. The Italian Renaissance painter, who worked for fifty years at the Gonzaga Court in Mantua, had trained his eye for anatomical detail through the study of ancient sculpture. He achieved great

plasticity of form in his figures through the use of a perspective technique known as foreshortening, and it is probably not a coincidence that Mantegna depicted the body of Christ lying in a tomb. In 1453, a few years before the picture was painted, Constantinople, the capital of the Eastern Roman Empire, fell to the Turks. When the Ottomans took the city, Christendom lost a precious relic, the "anointing stone" on which, according to tradition, Joseph of Arimathaea had placed the body of Christ. The work by Mantegna could be interpreted as a critical response to the Turks defilement of Christian holy places, since popes of that period called for crusades against the Turks to free Constantinople and the Christian relics from the hands of unbelievers.

ANDREA MANTEGNA
(Italian, 1431–1506)
The Entombment

c. 1480
Oil on canvas
66 × 81.3 cm
Pinacoteca di Brera, Milan

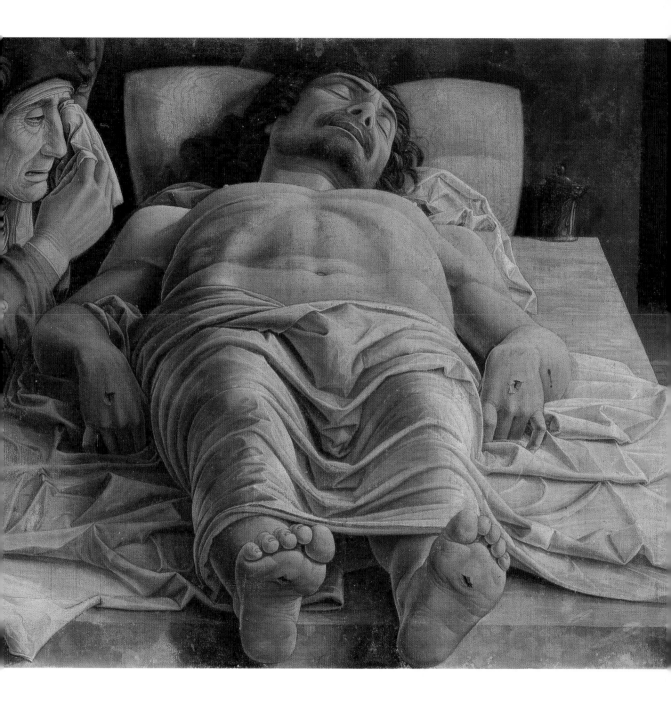

Venus: The Evening Star
The Goddess of Love and her mysterious origins

Where Aphrodite stepped onto land: Petra tou Romiou, a beautiful bay in the south-west of Cyprus

You might swear that the goddess [Venus] came out of the waves. Her right hand covering her breasts, she wants to enthral us. And wherever she plants her divine foot, flowers spring up to greet the skies.

Angelo Poliziano, *The Realm of Venus*, c. 1475

The origins of the gods have always been a mystery and the origin of Venus is a particularly difficult case. Malicious tongues say that she came from the countryside. Probably a successor to an ancient mother goddess, she was venerated in what is now Italy as the patroness of gardens and vegetable farming – especially on Veneralia, the feast day of Venus, April 1. In defence of her reputation, one should add that she lost her earthiness early on. Beginning in the fourth century BC she was equated in Rome with Aphrodite, the Greek goddess of love, who was the patroness of coquettish young women, of laughter and fun, and of sweet desire and clemency.

Aphrodite's origins are also rather uncertain, and the various legends about her birth contradict one another. These stories agree about one thing, that Aphrodite emerged from the sea. According to the early Greek poet Hesiod, who established the family tree of the Olympian gods, Aphrodite was born of the foam which billowed up around the genitals of her cas-

Medici Venus, c. 1st century BC
A Roman copy of a Greek
Aphrodite

trated father Uranus, which were cast into the sea by his son Saturn (Cronus), who was responsible for this violent act. Another legend tells us that Aphrodite was born in a bivalve shell. The Italian Humanist poet Angelo Poliziano (Politian), who was an advisor at the Medici court in Florence, elaborated on these ancient tales in his writings:

"And born within [the white foam],
in rare and joyous acts
a maiden with a heavenly race
by playful zephyrs
is pushed to the shore.
She travels on a sea-shell;
and it seems
that the heavens rejoice."

The zephyrs, blowing a strong wind, steer her "ship" towards the Mediterranean island of Cyprus, where she is greeted by nymphs, who are "surprised by joy at the sight of her" and dress her in a cloak decorated with flowers – for even the goddess of love cannot remain nude forever. The Italian Renaissance painter Allesandro Filipepi, later

known as Sandro Botticelli, may well have taken Poliziano's poem as the literary model for his painting *The Birth of Venus*. Probably commissioned by the Medici family, the painting depicts the goddess as the personification of Love. She is to lead the Florentines, who at the time were growing increasingly enthusiastic about Greek philosophy, back to its loftiest ideals: goodness, truth and beauty.

Today the planet Venus, sometimes called the Evening Star, is not the only reminder of how important the goddess once was. The fifth day of the week also bears her name: "Friday", and the German "*Freitag*", derive from the name of the Teuton goddess Freya, who was equated with Venus. Friday in Italian, *venerdì*, and in French, *vendredi*; respectively have retained much of the original sound of "Venus", and both mean "Venus Day".

SANDRO BOTTICELLI
(Italian, 1445–1510)
The Birth of Venus

c. 1484–86
Tempera on canvas
173 × 278 cm
Galleria degli Uffizi, Florence

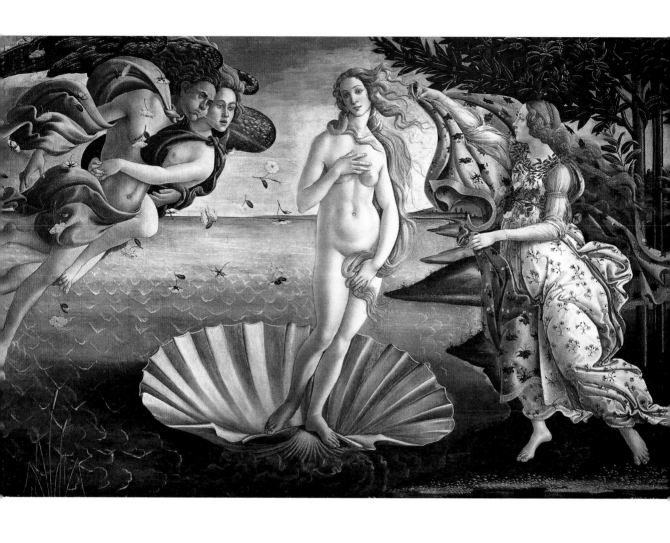

Myths and Medicine
How to catch a unicorn

It has a single horn in the middle of its forehead. But how can it be caught? One places an elegantly clad virgin in its path. And then, the beast leaps into the virgin's lap and follows her.

Physiologus, *The Unicorn*, third century AD

The fifth century BC **Greek historian** and personal physician to Persian Kings, Ctesias is said to have discovered all the wonders of his time. And so, he was the first to tell of the amazing beast called the unicorn: it could be found in Asia and was a white, donkey-like horse with a red head, blue eyes and a large horn. According to Ctesias, the horn, if scraped down and ground to a powder, was an antidote to poison and relieved muscle cramps. Although malicious gossip had it that Ctesias was a drinker and a pathological liar, his tale of the unicorn lived on. Physiologus, an anonymous writer who invested all sorts of animals with Christian symbolism, took up the tale, associating the unicorn with Christ. Conceived by a virgin, the Son of God had become a "horn of healing" as an antidote to all the world's ills. In the Middle Ages, when poison had become a popular instrument to settle political disputes, many rulers were anxious to protect themselves from assassination through the horn of the unicorn. By the sixteenth century it was considered more than an antidote to poison and an aphrodisiac; it was also "serviceable and wholesome as a remedy for epilepsy, pestilential fever, rabies and parasitic worms".

But how is one to catch a unicorn? Physiologus himself had remarked that the marvellous beast, which loved solitude and shunned humans, was "possessed of high courage". He stated further: "The hunter cannot approach it because it is so powerful." The famous legend which told of placing a virgin in the path of a unicorn was still known. And although artists had been dealing with the subject matter for centuries, few success stories had been recorded. All that was known was that a unicorn could not be deceived by an "unvirtuous" virgin. If the unicorn were tricked in such a way, instead of placing its head in her lap it would ram its horn into her side.

Capturing a unicorn was not a simple undertaking. Considering this, the number of *cornua unicornuum* (unicorn horns) in the treasuries and curiosity cabinets of Renais-

"Only that which has never existed anywhere can remain eternally young."
Drawing by Jean Cocteau, 1953,
for the première of the ballet
"The Lady and the Unicorn"

sance princes is astonishing. Upon closer inspection, these "horns", which can be up to three metres long, transpire to be the tusks of male narwhals. It is for this reason that the narwhal is also known as the "unicorn whale".

Anonymous
The Lady and the Unicorn

late 15th or early 16th century
A mon seul désir, sixth scene
from a six-part tapestry woven in Brussels
Wool
Musée National de l'Hôtel de Cluny, Paris

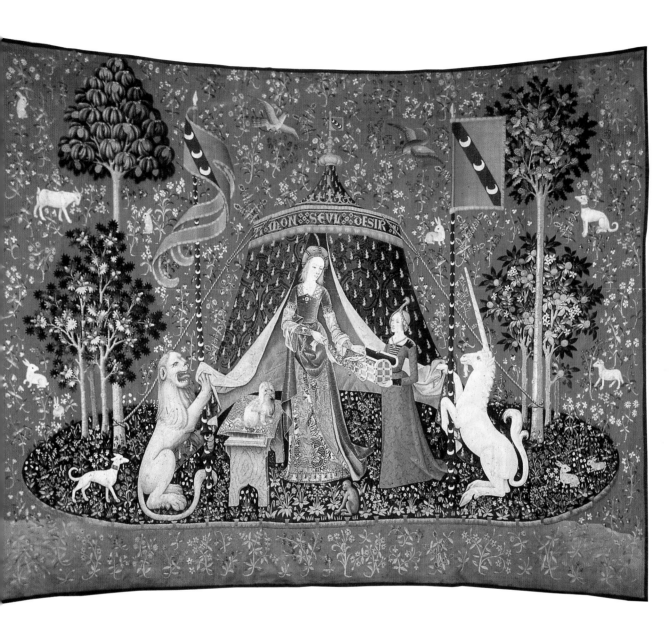

Thus God Created Man in His Image
The first artist self-portrait

In the Middle Ages a painter was "just" an artisan. He enjoyed the same status as stonemasons and woodcarvers, not to mention bakers, tanners, basket weavers and cobblers. Painters were used to "disappearing" behind what they painted. They usually did not even sign their work and most were soon forgotten. Then a man appeared who was possessed of supreme self-confidence: Albrecht Dürer. Born in the free imperial city of Nuremberg in Germany, he was equally superb as a painter, a draughtsman and a woodcarver, a universal genius of the Renaissance on a par with Leonardo da Vinci. An inventive and bold thinker, Dürer was open to the Humanist currents of his day. Well aware that he was original, talented and free, he refused to be merely an anonymous instrument of divine inspiration. He saw himself as an artist who pursued his own artistic aims, and had the courage to show his own face and personality in his work. It is true that a number of artists had already painted portraits of themselves as penitents or by-standers. Albrecht Dürer had no use for compromises. He took the self-portrait one step further and portrayed himself as he really

Dimensions and figures: geometric diagrams showing proportions for heads and faces by Villard de Honnecourt

was, thus creating the genre of artist self-portraits. Five earlier Dürer self-portraits are known but the present one in which the artist is wearing a fur coat is the most momentous. Dürer had never before portrayed himself in such an uncompromisingly frontal pose. The manner of self-representation he chose for this work had, until then, been reserved for depictions of Christ or royalty. Making himself look like Christ in this work was a deliberate statement of intention and supports Dürer's firm belief that artists' creativity derived directly from God's creative powers. In 1512 he wrote: "The high art of painting was greatly appreciated for many centuries by mighty kings. They made outstanding artists rich and bestowed many honours upon them since they knew that great masters are on a level with God. A good painter is full of figures and forms and if it were possible for him to live for ever, he would always bring forth something new."

Self-Portrait in a Fur Coat, built on a pyramidical arrangement of planes, remained in Dürer's possession during his lifetime. Posterity views it as his monument to his idea of what an artist really is. In translation, the Latin inscription reads: "Thus I, Albrecht Dürer of Nuremberg, painted myself in my own colours at the age of twenty-eight."

ALBRECHT DÜRER
(German, 1471–1528)
Self-Portrait in a Fur Coat

1500
Oil on panel
67 × 49 cm
Alte Pinakothek, Munich

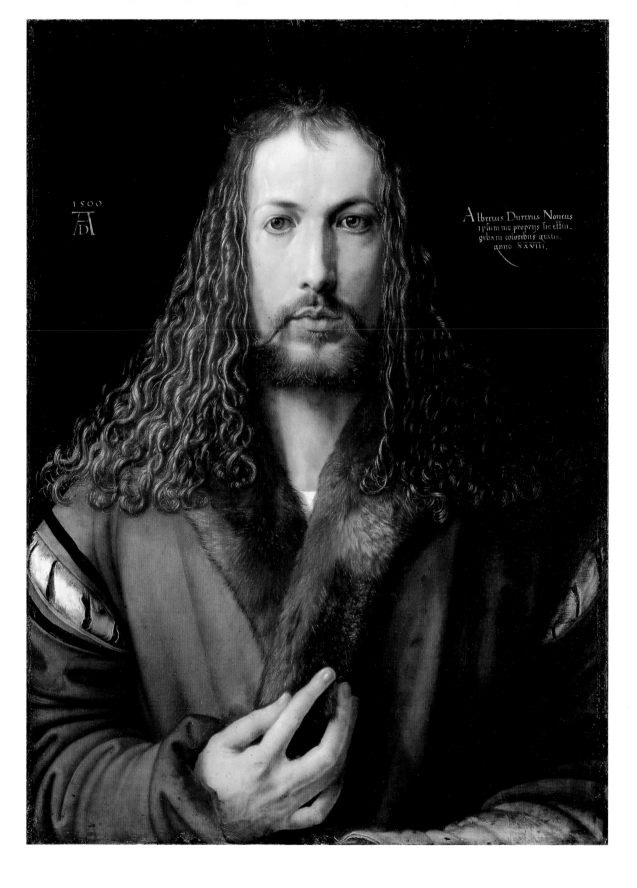

Heaven and Hell
Crime and corruption in a turbulent world

The spectacle depicted here is a devastating one: devils and demons, spectres and other monstrous figures attack the poor sinners to rack, torture and torment them in indescribably grotesque ways. The instruments of torture that feature so prominently in this hellish scenario, such as the bell and gigantic musical instruments, are wholly unconventional. Pathetic sinners are woven alive into the strings of an enormous harp, shut into a drum or shackled to a huge lute to endure the beat of a diabolical symphony, a world-class apocalyptic martyrdom. Despite the surreal world of madness and perversion that unfolds like a nightmare in this painting, it is undeniably a masterpiece of consummate elegance and perfection.

Never before or since has a painter succeeded in creating a more symbolically perverse orgy of torture than Hieronymus Bosch. There could be no crasser contrast to the works of the Italian Renaissance than this. The right panel of his triptych *The Garden of Earthly Delights*, considered to be the Netherlandish painter's masterpiece, reveals nothing of human beauty. It intricately embroiders the hellish sufferings to which man in his imperfection is condemned. Bosch's imagination is inventive on an unprecedented and unparalleled scale. With ghoulish wit, he delights in staging this inferno teeming with monstrous atrocities. As overwhelmingly bizarre as all this may seem, Bosch's imagination was, in fact, rooted in the reality of his times. People groaned under the weight of increasing taxation. Crime and corruption were rampant. Bishops, cardinals and Popes kept mistresses, fathered children and even showed them to the public at Mass. Of monks it was said then that they spent the day indulging in "flatulent discourse, dice games and gluttony". It was commonplace that their "corruption stank to high heaven". Bosch's contemporaries may indeed have recalled the words of the prophet Isaiah (5: 11–12, 14): "Woe unto them that rise up early in the morning, that they may follow strong drink; that continue until night, till wine inflame them! And the harp, and the viol, the tabret, and pipe, and wine, are in their

Paradise, worldly pleasures and Satan's realm:
An overall view of Bosch's three-piece masterwork
The Garden of Earthly Delights

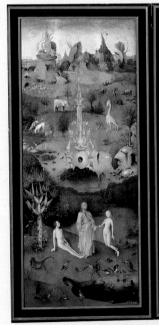
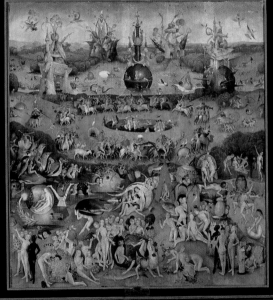
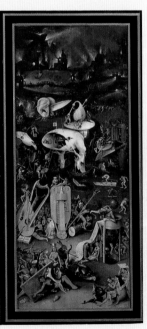

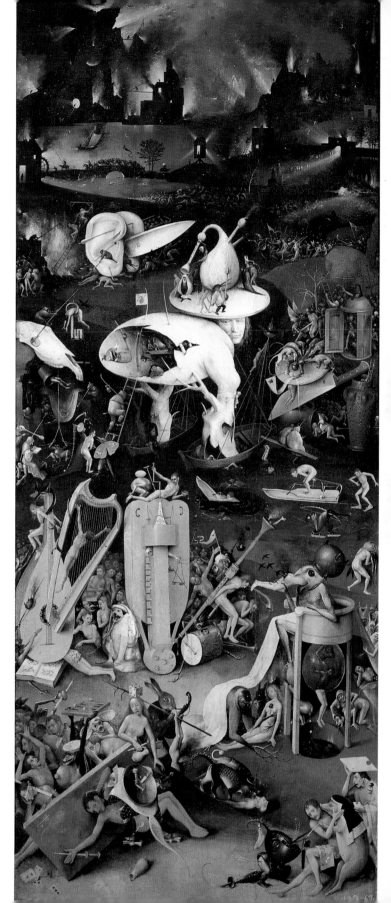

> In the midst of the fire stand diabolical hangmen with knives, scythes, drills, axes, picks, shovels and other instruments with which they torment the souls of gluttons, beheading them, running them through with spits, drawing and quartering them and then throwing them into the fire. There they melt like fat in the pan.
>
> After *The Vision of Tundale*, 1484

feasts: but they regard not the work of the Lord, neither consider the operation of his hands.... Therefore hell hath enlarged herself, and opened her mouth without measure: and their glory, and their multitude, and their pomp, and he that rejoiceth, shall descend into it." However, the man who unleashed such unmitigated atrocities onto the canvas did not fear Divine Judgement, at least not in the eyes of the Spanish satirist Quevedo y Villegas (d. 1645), who had the painter engage in a fictive dialogue in which he claimed not to believe in the devil or in hell.

HIERONYMUS BOSCH
(Netherlandish, *c.* 1450–1516)
The Musicians Hell

c. 1505
Right panel of the triptych
The Garden of Earthly Delights
218.5 × 91.5 cm
Museo del Prado, Madrid

The Demonic Enchantment of a Smile
The secret of the *Mona Lisa*

The lady smiles with regal serenity. Her instinct for conquest, for cruelty, the whole legacy of her sex, the will to seduce, to enmesh in deceptive wiles, the apparent goodness concealing malicious intentions – all this appears and disappears behind a veil of serenity to be lost in the poetry of her smile. Smiling, she is good and evil, cruel and merciful, gentle and cat-like.

Angelo Conti, *On the Mona Lisa*, 1909

Is she cold-hearted? Soulless? Seductive? "Hundreds of poets and men of letters have written on this woman. And none of them has solved the enigma of her smile, none has read her thoughts", to quote an essay written by Angelo Conti. Attempts at interpretation are legion, yet none is satisfying. Some see "the embodiment of all the love experienced in the history of civilisation", others "the narcissistic traits of Leonardo himself". Even the father of psychoanalysis, Sigmund Freud, felt compelled to comment on the *Mona Lisa*: "If one thinks of Leonardo's pictures, the recollection of the beguiling and enigmatic smile that he has magically conjured on to the lips of his female figures comes to mind. An unchanging smile on long, curving lips: it has become the distinctive feature of his work and is usually called 'Leonardesque'. The exotic, beautiful face of the Mona Lisa is most captivating to the spectator and confounds his wits." Even Freud was forced to admit defeat: "Let us leave the enigma of the Mona Lisa's countenance unresolved."

We do know something about the artist's model. She was known as Mona, or Monna, which means "Madam", Lisa del Giocondo.

The most influential genius of his time: Leonardo da Vinci, *Self-Portrait*, *c.* 1516

Born in 1479, she married the respectable cloth merchant Francesco del Giocondo and lived in Florence. There she was noticed, at the age of twenty-four, by Leonardo da Vinci, who was twice her age. An extraordinarily gifted painter, sculptor, draughtsman, architect, natural scientist and engineer, he was arguably the greatest genius of his age. Giorgio Vasari, who founded the discipline of art history, understated the unparalleled powers of this polymath and universal genius when he referred to him as "most admirable and divinely gifted". He is said to have worked on the *Mona Lisa* for three years, using the most sophisticated techniques to distract his model so that he might capture that enigmatic smile.

LEONARDO DA VINCI
(Italian, 1452–1519)
Mona Lisa (La Gioconda)

1503–05
Oil on panel
77 × 53 cm
Musée du Louvre, Paris

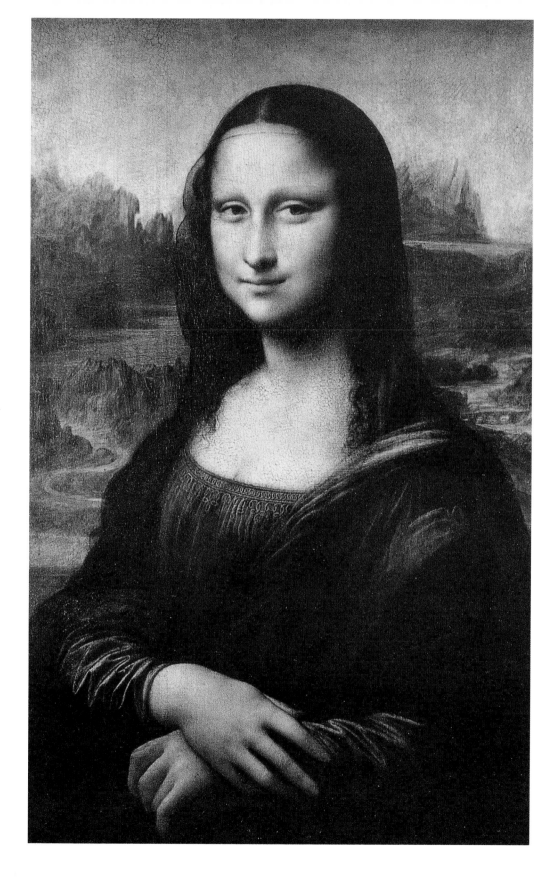

"And the Lord God Called unto Adam, and Said unto Him, Where Art Thou?"

Michelangelo recreates man

And God said, Let us make man in our image, after our likeness: and let them have dominion over the fish of the sea, and over the fowl of the air, and over the cattle, and over all the earth, and over every creeping thing that creepeth upon the earth. So God created man in his own image, in the image of God created he him; male and female created he them.... And the Lord God formed man of the dust of the ground, and breathed into his nostrils the breath of life; and man became a living soul.

Genesis (1: 26–27, 2: 7); heading: Genesis (3: 9)

Michelangelo was born in Florence in 1475. As a boy of thirteen he was apprenticed to the workshop of the painter Domenico Ghirlandaio (1449–1494). There his talent was discovered and furthered by Lorenzo de' Medici, a great lover and patron of the arts. As a young man Michelangelo was allowed to live in the Medici palace as a guest, where he could study the ancient statues in the garden and was instructed by the ruler, Lorenzo, himself. However, by the time he reached the age of eighteen, that was not enough for Michelangelo Buonarroti. How was a sculptor to represent a human body in motion without knowing how the muscles functioned under the skin? He wished to study anatomy, but he needed corpses to do so. He knew he would not be admitted into a charnel house, as it went against his contemporaries' sense of propriety and moral principles. The popular American novelist Irving Stone – whose book about Michelangelo, *The Agony and the Ecstasy* (1961), was a bestseller – allowed chance to drop a key into his hero's hands: the

key to the hospital of Santo Spirito. Eagerly, yet terrified of being caught, he set to work at night. By the flickering light of a candle, he carefully dissected corpses to study the way muscles were formed and how they worked, how the spinal column was arranged and where the organs were located. Without empirical observation and active study, no matter how he may have gone about it, Michelangelo would never have become the model that he has been for subsequent generations of artists. Nor would he have been revered in his own lifetime as a sculptor, a painter, a writer of profoundly moving sonnets and a thinker in the Platonic mould. To him the idea, the conception of a work of art – and this was especially true of sculpture – was latent in the material, waiting to be recognised by the artist and wrested from it in the creative process.

Michelangelo's *Creation of Adam* is surely one of the most sublime portrayals of man ever achieved. On 10 May 1508 Michelangelo began to work on this fresco on the ceiling of the Sistine Chapel in the Vatican. Initially he had misgivings about

accepting the commission because he viewed himself primarily as a sculptor. He suffered agonies while painting the Sistine ceiling, as his contemporary, Giorgio Vasari, sympathetically relates: "From keeping his head bent

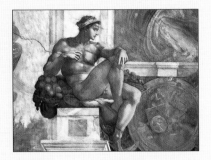

back for months on end to paint the vaulted ceiling, he ruined his eyes so that he was no longer able to read even a letter and could not look at any object without holding it up above his head." But that was not all. Michelangelo, then thirty-five years old, had to placate his sixty-seven-year-old patron, Pope Julius II, who "was of an impatient, choleric temperament and could not wait until the work was finished". By 31 October 1512, Julius II was finally able to marvel at the completed fresco, with its over 300 figures.

The ideal of Classical beauty: Two nude figures from the ceiling fresco in the Sistine Chapel

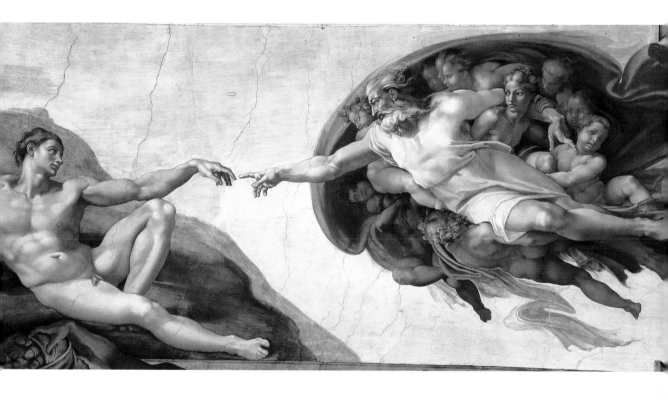

MICHELANGELO BUONARROTI
(Italian, 1475–1564)
The Creation of Adam

c. 1511
Fresco
Detail of the ceiling, Sistine Chapel in the Papal palace,
Vatican, Rome

Queen of Angels and Men
The Sistine Madonna and Dostoyevsky

**Angels bend to you in solemn ceremony and
Saints pray where your foot steps: glorious
Queen of Heaven! To you the lyre of the
spheres resounds, which God has strung.
Your spirit gazes, divine to see, through the
veil of your unfading, blooming figure;
you bear a child of sublime omnipotence,
victor over death and liberator of the world.**

August Wilhelm von Schlegel, *Sonnet to the Sistine Madonna,*
c. 1840

Visiting Dresden, the Russian novelist Fyodor Dostoyevsky (1821–1881) could hardly tear himself away from *The Sistine Madonna*. He kept returning to the Gemäldegalerie where it hung to spend hours in front of it. Vasari, the Founding Father of art history, said of the artist: "How generous and benevolent Heaven may on occasion show itself to be by showering one man with the infinite riches of its treasures, all the grace and rare gifts otherwise

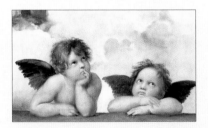

distributed over a long period of time among many individuals, can be clearly seen in the beauty and grace of Raphael." Dostoyevsky may have had similar feelings about the painting and the artist. On his last day in Dresden, he pulled up a chair in front of the painting so that he might be closer to the Madonna's face: "What beauty, innocence and sadness in that heavenly countenance, what humility and suffering in those eyes. Among the ancient

Greeks the powers of the divine were expressed in the marvellous *Venus de Milo*; the Italians, however, brought forth the true Mother of God – the Sistine Madonna." The author of *Crime and Punishment* (1866) went so far as to claim that, compared to this masterpiece, other representations of the Virgin resemble bakers' wives or other pedestrian, petty-bourgeois women.

A major Italian artist by 1500, Raphael was commissioned at the age of thirty-nine to work on the design of the new St Peter's in Rome. The young architect had already painted *The Sistine Madonna* for the high altar of San Sisto in Piacenza, where the relics of Pope Sixtus II (martyred in 258) had been kept since the ninth century. *The Sistine Madonna* hung in the church until 1753, when it came into the possession of the Prince Elector, Frederick Augustus II of Saxony. Before Dostoyevsky, German writers, such as August Wilhelm von Schlegel, Heinrich von Kleist and Franz Grillparzer, had been enthralled by the painting. *The Sistine Madonna* continues to enjoy wide acclaim to this day. In recent times, advertising and commerce have discovered the irresistible appeal of the two bored, mischievous angels on the lower edge of the picture plane. They appear on cups and napkins, letter paper and lampshades. Putti like these are a

type of angel, which made their first appearance during the Renaissance. Deriving from the Italian word for "child" or "infant boy", the putto, with his chubby, sensual cheerfulness, is in the tradition of Eros or Cupid, the god of love. In ancient writings and representations, Eros was portrayed as a half-naked boy with wings, while his figure ranged from slim to plump. The child-like appearance of Italian putti is an expression of their innocence. In connection with the Virgin, they represent the immaculate purity of the Queen of angels and men.

RAFFAELLO SANZIO, called RAPHAEL
(Italian, 1483–1520)
The Sistine Madonna

c. 1513
Oil on canvas
265 × 196 cm
Staatliche Kunstsammlungen Dresden,
Gemäldegalerie Alte Meister

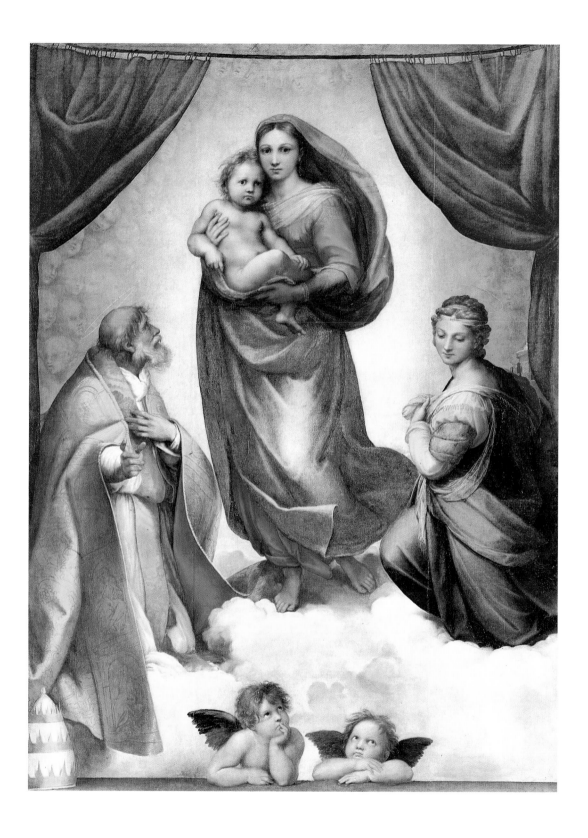

Money Makes the World Go Round
Trade and coins in early modern times

When the little "moutons d'or" were devalued to twelve "sous parisis", there was no bread, no wine nor anything else. The money changers refused to pay a decent rate of exchange. And people hoarded their money although it was worth nothing. Many simply tossed their coins right over the money changers' shops into the river.

From the diary of an anonymous Parisian, 1427

The term "trade" was first used in the modern sense in ancient Egypt. From the fourth millennium BC, the land of the Pharaohs maintained trade links with other civilisations. These commercial ties consisted primarily of the bartering of goods, such as raw materials, hides, tools, even the bright-coloured feathers of exotic birds, valuable shells and, of course, precious stones. The

Money raining down on the people: At the coronation of King Joseph II, coins are thrown to the crowds, 1690

Persians were the ones to invent the mintage of coins. The bartering of goods gradually yielded to payment in currency, although the heyday of the coin did not arise until the Middle Ages, when importing goods became of primary importance. Suddenly Venetian, Genoese and Pisan ships were sailing across the Mediterranean to meet caravans bringing silk overland from China or spices from India. On returning to their home ports, the Italian mariners sold their valuable cargoes to merchants. In the Holy Roman Empire, for instance, powerful mercantile enterprises sprang up everywhere. The Hanseatic League controlled trade to and from the North Sea and the Baltic coasts.

Once the era of overseas discovery and exploration was well underway, trade became a global matter. At that time, paper money (a Chinese invention) was used in Europe merely as a receipt for monies tendered, and the material value of coins still corresponded to their nominal value. Yet money looked different depending on where one went. Only money changers were able to determine the value of a coin by looking at it through a magnifying glass and by placing it on the scales to find out its exact gold or silver content. For this reason money changers were an indispensable part of life in the great trade centres and market towns. Even the man in the street required their services. Without the money changers a soldier who wanted a tankard of beer in the town where he was garrisoned would have had to drink water if he had carried only the currency of his native city. Flemish painter Quentin Massys observed a money changer at work in Antwerp. At that time the city was the main port of the Low Countries, and bustled with economic activity. Money changers enjoyed high status. Nevertheless, they were always suspected of being stingy, avaricious and of charging exorbitant interest. Perhaps the wife of the money changer depicted is contemplating a prayer book in the pious hope that she and her husband will not be led into temptation by the lure of riches....

QUENTIN MASSYS
(Flemish, 1465/66–1530)
The Money Changer and His Wife

1514
Oil on panel
71 × 68 cm
Musée du Louvre, Paris

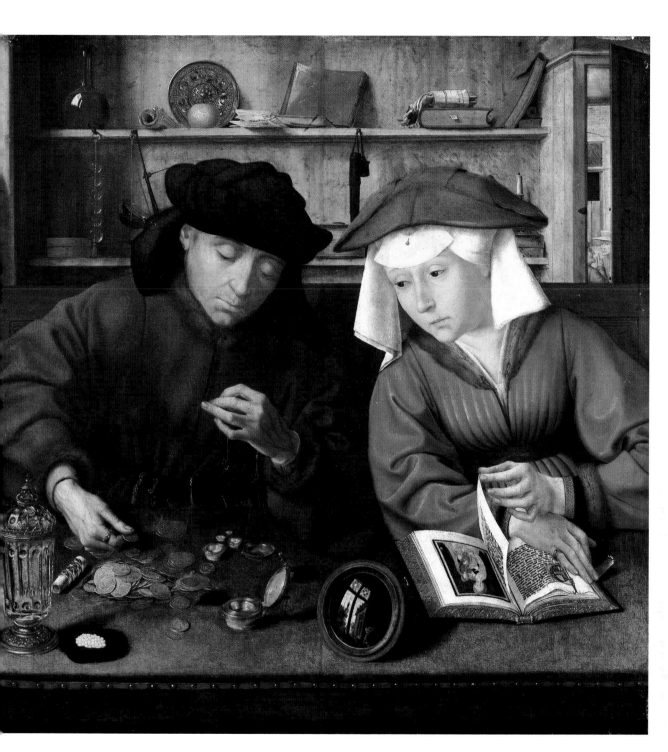

Plagued to Death
Consolation in suffering

Appear to me as my shield, my consolation in the hour of my death. And let me see thine image in thy sufferings on the cross. I will look up to thee, full of faith will I press thee fast to my heart: who thus dies, dies well.

Paul Gerhardt, 1656, after the *Salve caput cruentatum* of Arnulf of Louvain, before 1250

With the deep-cleft valleys of the Vosges Mountains, and the idyllic market towns which dot the eastern slopes with their charming half-timbered houses, Alsace-Lorraine is renowned for its quaint, picturesque scenery. Yet death haunted medieval Isenheim, on what is now the Wine Route between Colmar and Guebwiller. Dedicated to caring for the

Fear of "hellfire": A doctor wears protective clothing to ward off the plague, 1725

sick, the monastery of St Anthony – whose name derived from the patron saint of lepers – maintained a hospice. In the Middle Ages lepers were spoken of as being branded by "hellfire" or the "burning disease". All they

could do was await death, which gradually but inevitably devoured them. Fear of contagion made them outcasts in society. They were also regarded as sinners who were being punished for mortal sins by being afflicted with leprosy. Only the devoted care of committed monks and nuns relieved their suffering.

Monks and nuns cared even more for the souls in the disintegrating bodies of their patients. Communal prayer was the high point of weekdays in the hospice. In the Isenheim hospice, monks, nuns and their patients prayed together before the *Crucifixion* painted by Mathis Neithardt Grünewald, a native of Würzburg. The Abbot, Guido Guersi, had commissioned this work to adorn the central panel of a hinged altarpiece on view during the week in the hospice church. The visionary expressive power of Grünewald's sublime *Crucifixion*, his masterpiece, reveals the painter as one of the greatest of that or any age. Emperor Rudolf II desperately wanted to acquire the painting for his collection. The Prince Electors of Brandenburg and Bavaria also made attractive offers for it to enhance their collections. Nonetheless, for the time being, the luminous Grünewald *Crucifixion* remained in the setting for which it had been created: the church of the Isenheim lepers' hospice. Here it

consoled those who could identify with what it portrayed. In Christ's martyred body as Grünewald had painted it, the lepers in the

Death is all around: A ward in a hospital in the Middle Ages, 1514

Isenheim hospice could find a personal relationship to their Lord. Not until the Isenheim monastery was disbanded in the secularisation that followed the French Revolution was the Colmar *Crucifixion* finally moved – to a museum.

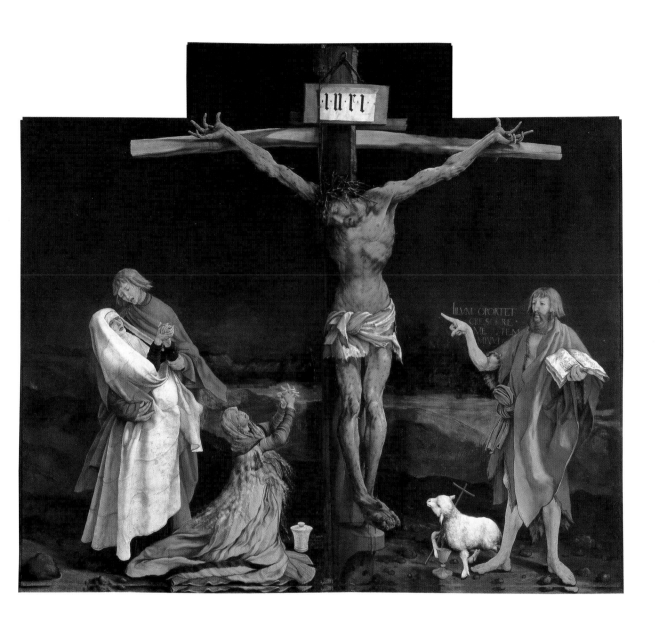

MATHIS NEITHARDT, called GRÜNEWALD
(German, c. 1480–1529)
Crucifixion

signed 1515
Oil on panel
207 × 301 cm
Alsace Musée Unterlinden, Colmar

"When Shall We Three Meet Again"
Europe swept by witch-burnings

Hell's weather cauldron, 1489

They concocted devilish ointments of toads' eyes, choke cherries, peppercorns and spiders. They poisoned the air with powders ground from intestines. They caused cataclysmic deluges to fall from the heavens. They set off avalanches and turned themselves into red-eyed goats. Their favourite food was pickled children. Imagination knew no bounds when

Burning witches at the stake, 1555

it came to describing the monstrous things done by witches and their evil powers. Some early tales are inadvertently funny. Witches blew up storms by vigorously fanning them with their slippers or slid down into valleys on the backs of avalanches, the tails of their scarves flapping in the wind. In early Modern times, however, witches were no laughing matter. Enlightened bishops – who castigated belief in ghosts, witches and black magic and regarded it as utter nonsense that represented a revival of pagan practices – were not heeded. Most theologians not only promoted dark superstition; they were convinced that sorcery was a reality and the result of pacts with the devil. Witchcraft was heresy, which made it doubly important to prosecute it and to persecute practitioners. In 1487 a compendium of horror stories was published in Strasbourg, the *Hexenhammer* (Witches' Hammer), which continued to be read in Europe until the seventeenth century. Both Protestant and Catholic judges consulted it as a penal code for dealing with witchcraft. One can imagine King James, famously obsessed with witchcraft, having been sent a copy by his daughter from the Palatinate. At any rate, the book may be said to have sparked off much of the witch-burning madness of the early Modern age. Its authors approved of torture, maintaining that women in particular were inclined to the sin of witchcraft. Of course women who gave themselves up to "lust and carnal desire or even sodomy" were prime targets for persecution. The German painter Hans Baldung Grien, who from 1509 lived in Strasbourg – where *Hexenhammer* had been published not long before – most likely wanted to get in on the act with his *Two Witches*. Despite the continued call for moderation and reason, witch-burnings – which had ceased in England by 1685 – were still common practice on mainland Europe as late as 1749. Trials however continued until 1717 in England, whereas the last recorded trial of a witch took place in 1793 in Germany.

HANS BALDUNG, called GRIEN
(German, 1484/85–1545)
Zwei Wetterhexen (Two Witches)

1523
Oil on panel
65 × 46 cm
Städelsches Kunstinstitut, Frankfurt

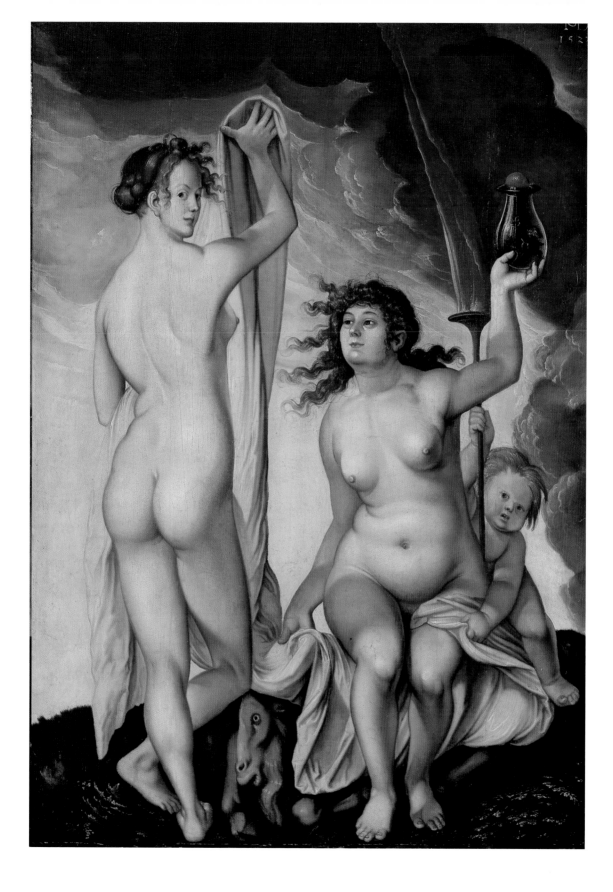

A Battle that Changed the World
An eyewitness to a cosmic event

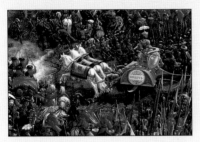

Darius fleeing

Dreadful he may be, but Alexander
possesses supernatural powers.
If those eyes hadn't looked at me that way,
that battle would not have been lost.
I would not have fled.

Monologue spoken by King Darius, in Klaus Mann's
Alexander: A Utopian Novel, 1929

Alexander in pursuit

Alexander, whom posterity styles "the Great", was twenty-three years old when he and his Greek troops encountered an adversary old enough to be his father, King Darius III of Persia. Battle was joined on the plain of Issus, an old Mediterranean port near what is now the Turkish-Syrian border, in 333 BC. The brilliant Alexander, a pupil of the philosopher Aristotle, managed to break into the Persian left flank. He is said to have looked so piercingly into Darius's eyes that the Persian king fled. His troops panicked and the massacre that ensued lasted until late that night.

During the battle Darius's mother, wife and children were captured. Alexander treated them honourably, which earned him the respect of the Persians. As hostages, however, they did influence Darius's behaviour. Yet, when Darius showed readiness to compromise, Alexander refused his offer. His decision made world history. He wanted to conquer Persia, but much more he wanted to rule the world: "Should you desire to know what my aim is, you should know that the bounds of my new Empire will be those that God has set the earth." After defeating Darius a second time, he conquered Egypt, the kingdom of Babylon and eastern Persia, calling himself the "King of all Asia." He drove the borders of his vast empire far beyond what is now Pakistan, all the way east to India and the banks of the River Bias. His victories were not merely political. More importantly, he carried Hellenic culture with him everywhere he went. He also promoted religious tolerance, including of Judaism. Napoleon thought highly of him, admiring in particular Alexander's ability to win the hearts of the peoples he conquered.

Albrecht Altdorfer was the first great painter to take landscape as his exclusive subject matter. He represented the historic Battle of Issus as one of his contemporaries, the German physician and scholar Paracelsus, might have viewed it: an epic struggle of life and death fought out on a cosmic scale, whose drama is reflected in the swirling clouds above and the endless vista beyond.

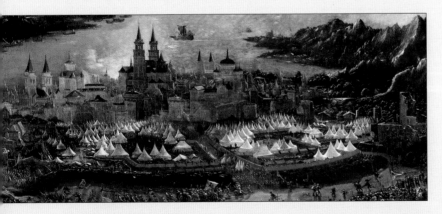

The camp outside Issus, as Altdorfer imagined the scene

ALBRECHT ALTDORFER
(German, *c.* 1480–1538)
The Battle of Issus

1529
Oil on panel
158.4 × 120.3 cm
Alte Pinakothek, Munich

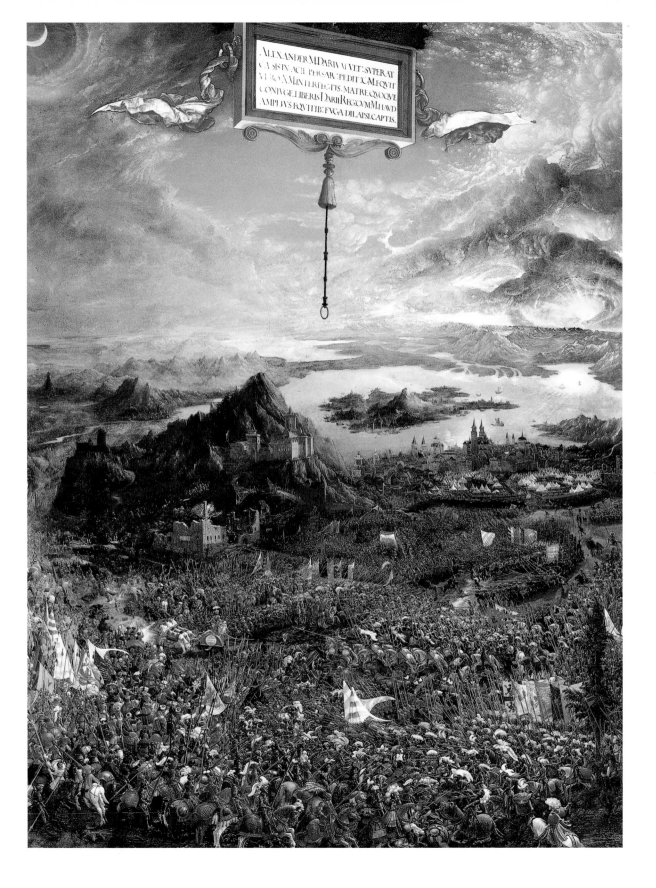

A Hotbed of Crime and Fornication
Martin Luther's "Ninety-Five Theses" and schism

Trouble was brewing in Europe: abuse of authority, ostentation, debauchery and bribery. Or so some Christians viewed the state of affairs around 1500. They considered the Pope the devil incarnate and his Church a bastion of lust, stupidity, greed and corruption. The sermons of the Dominican Johann Tetzel were water on the critics' mill. In 1517 Tetzel proclaimed that the Pope had granted him such authority that he could grant absolution even to someone who confessed he had fathered the child of the Virgin Mary – that is, if the sinner was to pay.

For some time now pulpits had been resounding with sermons offering remission of sins for money and a direct path to Heaven without a detour through Purgatory. The sermons preached by Johann Tetzel, however, were the ones that provoked Martin Luther, an Augustine monk and professor of theology at Wittenberg. In mounting a challenge, Luther said it was utter nonsense to think God could be bought. He held that the only thing one could do for one's salvation was to believe in God and live accordingly. Luther was in a rage when he wrote out his "Ninety-Five Theses". He is said to have nailed them

to the portal of Wittenberg Castle Church on 31 October 1517. All that has been conclusively proved by historians, however, is that he sent his "Theses" to his bishop on the Saturday that marks the beginning of the Reformation.

Wittenberg Castle Church: Martin Luther reputedly nailed his "Ninety-Five Theses" to the portal

Luther's goal was a theological debate; the authorities would have none of it. But thousands of copies of the "Theses" had been made and distributed, thanks to the new tech-

nology of printing, and a popular movement coalesced around them. It was too late for the ancient Church: the Reformation became a revolution, scourging pilgrimages and liturgical practises as "senseless foolery". Led by Luther's rhetoric which was sometimes eloquent and religious, sometimes violent and vulgar, the Reformers went quickly from demanding the abolition of priestly celibacy to a thorough re-casting of the Church. And the movement assumed a political and social dimension, propagated under the slogan: "freedom of Christian people". Together with the Humanist movement, the Reformation effected cultural change on a hitherto unprecedented scale.

Luther had a broad following: he was joined by merchants, peasants, craftsmen and princes. Supported by the princes, Luther was able to stand up to the Pope and the Emperor. Among his followers was the Northern Renaissance painter Lucas Cranach the Elder. At the Wittenberg Court, Cranach became a personal friend of the Reformer. Cranach executed several portraits of Luther, among them one for St Mary's Church, Wittenberg. It portrays Luther in his office as preacher there. In much of northern Europe, the ancient Church was no match for Luther's movement. After the Schism with Rome had taken place, Protestantism was ready to grow into a world-wide movement.

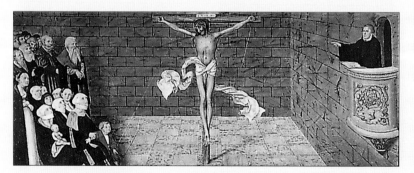

General view of the altar predella in St Mary's Church, Wittenberg

Whatever happens on pilgrimages other
than whores and knaves from all over
the place get together for their fun?
And does the Pope do anything other
than defile and prostitute himself?
We want neither to go on pilgrimages
nor to heed the words of the Pope,
but only to seek God in our hearts.

Martin Luther, "Table Talk", 1537

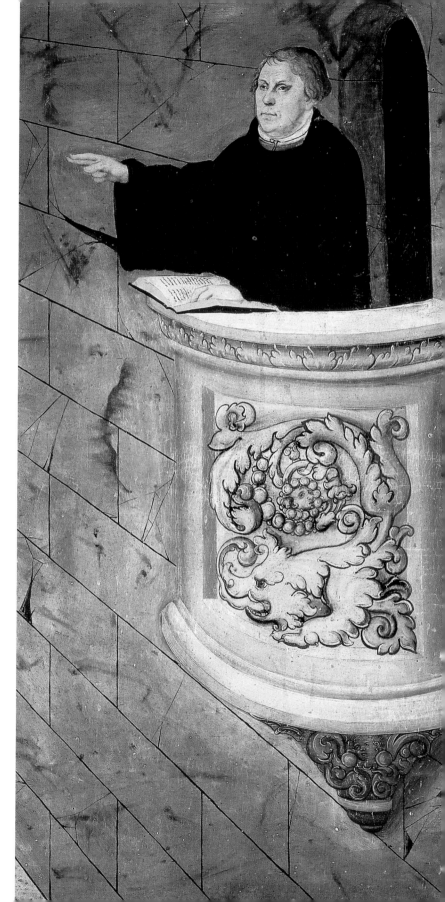

LUCAS CRANACH THE ELDER
(German, 1472–1553)
Martin Luther Preaching

before 1539
Detail of the altar predella
in St Mary's Church, Wittenberg

Give Yourself Body and Heart to Me

Henry VIII and his wives

If you would be a true loyal mistress and friend and give yourself body and heart to me, who will be, and has been, your most loyal servant (if your hardness does not forbid it), I promise you not only that the name will be yours by right, but also that I will take you for my only mistress, casting all others out of my thoughts and affections, and serving only you.

King Henry VIII of England, in a letter to Anne Boleyn, c. 1527/28

Posterity has not thought highly of him. Swiss historian Jacob Burkhardt called him a "clown and devil alike". Charles Dickens found him an unbearably bloodthirsty and swaggering bully, a fat, ruthless blot on the ever set eyes on. He is much handsomer than any sovereign in Christendom". By the end of his life, Henry was so corpulent he could hardly walk. The portrait of 1539/40 by the Court Painter to the English Court, Hans

What makes Henry VIII such a fascinating villain is the brutal way he rid himself of his other three wives. Because the Pope refused to annul his first marriage, Henry broke with the Church of Rome although he was a practising Catholic. He founded the Anglican Church, made himself sovereign head of it and declared his marriage vows null and void, which enabled him to marry Anne Boleyn without having to worry about Papal interference. Anne Boleyn, like his fifth wife, was executed in the Tower of London by the king's order. Both ladies were accused of having been un-

 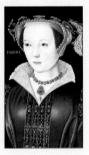

Fate and fortune: Henry VIII's six wives (from left to right) Catherine of Aragon, Anne Boleyn, Jane Seymour, Anne of Cleves, Catherine Howard and Catherine Parr

map of British history. King Henry VIII of England still epitomizes cruelty, gluttony and lust. During the thirty-seven years of his reign, some 70,000 people were sentenced to death and executed. Even his most distinguished English contemporary, the great Humanist and writer Sir Thomas More, who was his Lord Chancellor, was charged with high treason, dying a martyr under the executioner's axe.

The king's great girth is often attested to by historians. As a young man, Henry was good-looking and athletically built, to a Venetian observer "... the handsomest potentate I

Holbein the Younger, a native of Augsburg, shows that the king was already quite portly. Only a few years after it was painted, it took four gentlemen of the bedchamber and a block and tackle to hoist Henry VIII into bed. Amorous escapades were now out of the question, though he probably had had more than enough of those anyway. Married six times, he became more notorious for his marriages than for any other reason. Not that Henry VIII, in his youth an excellent dancer and a witty raconteur, was the only Casanova in history to grace, or disgrace, a throne. History has known far worse characters.

Three of Henry's marriages ended harmlessly, or at least conventionally. His third wife died in childbirth; his fourth marriage ended in divorce and his sixth wife survived him.

faithful to their lord and sovereign. The truth is, Anne Boleyn was beheaded because Henry had fallen in love with another woman, whom he wanted to marry. The charge of infidelity may have been true in Catherine Howard's case. Only twenty when she married the king, she may well have been bored by the marriage. At forty-nine, he had bags under his eyes and was fat, surely not a man to die for.

HANS HOLBEIN THE YOUNGER
(German, 1497/98–1543)
Henry VIII

c. 1540
Oil on panel
88 × 75 cm
Galleria Nazionale d'Arte Antica, Rome

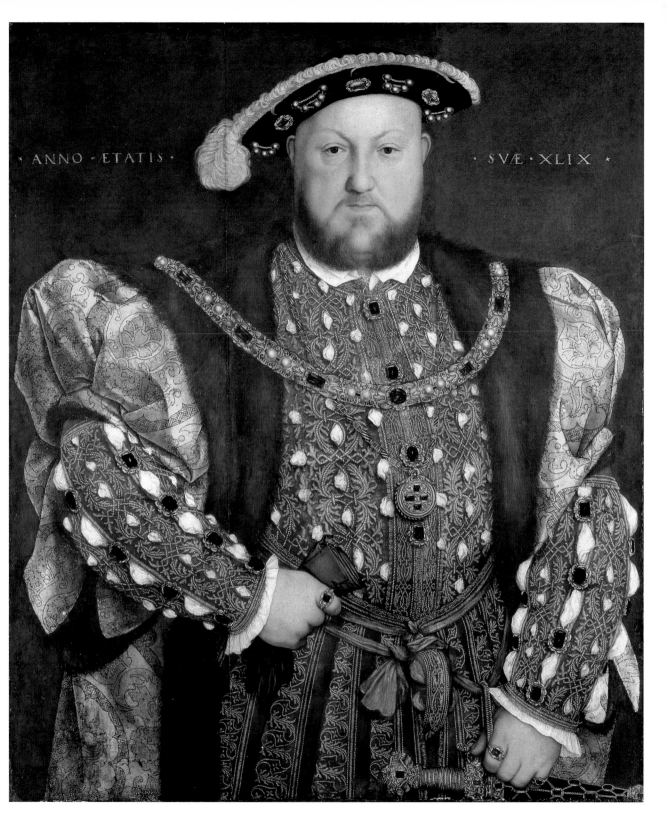

ANNO · ÆTATIS · · SVÆ · XLIX ·

Who Has Ever Read in His Soul?
The Emperor Charles V, his forces spent

Norblin, after Antoine-Jean Gros, 1812, *Francis I of France Shows Emperor Charles V the Royal Tombs in Saint-Denis*, 1837

In only a very few years the burden he bore had become too much for him. At thirty-three he fell ill of gout, only to be plagued all too soon by a host of other ills. And at fifty he marshalled many armies and ruled vast territories of this world – yet he was hardly able to control his own destiny. With neither his hands nor his feet nor his other faculties under control, he was a broken man, beset as he was by so many afflictions.

Prudencio de Sandoval, *On the Emperor Charles V*, before 1620

Although his physicians were appalled, they could do nothing to stop their sovereign, Charles V, from drinking ice-cold beer before breakfast and indulging in lavish repasts. Contemporaries reported that he was fond of fresh oysters, anchovies, eel pie, olives and hot, spicy Spanish sausages. Although his fingers were stiff from gout, he refused to let anyone cut up his meat for him.

The Holy Roman Emperor who, on the one hand, called for heretics to be burnt at the stake and, on the other, loved birds and flowers, was not admired – in fact he was often criticised and rejected. Yet, there has hardly ever been a ruler who has held so many lands under his sway. Born in Ghent in 1500, Charles V inherited the Duchy of Burgundy at the age of six. At sixteen he held the Spanish crowns and with them the Netherlands and the Kingdom of Naples and Sicily. His father bequeathed the Austrian crown lands to him. At nineteen he was elected king of the Germans and at thirty he was crowned Holy Roman Emperor in Bologna. Because the Spanish overseas colonies were founded during his reign, Charles V was also ruler of Mexico and Peru, while the Netherlands' conquests in the Pacific made him King of the Philippines. He had over seventy titles and ruled an empire in which the sun never set. For all that, Charles V was not power-hungry.

Everything his ancestors had not managed to conquer in changing alliances and valiant campaigns simply fell into his lap through inheritance and complex family genealogies. Perhaps he dreamt of a worldwide Christian empire to which he might have wanted to add the coasts of Africa and even more mythical

The Entry of Charles V and Pope Clement VIII at the coronation of the Emperor in Bologna, 1530

realms overseas, but his strength was no longer equal to the task. A "pious prisoner of power", as one French scholar called him, he was torn between the factions quarrelling over his empire. At the age of fifty-five – seven years before he had had Titian paint the present portrait – he abdicated and retreated to his Spanish country estate.

The leading Venetian painter of his day, Titian had been appointed Court Painter to Charles V and created him Count Palatine and Knight of the Golden Spur – an unprecedented honour for a painter. The Emperor is depicted sitting in an armchair. In his youth, he flaunted fashionable clothing; by now he has become a ruler who is so miserly that a visitor to his Court reported his hat was shabby and his cloak threadbare. He is contemplative, yet his eyes are blank, as if all the doubts he has entertained in his life are mirrored in them.

TIZIANO VECELLIO, called TITIAN
(Italian, *c.* 1487/90–1576)
Emperor Charles V

1548
Oil on canvas
205 × 122 cm
Alte Pinakothek, Munich

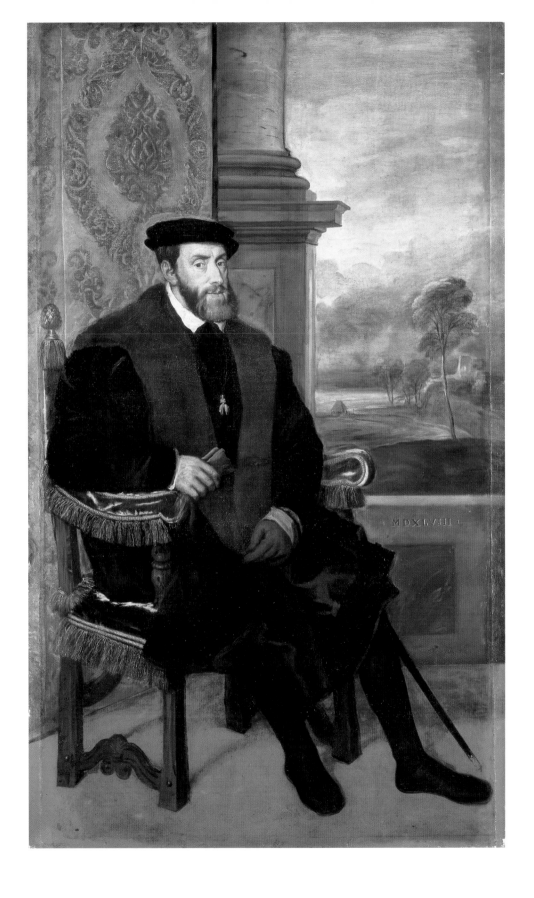

MDXLVIII

Let Us Build a Tower to the Heavens
The world as a construction site

King Nimrod, Chamas's grandson, Noah's son, said he wanted to revenge himself on God if God should again afflict the earth by visiting a second deluge upon it. Therefore he said he would build a tower so high that the flood-waters would not reach its top.

Josephus Flavius, *Antiquities of the Jews*, Book I, Chapter 4, first century AD

A "small cog" in a big machine: One of the many workers

Teeming with master builders, carpenters, stonemasons, mortar mixers and brick-masons, the enormous construction site depicted by Pieter Bruegel the Elder in *The Tower of Babel* recalls something like an anthill. It is clear that no expense was spared here. A tower was to be built, which would reach the Heavens. However, it was not intended merely to withstand the floodwaters of a second deluge. If one believes what is written in the Old Testament and in the writings of Josephus Flavius, a Romanised Jewish historian, or even what is supposed to have been in *The Sibylline Books*, the tower primarily symbolised man's defiance against divine omnipotence. Evidently the act of building achieved its purpose: "The Lord waxed wroth and became enraged when for Hoffart the tower was engaged", quipped the Strasbourg Humanist Sebastian Brant in his *Narren-schiff* (1494), published in English as *The Shyp of Folys of the Worlde* in 1509. Needless to say, the Lord was not amused by these excesses. He descended from the Heavens to punish the construction workers who, until then, had spoken to each other in the same language.

After the visitation they were left with a confused babble of tongues. Since people could no longer communicate with each other, the tower was left unfinished. A gigantic monument to hubris, it crumbled into decay. Did such a tower actually stand in Babylon, then one of the world's oldest cities, long the political and cultural hub of the ancient Near East? Archaeologists are not in agreement on this point. Nevertheless, in 1899, the remains of a sanctuary were uncovered on the site of ancient Babylon. In the middle of the temple precinct traces were found of a square tower consecrated to the god Marduk. Its sides were 91.5 metres long and it was estimated to have been some 90 metres high. Was this the legendary Tower of Babel?

The Netherlandish painter Pieter Bruegel the Elder transplanted the Tower of Babel to Antwerp, where he joined the St Luke's Artisans' Guild in 1551. That Pieter Bruegel made the Tower of Babel the subject of a painting shows the painter felt he, too, was living in a time of social,

political and religious unrest. He obviously thought a great deal about what the biblical tower symbolised: ambition, pride and the transience of human existence. His painting may, therefore, be a sign that some sane voices were calling for moderation and reflection in an exhilarating age of global exploration and of expanding trade links. On the other hand, *The Tower of Babel* might just as easily be taken to represent a manifesto against the denial of human rights, oppression and tyranny, a vision invoking the imminent end of the Spanish domination of the Netherlands. The painting might also be interpreted as moral support for the Reformation. Its leading exponents never ceased to censure the Papacy and the princes loyal to Rome for "resurrecting" the godless city of Babylon. The Reformers were of the opinion that it was high time for more linguistic diversity since, as they saw it, the Church of Rome no longer had anything worth saying.

The Empire State Building, New York

PIETER BRUEGEL THE ELDER
(Netherlandisch, *c.* 1525–1569)
The Tower of Babel

1563
Oil on oak
114 × 155 cm
Kunsthistorisches Museum, Vienna

Cowards Don't Go to Heaven
The first Christian victory at sea against the Ottomans

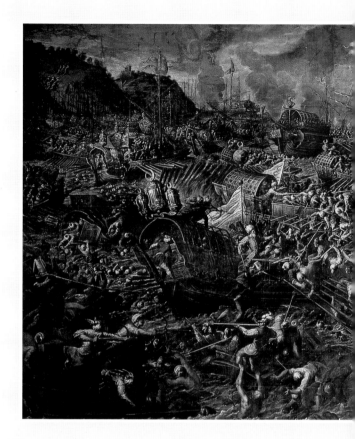

If two galleys ram each other with their bows, a seaman need only walk a two-foot-wide plank to enter the enemy galley. And even if he knows that he would plunge down into Neptune's lap at once should he miss his footing, he confronts the mighty mouths of fire-spewing cannon undaunted and, driven on by his sense of honour, he will cross this small plank to the enemy ship.

Miguel de Cervantes, *The Adventures of Don Quixote*, 1605

The victor of Lepanto:
Don Juan d'Austria;
woodcut by Anton von Leest,
end of the 16th century

Návpaktos is a charming little Greek town at the entrance to the Gulf of Corinth. In the early morning, old men sit over glasses of Ouzo and cups of coffee on tottery blue chairs along the quay. Day after day they enjoy the spectacle of the peaks across the Gulf on the Peloponnesus emerging from the haze. This was where, on 7 October 1571, Christian navies battled Ottoman galleys bristling with canons to save, as the West saw it, the powers of Christendom from being subdued by

Muslim forces. A bloodbath for both sides, the event went down in history as the "Battle of Lepanto", which is the Italian name for Naupactus, the name of the town in ancient times.

Renaissance Europe always feared – not without reason – the possibility of being invaded by Ottoman armies. Three centuries before the Battle of Lepanto, Crusaders laid waste entire regions of what is now Turkey at regular intervals. Now the tables had been

turned. Whilst the West was imploring its Saints to intercede for its armies, the Ottoman forces were burning Belgrade. In 1526 they conquered Hungary and, by 1529, they had reached the gates of Vienna. This was the point at which the West retaliated. After morning mass on Sunday, 7 October 1571, the galleys of the "Holy League", an alliance of Venetians, Spaniards and Papal troops, were cautiously cruising the northern coast of the Gulf of Corinth when suddenly a murmur

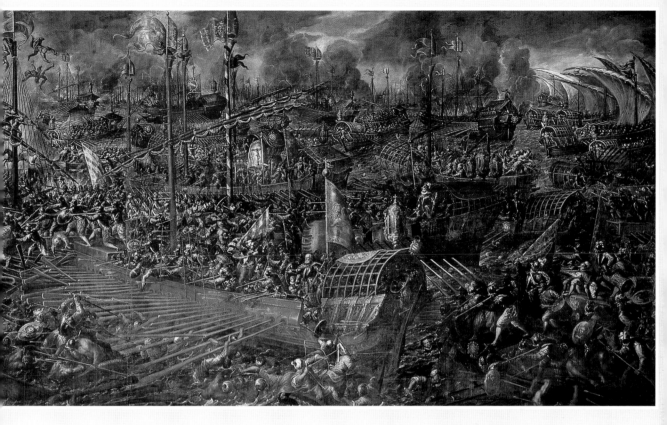

ANDREA DE MICHIELIS VICENTINO
(Italian, *c.* 1542–*c.* 1617)
The Battle of Lepanto

after 1577
The Doge's Palace (Sala dello Scrutinio), Venice

went up from ship to ship: the Ottoman fleet had been sighted. Numbering 274 men-o'-wars, it was drawn up in a broad crescent formation ten nautical miles to the east in the Gulf. At that time, the rules of naval warfare did not permit flagships to engage in combat. This convention was, however, jettisoned at Lepanto. By the time the Ottoman Sultana rammed the foredeck of the Spanish Real, splintering it under the blow, the battle had already been decided. Fighting ceased at

2 p.m., when a Spaniard beheaded the Ottoman commander in the fray and brandished his horrible trophy for the Turkish forces to see. Overcome at the sight, the Ottoman navy was paralysed. The Sultana was seized and the battle won by the Christian forces. The Holy League suffered 7,000 casualties, while 40,000 Ottoman seamen had been killed. One of the most distinguished survivors was Miguel de Cervantes. The Spanish writer, whose left hand was permanently maimed

from injuries sustained in the fighting, recorded his experience in *Don Quixote*.

Yet, the hero of the day was John of Austria. The commander of the victorious Western forces was the illegitimate son of Emperor Charles V and Barbara Blomberg, the daughter of a belt-maker from Regensburg, Germany. The man who had been scorned as a bastard won renown as the saviour of Europe, and was even paid homage by the Pope.

Blessed Be the Fruits of Culture
Prague around 1600

Look at the apple, look at the peach, how round and full of life, cheeks to right and left; notice, too, my eyes, of which one cerise, the other mulberry. Outside I look a monster, inside I bear noble traits, concealing a royal portrait.

Don Gregorio Comanini, *The Vertumnus of Arcimboldo* 1591

Alchemists attempting to make gold, astrologers studying the stars and the constellations and physicists desiring to build a machine of perpetual motion and to square the circle were amongst the Laputan circle of scholars that Emperor Rudolf II (1576–1612) assembled at Hradčany castle in Prague. The most important member of the Habsburg dynasty ever to reside there, Rudolf II was renowned as a

The jewel in the Bohemian crown: The Hradčany castle ward in Prague

generous patron of the arts. Nonetheless, many of his contemporaries were convinced that his hobbies kept him from the more pressing business of ruling. They were particularly suspicious of the Emperor's passion for all things arcane: mythology, occult phenomena and the mysterious powers of nature. In

short, the Emperor was regarded as an introverted weakling who was incapable of making decisions. Needless to say, Rudolf could afford to ignore such objections. He was supported in all his interests by a fatherly friend, a man of the "keenest intellectual powers", who was as highly respected as widely read and scholarly. This cultured man came from Milan and was named Giuseppe Arcimboldo. In his youth, Arcimboldo had designed stained-glass windows for Milan Cathedral. In 1562 he was called by Emperor Ferdinand I, Rudolf's grandfather, to the Habsburg Court, where he stayed on to serve three generations of the dynasty with great loyalty. He is first mentioned in the imperial records of 1565 as an official portrait painter to the Court. However, he was not just a painter. "Arcimboldo's noble intellect invented a great many clever, charming and unusual things for the magnificent revels held at Court", a contemporary reported. The masques Arcimboldo designed as settings for those court festivities must have been impressive. He once staged a mythological parade with real elephants and fake dragons, which were really horses in disguise. Today Arcim-

boldo is remembered primarily for his witty allegorical paintings. Flowers, fruits, fishes, birds, roots and even books are ingeniously arranged to form recognisable portraits. Drawing on botany, landscape architecture and hunting, Arcimboldo found all the inspiration he needed in the Habsburg "Wunderkammer", or cabinet of curiosities, which was overflowing with marvels: giant shells, sword fish, mummies, rare precious stones, stuffed animals and exotic artefacts from India. There was even a "devil confined in a glass". Arcimboldo did not look on his paintings as mere conceits in the Renaissance tradition; he meant them to be profoundly symbolic. The portrait of Rudolf II as Vertumnus, the Roman god of vegetation and the seasons, was certainly not meant as a travesty or a parody. On the contrary, the court portrait painter's intention was to honour his Emperor as the personification of generous patronage and cultural enlightenment. Arcimboldo's homage to his patron did not help Rudolf politically, however, for his brother Matthias still succeeded in deposing him. His reason for doing so was that Rudolf was no longer capable of reigning, owing to so many other distractions.

GIUSEPPE ARCIMBOLDO
(Italian, 1527–1593)
The Habsburg Emperor Rudolf II as Vertumnus

c. 1591
Oil on panel
70. 5 × 57.5 cm
Skokloster Castle, Stockholm

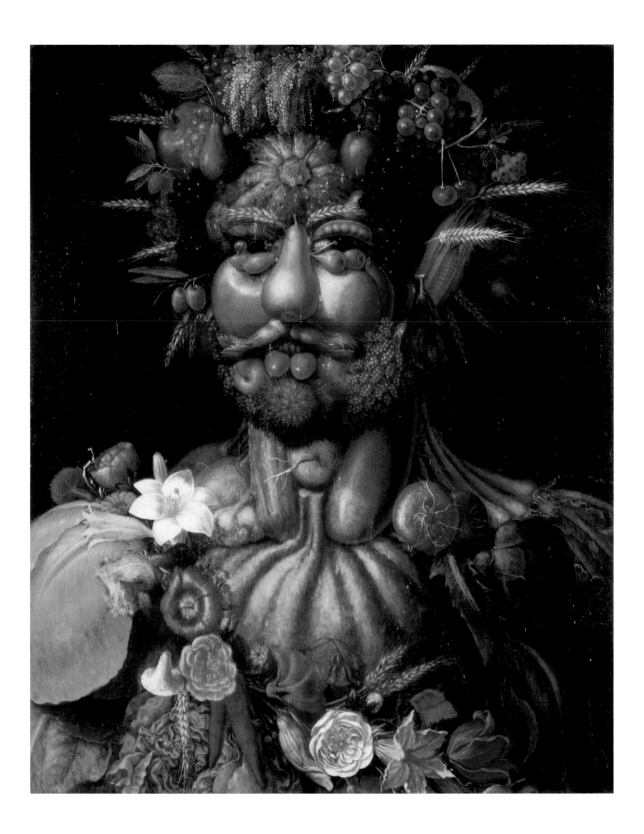

Only a Storm Brewing?
Toledo between splendour and disaster

Toledo is a unique open-air museum of Spanish history. The eastern slope of this oriental-looking city is crowned by the Alcázar, the citadel. To the left the cathedral's tower rises up out of a sea of medieval houses. A wreath of Moorish Gothic fortifications encircles the city like a diadem, and at the foot of the impressive granite outcropping, the River Tagus cuts through a magnificent gorge.

High above the Rio Tajo: The Alcázar in Toledo

The city of Toledo has seen glorious times. Yet disaster loomed on more than one occasion, for the first time in 192 BC when the city, which is one of Spain's most ancient, was conquered by the Romans. Nearly 700 years later, at the time of the Great Migrations, the West Goths subdued Toledo and made it the residence of their kings. Although the city was still brilliant, the West Gothic kingdom was tottering into decline. When the Arabs appeared on the Iberian peninsula, members of the Jewish community in Toledo opened the gates of the city to them on 11 November 711. This was their revenge for the hardship they had been made to endure by their fellow Toledans. Losing its status as a major city, Toledo was degraded to that of one of the five district capitals of Moorish Spain.

Pacified with great difficulty, Toledo eventually flowered into a centre of science and the arts, where a fruitful dialogue between Jewish, Christian and Islamic cultures took place. From 1085 the city was again governed by Christians. Not only did Toledo become Catalan's capital, it was noted for its policy of religious tolerance towards Jews and Arabs. As early as the twelfth century, an Arab scholar praised Toledo as being "the centre of Europe".

However, palace revolts, civil wars and excesses committed by the Church ensued, shaking the city. Its star was on the wane. The Inquisition moved in and Jews and Arabs were expelled. The royal residence was transferred to Madrid, and a century of troubles broke over the city.

Did El Greco, who settled in Toledo in 1577, wish to highlight the tragic side of his new home when he painted his *View of Toledo (Storm over Toledo)*? Born at Fodele on Crete, he went to Venice at the age of twenty-four to become a pupil of Titian. After long sojourns in Parma and Rome, El Greco moved to Toledo, a city that had lost its political importance. However, perhaps for this very reason it was able to focus on the role it had retained as the country's leading centre of Church activity. El Greco was a mystic and he may have found Toledo, where the opponents of the Reformation were more ardent than elsewhere, a bastion of the "true" belief, a place the painter saw as threatened by the very forces that were shaking the foundations of the old order.

DOMENIKOS THEOTOKOPOULOS
called EL GRECO
(Greek/Spanish, 1541–1614)
View of Toledo

c. 1595/1610
Oil on canvas
121 × 109 cm
The Metropolitan Museum
of Art, New York

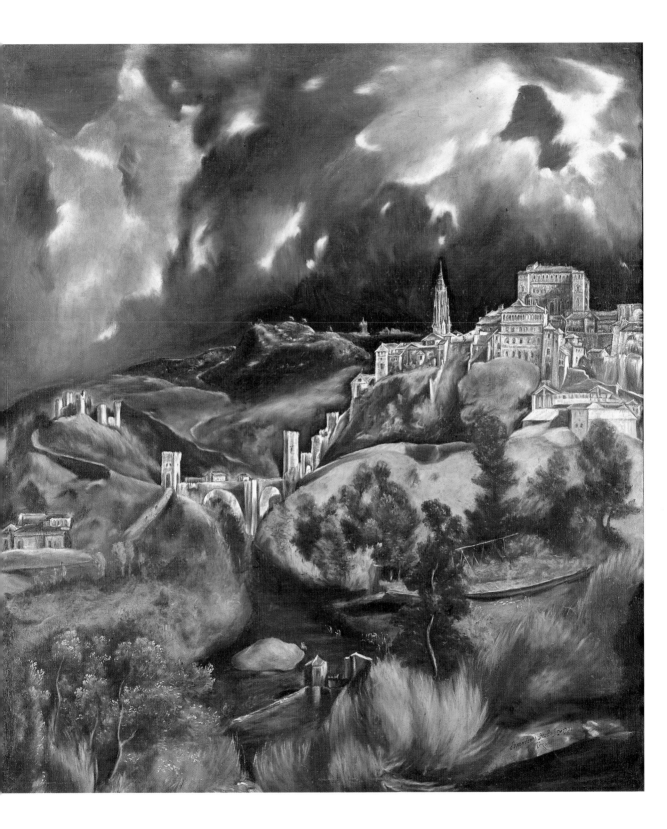

Expanding Horizons
Christopher Columbus on his way to the New World

They run about naked, are tall, with handsome bodies and pleasant countenances. Their skin colour resembles that of Canary Islands dwellers – they are neither white nor black. They would surely make good servants. I noticed that some wear a little piece of gold in a hole they make in their noses. This gold can probably be found in the interior of the country.

Christopher Columbus, from a log entry, 1492

Christopher Columbus, the Discoverer of America, by Sebastiano del Piombo, 1519

At daybreak the ships weighed anchor in the Spanish harbour of Palos de Frontera. Thus began on 3 August 1492 an adventure that was to change the world. The Italian commander of the three ships – the Niña, the Pinta and the Santa María – with their crew of eighty-eight men was Christopher Columbus, who would go down in history as the discoverer of America. Columbus was born in Genoa in 1451, and he had long cherished the plan of finding a western passage to India. Since Greco-Roman antiquity, the talk of a western route to the East had never entirely ceased. Until Columbus, no one had dared set out to explore the possibility because the long voyage across the open sea presented not just a problem of navigation, but a psychological barrier as well. For centuries, vivid imaginations had pictured the ocean teeming with giant squids and other sea monsters. With the dawn of Humanism, however, such superstitious notions were jettisoned. Soon, with the development of new astronomical navigation instruments, the bearings of a ship could be taken accurately, even out of sight of

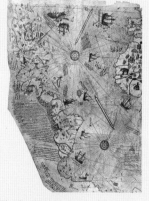

The New World: The Islands of the Caribbean Sea as shown on one of the first maps of the world, drawn from sketches made by Christopher Columbus, 1513

land, and crossing the Atlantic no longer seemed so daunting; indeed, it looked like a practicable venture. Since the Ottomans had expanded their hegemony into the eastern Mediterranean, the traditional trade routes to India were blocked. Consequently, the Spanish King Ferdinand and Queen Isabella gave Columbus the money he needed and permission to start. In the agreement they concluded with him, the Spanish Kings conceded to Columbus the right to be Viceroy of all islands and territories he should discover and ten percent of any profit he might make. Both parties to the agreement were hoping for a rich haul of gold and silver.

Columbus set out with a document in his pocket which designated the purpose of his voyage as "service to God and the dissemination of the true religion", even though four of his crew were men who had been convicted of committing violent crimes but had been pardoned by Ferdinand and Isabella. It took Columbus and his three ships over sixty days before they sighted land. On 12 October 1492 they landed on the island of Guanahani, now one of the Bahama Islands. Columbus, of

course, thought he was in India. In fact he was the discoverer of the New World. Falling on his knees and weeping, he kissed the earth, calling the place he had discovered San Salvador – Holy Redeemer. Then he raised the Spanish flag, had a crucifix erected and took possession of the land for Spain. The "Indios", as he dubbed the natives, struck him as being friendly and gentle. They seemed to have no idea of what weapons were. "I also think that they could be converted to Christianity without any difficulty", he noted in his log book. After discovering Cuba on 27 October 1492 and Haiti on 6 December, he departed for Spain with crates of gold which he had found. When the Spanish rulers saw what he had brought back with him, they started to plan future voyages; these explorations profoundly changed the course of history in the Americas, devastating ancient societies and giving rise to new ones.

Where tobacco grows: Inhabitants of Virginia; engraving, 1591

THEODORE DE BRY
(Netherlandish, 1528–1598)
Columbus Landing in the New World on 12 October 1492

1596
From *Americae Retectio*, 9th Book
Coloured engraving
State and City Library, Augsburg

Love Rules the World
Light and shade in Caravaggio's life

Amor rules everything, as ancient
writers say. All that Cupid really rules
is our hearts. Only your Amor,
Caravaggio, conquers both hearts
and the senses.

Marzio Milesi, *On Michelangelo Merisi da Caravaggio*

Amor, Eros, Cupid – no matter what name he is hiding behind, it is always the god of love that is talked about, the driving force in the world. Succumb to his charms at your own peril: "Amor remains a knave. Whoever trusts him will be deceived", wrote Goethe, who surely knew from experience. In antiquity Amor was depicted as boyishly charming and wearing wings. From the fourth century BC, he carried a bow and arrows.

Life without morals: Nigel Terry
in the role of Caravaggio, 1986

This last guise was the motif Michelangelo Merisi from Caravaggio near Bergamo had in mind when he accepted a commission from Marquis Vincenzo Giustiniani in Rome in 1602. Nevertheless, Caravaggio's Amor was notably different from earlier representations of mythological figures. His Eros is cheeky, he laughs impertinently, and is aggressively roguish; he is also sexier than Cupid had ever

been before. Speculation on what his left hand is doing behind his back fills volumes. All this may have contributed to making the painting Caravaggio's most famous work – and possibly the most celebrated Cupid in history. Moreover, Amor, who also stands for homosexuality and was the love child of the love goddess, Aphrodite, by the god of war, Mars, reflects the duality of Caravaggio's own nature. A passionate lover of men his own age, he could be dangerously violent on occasion.

Caravaggio was a genius who was known for impish humour. He loved to stroll through the streets of Rome strumming on his guitar, yet he also had the reputation of being hot-tempered and was always getting into brawls. This trait tragically cut his career short. After years of impoverishment, he had finally achieved recognition. To show how successful he was, he even allowed a boy to carry his sword. On 29 May 1606, he was involved in a fight, which left one of the participants dead, murdered – it was maintained – by Caravaggio. Banished from Rome, he fled to Naples, Malta and Sicily, where paintings lined his path. At last he arrived in Monte Argentario, Tuscany, hoping to be permitted to return to Rome. In vain. He died of malaria in Monte Argentario at the age of thirty-six, "in squalor and neglect". As the irony of fate would have it, the Papal letter that would have permitted his return to Rome had already been sent.

A scene from Derek Jarman's film *Caravaggio*, 1986

It hardly seems a coincidence that Caravaggio should have introduced chiaroscuro, the dramatic contrast of light and shade, to European painting, since few painters had as much firsthand experience of light and dark in their own lives as he had.

MICHELANGELO MERISI DA CARAVAGGIO
(Italian, 1571–1610)
**Amor vincit omnia
(Profane Love)**

1602/03
Oil on canvas
191 × 148 cm
Staatliche Museen Preussischer Kulturbesitz,
Gemäldegalerie, Berlin

Tempestuously Voluptuous
Turbulent painting

Castor and Pollux, Zeus's sons abducted
Both Leucippus's daughters. The two brothers,
Aphareus's sons, mighty Idas and Lynceus,
In love with the girls, stormed after them:
"Friends, it is indecorous for men of breeding
To woo women wedded to others."

Theocritus, *The Dioscuri (Idyll XXII)*, third century BC

Rubens is said to have painted with blood on occasion. He certainly loved excitement, dramatic scenes and passion. He exuded limitless vitality, as shown in his paintings of drinking and dancing scenes, of robbery and death. A bloodbath of colour out of which spectacularly voluptuous bodies rise up from a sea of Baroque turbulence – eyes speaking helplessly of fear or lascivious lust, figures swooning in desperation or ardently passionate. His trademark is sensuality and voluminous nudity. When he painted the *Last Judgement* for a high altar in a Jesuit church, the work had to be removed because the priests could no longer officiate at mass or concentrate on hourly prayers as long as those "disgusting nudes" were there. It was not only critics of the period who were repelled by the carnality of his work; even today his pictures are occasionally derided as "sides of ham".

Peter Paul Rubens, from 1598 a master of the Antwerp St Luke's Artisans' Guild, ignored the ironic comments of his detractors. Politically committed, the Flemish painter acted as a diplomat for the Spanish Governors of the Netherlands, which enabled him to travel often and extensively. He soon made enough money with his painting to be financially secure. After serving several royal Courts, he realised that he "could not stand Court life", although he did accept an appointment as Court Painter to the Spanish Governors of the Netherlands. Rubens built a house in Antwerp, where he lived and worked most of the time. Elevated to the peerage, he even bought a castle, leading the life of a country gentleman. His meteoric rise to fame and fortune was only possible because he was showered with commissions. Over 3,000 paintings are known to have left his studio, where he employed a great many assistants. Only some 600 of these works were painted by his own hand. Sharing a love of Greek and Roman literature with many of his contemporaries, Rubens gleaned the motif for *The Rape of the Leucippidae* from mythology. Malicious contemporaries regarded it as "a bundle of bodies tied up in a knot". Again, Rubens chose to illustrate a dramatic event. The nude women are the daughters of Leucippus, King of Argos. The Hellenistic pastoral poet Theocritus told a late version of the story of how they were kidnapped from their wedding feast after marrying Idas and Lynceus. The miscreants, the twins Castor and Pollux, were demigods who had also fallen in love with the sisters. Rubens does not depict the sequel to the kidnapping, although it would certainly have been a classic motif for the artist: the bridegrooms' pursuit of the kidnappers ended with both bridegrooms and one kidnapper dead. Zeus, the demigods' father, executed Idas with a thunderbolt. Pollux, who was immortal, was the only survivor of the slaughter.

Rubenesque figure: From *Big Women* by Herlinde Koelbl

PETER PAUL RUBENS
(Flemish, 1577–1640)
The Rape of the Leucippidae

c. 1618
Oil on canvas
222.3 × 209 cm
Alte Pinakothek, Munich

Wine, Women and Song
A medieval pub-crawl

The favourite I have lies in an inn cellar.
Clad in a wooden coat, he's known as Muscadella.
Me he's made drunk through the nights
And jolly all day.
God's on his side, there's no doubt of his sway.
Reviving my blood, he grants strength for the jape.
May God only keep thee, thou juice of the grape.

After Antonio Scandello, *The Favourite I Have*, before 1580

Carefree wining and dining:
somewhere between the
trough and the table; engraving
by Jeremias Falck

The sixteenth century was the age of feasting and drinking. On a sophisticated plane, Thomas More and Erasmus of Rotterdam exchanged their witty writings at banquets. In German-speaking territories, the Reformer Martin Luther brought conviviality down to earth. Of course his ninety-five theses are remembered, but so is his "Table Talk" in which the voluble glutton explained his theology in a welter of sausages, sauerkraut and graphic language. One wonders whether his table companions were always able to follow his train of thought. More than likely not.

Contemporary sources note that many princes became drunk every day. They may

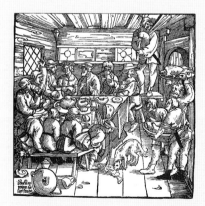

A wedding feast in the country;
woodcut by Nikolaus Solis, *c.* 1550

be pardoned for their excessive drinking when one remembers that it took a lot of strong drink to wash down the vast quantities of roast meat, nutmeats and gingerbread that banqueters consumed in those days. The nobles were not the only ones to indulge in such culinary excesses. Tradesmen and craftsmen also sat down to festive tables groaning under the weight of the fare. To drink beer, wine and more potent potations, men preferred to meet at taverns, most of which also offered beds for the night. The Dutch scholar and wit Erasmus of Rotterdam had quite a bit to say about what went on at an inn where he was staying: "The heated public room is open to all guests. Here one is combing his hair and another polishing his shoes or boots. It is part of good hospitality to ensure that everyone is soaked with sweat. Finally wine of considerable acidity is brought in. One is amazed at the shouting and din which arise when heads are hot with drink. Buffoons and jesters often mingle in the tumult and the delight those present have in them is unbelievable. They make so much noise with their songs, babble and shouting, their leaping and brawls that the walls threaten to collapse."

The greatest tavern roisterer among painters was probably Adriaen Brouwer. A brilliant raconteur, a gifted impromptu poet and a witty conversationalist, the painter had access

to the literary and affluent mercantile circles of Antwerp. However, the "genius of low-life" felt much more at home in taverns because he loved "drinking and licence" as his biographers tell us. They add that Brouwer "dawdled over painting but was quick at devouring his victuals". The genre scenes he painted, such as *Peasants Brawling in a Tavern*, probably represent firsthand experience. Although he was acclaimed and well paid for his work as a genre painter during his lifetime, Brouwer's passion for tavern life proved his undoing. As the story goes, Rubens, who admired the Flemish painter's work and even owned seventeen of his paintings, once took him in but soon threw him out again because he could not stand his bawdy ways. Brouwer, an "Adonis in rags" died at the age of thirty-three, possibly of the plague which he contracted in a tavern.

ADRIAEN BROUWER
(Flemish, 1605/06–1638)
Peasants Brawling in a Tavern

Undated
Oil on panel
30 × 25 cm
Alte Pinakothek, Munich

Wherever We Look there Is Fire, Plague and Death
Europe in the turmoil of the Thirty Years' War

We are now entirely,
 more than entirely, devastated!
Towers stand like smouldering charcoal,
 the church has been thrown down.
The Town Hall lies in rubble,
 the strong are vanquished.
Virgins have been ravished
 and wherever we look
there is fire, plague and death.

Andreas Gryphius,
Tears of the Fatherland, anno 1636

Between 1618 and 1648, Europe was on fire. From France to the Baltic Sea, from Sweden to Spain, marauding troops from all factions of the conflict devastated vast territories. Cities and marketplaces, castles and huts, even fields of grain ripe for harvesting were ravaged by war. Until the Thirty Years' War, Europe had not known destruction on this scale. During these years, the population diminished by more than a third. Entire regions were decimated. Barbaric incursions were followed by plague epidemics, which always found fertile soil in times of war. The German territories bore a considerable brunt of the disaster at the hands of Swedish mercenaries. When they wanted to break the resistance of a territory, the Swedish armies ruthlessly attacked one village after another, leaving nothing behind but scorched earth. "Almost the entire village was reduced to rubble, burnt by the enemy on the 24th", noted the abbot of Andechs Monastery in Bavaria in June 1632. "No one could save anything. All supplication and lamenting was

fruitless." The pious man was particularly horrified "at the unusual cruelty shown everywhere by the enemy to the elderly, the frail and the simple. In Erling twelve people of the above categories have fallen victim to their slaughter. After tormenting and torturing them, they were killed. The atrocity committed at Traubing against an old man and woman may serve as an example, where they heinously raped and mutilated her and gouged out the man's eyes before throwing both into the fire." In those dark days children in the streets sang gloomy songs: "The Swedes have come, have taken everything, broken windows, carried off the lead, made bullets of it and shot the peasants."

In autumn 1632, the suffering peoples of the German territories glimpsed a ray of hope. A decisive battle against the invaders seemed to be in the offing. On 16 November the German and Swedish armies clashed at Lützen, a town south-west of Leipzig. The Swedish King, Gustav II Adolf, fell in battle. The short-sighted monarch

wandered into the lines of the Holy Roman Empire where "soon his left arm was shot to bits above the elbow" before he was felled by two blows of a sword and died in a hail of musket balls. Despite the demise of their king, the Swedes won the battle. The conflict was to drag on for sixteen more weary years. The Peace of Westphalia finally put an end to the war in 1648, the date that marks the end of an age of religious conflict. A new era of European history dawned in which the welfare of principalities and kingdoms no longer depended on the religious affiliation of their subjects.

The helpless farmer and his demanding master; engraving by Rudolf Meyer

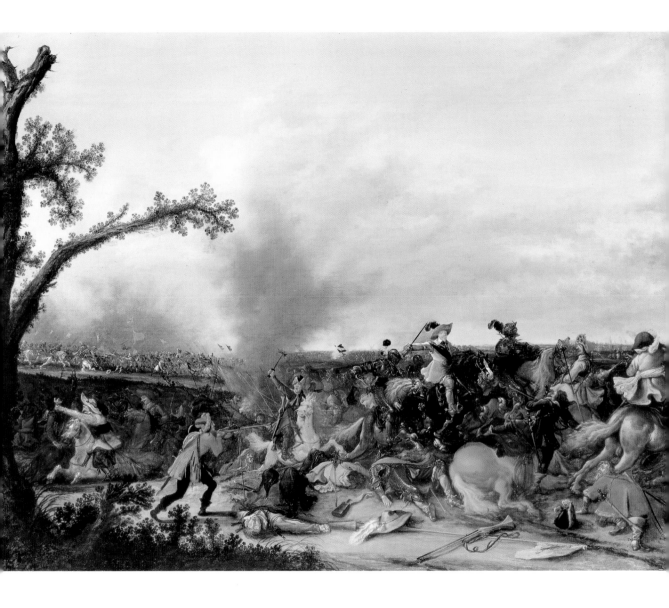

JAN ASSELYN
(Netherlandish, *c.* 1615–1652)
**Gustav II Adolf
at the Battle of Lützen**

c. 1650
Oil on panel
90 × 122 cm
Herzog Anton Ulrich-Museum,
Brunswick

A Well-Guarded Painting
The fascination of *The Night Watch*

How the drum beats,
How the pipe trills,
How trumpets also,
 and shawms,
 and kettle-drums sound,
O see
How fresh the flag flutters,
May your hearts
Leap light for joy.

Johannes Grob, *Soldier's Song*, seventeenth century

Pulsating with life — a drum is beaten, a dog barks, lances and muskets are raised, a flag is flown, children run about in all directions — *The Night Watch* is regarded as the masterpiece of the great Dutch painter Rembrandt Harmensz van Rijn. The only oddity is that the subject of the painting is not a night watch. The title emerged towards the close of the eighteenth century after the many layers of varnish coating the surface of the painting

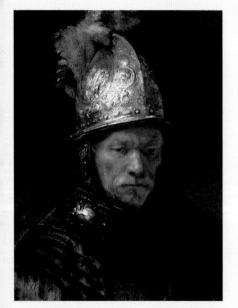

The Man in the Golden Helmet
c. 1650/55, is attributed to the circle of Rembrandt

had considerably darkened. The gloom thus produced led to the idea that the scene was captured at night. The original title of the painting was *The Company of Captain Frans Banning Cocq*. Instead of depicting a night watch, it is a group portrait of Amsterdam militia men. At the time it was painted, Amsterdam was Europe's leading mercantile city, with three civic militias. They called themselves The Crossbowmen, The Longbowmen and The Guild of Arquebusiers after the weapons the men of their companies had borne in the Middle Ages. The militias recruited members from the pool of men in their city fit for military service, while each district had its own company. In times of war and unrest, the militias fulfilled the function of protecting the community. Before Rembrandt's time, their duties included patrolling the ramparts of the city and mounting guard at its gates.

In 1633 Rembrandt settled permanently in Amsterdam. The civic militias still retained something of their military character, although by then theirs was predominantly a social function. The traditional guilds with their historic past represented different sections of the city, sometimes marking political factions, and their members paraded at civic festivities. Commissioned in 1640 by the Amsterdam Arquebusiers to paint their group portrait, Rembrandt probably portrayed the members before they were to participate in a

traditional parade, which may have been held in celebration of the visit of the French Queen, Marie de' Medici, in 1638. Contemporary sources show that the queen was welcomed by the marksmen's guilds and was accompanied by them in a ceremonial parade to a lavish feast in the festival hall of a guild house. Rembrandt's company of men was possibly depicted early in the morning of this royal visit. Led by their captain, Frans Banning Cocq, a reputable Antwerp merchant, the guild members seem to be about to take leave to greet the French queen outside the city. The large painting with its life-sized figures most likely hung in the festival hall of the Arquebusiers' guild house. In 1715 it was transferred to Antwerp's Town Hall. Because it was too large for the space it was to occupy there, it was promptly cut down to size.

REMBRANDT HARMENSZ VAN RIJN
(Netherlandish, 1606–1669)
The Company of Captain Frans Banning Cocq (The Night Watch)

1642
Oil on canvas
370 × 445 cm (fragment)
Rijksmuseum, Amsterdam

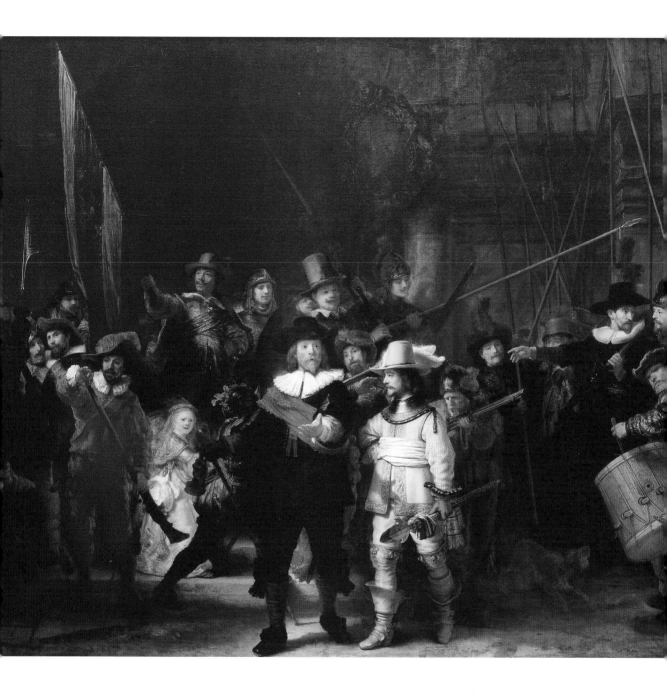

Landscapes, Light and Legends
Restrained Romanticism

In the land of incense, gold and magical tales:
The Queen of Sheba departing for Jerusalem

The Pope, the Spanish King, cardinals and Roman nobles showered him with commissions. Louis XIV of France, the first notable collector of his work, greatly admired the painter Claude Gellée, who took the name of his birthplace, Lorraine, as his surname. When he was twelve or thirteen, he moved to Rome, where he spent the rest of his life, with the exception of two years in France. In Italy he was caught up in the enthusiasm for antiquity and the Middle Ages. Claude Lorrain loved painting fantastic landscapes filled with temples, palaces, ruins and magnificent trees of his own invention. He not only worked over his compositions, he staged the scenes. His handling of light was what made him unique; indeed, Lorrain is famous for being the first painter to exploit overtly the manifold possibilities offered by the play of light and atmospheric effects. His paintings of seaport scenes with the sun reflecting off the surface of the water have earned him his reputation as a master of landscape painting. The Romantic philosopher Carl Gustav Carus

raved about Lorrain's "mild wafting of southern breezes" with all their "clarity inspiring sensibility". Johann Wolfgang von Goethe owned twenty-seven Lorrain etchings. In his *Italian Journey*, Goethe feels at a loss for words to express his debt to Lorrain: "There are no words to describe the clear haze hovering over the coasts when we used to go towards Palermo on the most lovely afternoons; the purity of contour, the softness of the whole, the subtle gradation of tones, the harmony of sky, sea and land. He who has seen it possesses it for a lifetime. Now I begin to appreciate Claude Lorrain."

Lorrain had always focused on landscape. However, he used his shady foregrounds as settings for mythological and biblical scenes, such as *Seaport with the Embarkation of the Queen of Sheba*. There are no literary references to the event. The Old Testament merely describes the legendary queen's stay in Jerusalem, where she visited King Solomon in the tenth century BC to ascertain whether his wisdom was all it was reputed to be. The subject-matter of the

painting, which was commissioned by a nephew of Pope Innocent X in 1648, the last year of the Thirty Years' War, is purely a product of the artist's own poetic imagination. Yet, Lorrain was not the only artist enthralled by the Queen of Sheba. In his play entitled *The Sibyl of the Orient or The Great Queen of Sheba*, the Spanish playwright Calderón de la Barca writes: "Where the sun's first cradle stands, where the light begins the travail of his daily journey, there lies a fertile, rich land like a thousand gardens of narcissi. This place, which glows so delightfully in the young beams of day, is ruled by the Queen of Sheba."

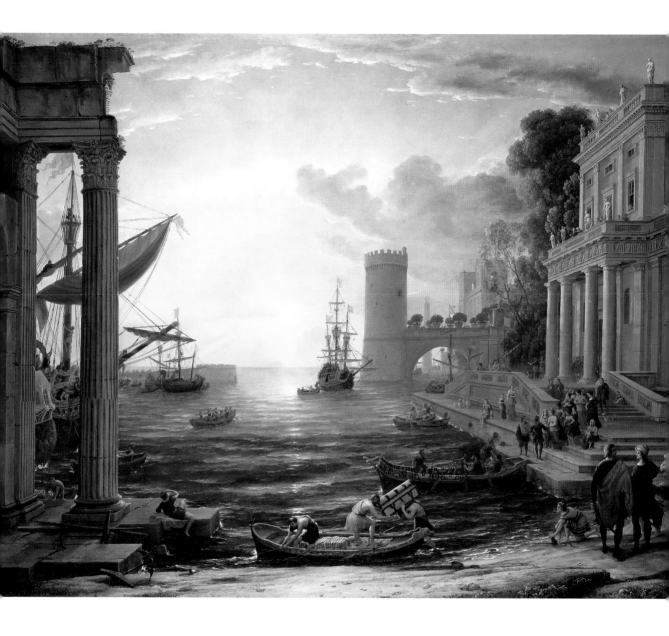

CLAUDE LORRAIN
(French, 1600–1682)
Seaport with the Embarkation of the Queen of Saba

1648
Oil on canvas
148.5 × 194 cm
The National Gallery, London

Behind the Scenes
At the palace of King Philip IV of Spain

**Palaces and temples were built,
armies engaged in battle,
the elements raged –
and the King in reality is nothing
but an actor in disguise, and his throne
a make-shift chair....
Masks and makeup, deception and
pretence – this is theatre.**

Adapted from Richard Alewyn's work on life
at the Court of King Philip IV of Spain, 1985

Their numbers were legionary. Some say there were 30,000 courtesans at the Court of Philip IV of Spain. Reigning from 1621 until 1665, the monarch had to leave governing to his regent, Count Olivares. No wonder, for in addition to women, Philip IV was an aficionado of hunting, the arts and literature. He was particularly fond of the theatre. Because the country was in decline, the king, like his countrymen, withdrew into a world of illusions. However, Philip IV did not content himself with occupying the Royal box; he wrote plays himself, most of them comedies. When he was not busy playing the King of Spain on the world stage, he could be admired displaying his talents as an actor in amateur performances put on at Court. Philip IV lived in and for the theatre. The responsibility for

A monastery and royal palace: El Escorial was under Diego Velázquez's administration in the 17th century

designing this world of illusion devolved increasingly upon the painter Diego Velázquez.

After being called to the Spanish Court in 1623, Velázquez had a meteoric career as a Court official. The last office he held was that of Lord High Usher of the Chamber, the highest rank he might attain in the king's retinue. Under Velázquez's tenure, the royal palaces were restored, enlarged and refurnished. For each of the numerous Court revels and festivities, among them the marriage of the Infanta Marie-Thérèse of Spain to Louis XIV of France, Velázquez threw himself into the task of designing all the decorations and curtains, stage sets and backdrops. It was not long before he was, to put it in modern terms, not only the Head Designer at Court but also its top-ranking Installation Artist. Philip IV was very fond of the man who created his dream world. He used to visit the artist in his workshop, which was in the palace. The king also provided him with lodgings near the royal apartments. Now an intimate friend of the king, Velázquez had no compunction about disturbing his royal master at any time. The painter became familiar with everything that was going on at Court and in the royal family. How close the painter's friendship with the king really was is perhaps shown most clearly in *Las Meninas*. The scene is like a photographer's snapshot, casually anecdotal about what was happening on the fringes of real life. The little Infanta Margarita appears in Veláz-

quez's studio, while the artist is painting a double portrait of her parents, which is reflected in a mirror on the rear wall. Responsible not only for construction work and staging festivities, he was also charged with ensuring that royal outings went smoothly. He saw to the linen, the firewood, the servants, the carpeting and guests' comfort and welfare, kitchen domestics and everything having to do with art. Overburdened by his many duties, Velázquez collapsed and died on 6 August 1660. He was buried in the dress and insignia of a Knight of Santiago. After his Favourite's death, King Philip IV is said to have personally taken up a brush and altered the artist's portrait. After all, when this picture was painted, the artist had not yet become a Knight of the Order.

DIEGO RODRÍGUEZ DE SILVA Y VELÁZQUEZ
(Spanish, 1599–1660)
**Las Meninas
(The Maids of Honour)**

1656
Oil on canvas
318 × 276 cm
Museo del Prado, Madrid

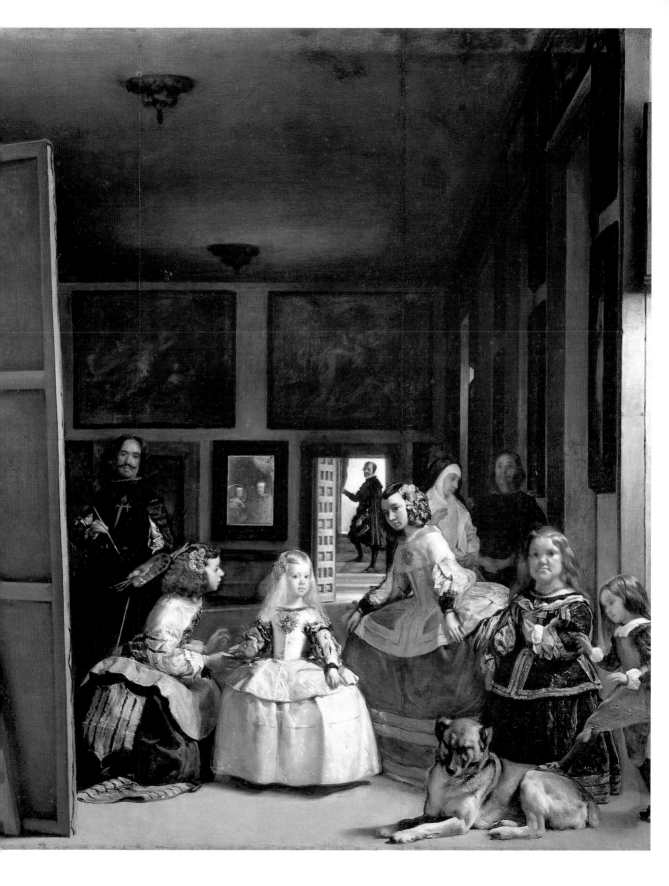

Everyday Scenes Transformed Into Poetry
The calm and peace of a great master

Creativity and chaos: Francis Bacon in his studio

We would need an entire book if we wanted to describe the art of painting. It ought to be presented to us in the guise of a beautiful young female with curly black hair and her mouth bound, wearing a gold chain about her neck from which a larva dangles. In one hand she is holding several brushes and the motto: *Imitatio* – that is, imitation.

Cesare Ripa, *Iconologia*, 1593

The Muses, the daughters of Zeus and the Titaness Mnemosyne, bear resounding names: Calliope ("fair voice"), Euterpe ("gladness"), Terpsichore ("joy in the dance"), Erato ("lovely"), Melpomene ("singing"), Thalia ("abundance" or "good cheer"), Polymnia ("many songs") and Urania ("heavenly"). These sisters were regarded by the ancient Greeks as the goddesses of the fine arts, music and literature. As ancient mythology has it, they lived on Mt Parnassus, a barren limestone spur of the Pindus Mountains in central Greece. On its southern slopes the Delphic oracle of Apollo prophesied in riddles. A consensus was never reached as to the domains over which the individual Muses presided, nevertheless, certain art forms came to be associated with each of them, although some overlapped: poetry and flute-playing, song and dance, comedy and tragedy, pantomime and even the science of astronomy. Yet, painting remained amongst the fields of art to be ignored entirely.

The Dutch painter Jan Vermeer van Delft was surely not the first painter to have felt slighted by his art being thus overlooked. However, he was one of the few to feel that he ought to do something about this sorry state of affairs. In short, he took the ninth muse, Clio, as his personal patron. Clio presided over history. Why did Vermeer take this particular Muse as his own and not the poetic allegory proposed by the Italian writer Cesare Ripa, who was widely read in Vermeer's day? Like many of his contemporaries, Vermeer probably saw history painting with a mythological background – the representation of biblical and allegorical scenes – as the major genre in painting. In his *Allegory of Painting*, Vermeer portrayed Clio as a young girl holding a history book in one hand and a trumpet proclaiming fame in the other.

The artist does not seem to have been inspired by his particular Muse all that often.

The man from Delft most likely painted only the thirty-four works that are known. Was Vermeer, in fact, a painter by profession? He is said to have inherited the Mechelen Tavern on the north side of the Delft marketplace from his father in 1652. Later the story goes that he worked as an art dealer. Even that was obviously not enough to keep him financially secure. When Vermeer, who today stands beside Frans Hals and Rembrandt as the most famous seventeenth-century Dutch painter, died in 1675, he left behind eight young children and a destitute widow. One of the first things she did was to give the Delft master-baker Hendrick van Buyten two paintings by her late husband to discharge debts amounting to 617 guilders and 6 stivers.

Vermeer's penchant for precision: A detail from the painting

JAN VERMEER VAN DELFT
(Dutch, 1632–1675)
The Allegory of Painting

c. 1666/67
Oil on canvas
120 × 100 cm
Kunsthistorisches Museum, Vienna

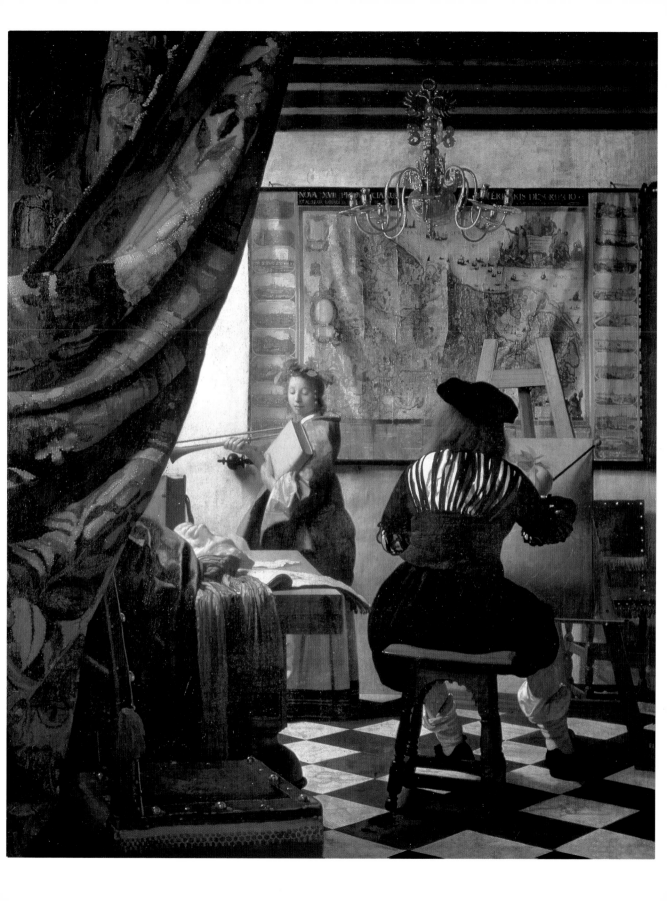

"L'état, c'est moi!"
Why Louis XIV failed to smile

The King is the regent and the image of God on earth, his majesty is the reflection of the divine; the entire state, the will of the people are embodied in him. Only he who serves the King serves the state.

Jacques-Bénigne Bossuet (1627–1704), Bishop of Meaux,
Politics According to the Teachings of the Holy Scriptures
(begun in 1678/79)

He wanted to impress and he was feared: Louis XIV of France, the Sun King, Absolutism incarnate. He particularly liked to be portrayed as an Imperator, omnipotent, magnificent and proud. He was remarkably healthy and was known for his sexual prowess. In Versailles, the magnificent palace he had built to commemorate himself, no woman was safe from him. Politically, he was equally successful. His invasion of Holland, his occupation of Strasbourg and of German territories, the sacking and burning of Heidelberg and Mannheim not only enraged his contemporaries; Louis XIV was given bad marks for his wars by later historians as well. His behaviour

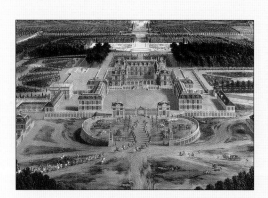

Centre of the absolutist world: *The Palace of Versailles*, painting by Pierre Patel, 1668

epitomised ruthlessness and brutality, abuse of power and perfidy.

At the end of his life, however, he was plagued by health problems, particularly those relating to his teeth, all of which he had extracted on the advice of his physicians, who were woefully incompetent. One gruesome dental disaster led to another, ultimately leaving the king's face lopsided. Yet the real reason for his unsmiling portraits is an aesthetic convention that goes back at least as far as the sombre busts of the Roman Republic and was given new emphasis in Absolutism. Rulers, divine or otherwise, were not only held in awe. Those who portrayed them were expected to observe the conventions of frontality and unsmiling dignity to enhance the quality of regal aloofness, which ultimately meant absolute power. Even royal women, little Infantas and the beautiful queens of Spain, were subject to this austere treatment.

The stern Absolutist convention had a sequel in the United States. The painter Charles Wilson Peale (1741–1827), who served in the American Revolution, was a true son of the Enlightenment. A man of many talents, he advanced early palaeontology, invented several new types of spectacles and made false teeth. The archetypal portraitist of Revolutionary War heroes, Peale might be called George Washington's official portrait painter. All his portraits of the first President of the United States (including, of course, the variant on greenbacks) are tight-lipped and unsmiling. Legend has it that George Washington, too, had trouble with his false teeth. Could they

Tooth-Puller, a preliminary model by the Meissen porcelain sculptor Johannes Joachim Kändler, 18th century

have been made by Peale? In any case it can be safely assumed that the President, like Louis XIV of France, was only too aware of the image he owed to his nation and to history.

HYACINTHE RIGAUD
(French, 1659–1743)
**Louis XIV of France
in His Coronation Robes**

1701/02
Oil on canvas
277 × 194 cm
Musée du Louvre, Paris

Pierrot and Other Clowns
Comedy and melancholy

Get your apparel together, good strings to your beards, new ribbons to your pumps; meet presently at the palace; every man look o'er his part In any case, let Thisby have clean linen; and let not him that plays the lion pare his nails, for they shall hang out for the lion's claws. And, most dear actors, eat no onions nor garlic, for we are to utter sweet breath, and I do not doubt but to hear them say, it is a sweet comedy

William Shakespeare, Bottom in *A Midsummer Night's Dream*,
Act V, Scene II, 36–46, 1600

In the eighteenth century, members of the French Court amused themselves splendidly: "The day before yesterday there was a great masque in Versailles". Thus a letter written in 1700: "The Duchess of Burgundy, in the guise of a village bride, came with her retinue of ladies in waiting, who were all masked, as she was, and whose hair was adorned with many flowers. This made a gloriously cheerful effect.... Eight days before there was another pretty harlequinade at Marly. The loveliest were the Savoyardes with their pedlar's bundles on their backs, which they opened. Two little harlequins and two Columbines popped out, little girls and boys, who danced beautifully." Even King Louis XV, then only eleven years old, took part in *fêtes galantes*, elegant entertainments, in 1721. He mimed a ballet dancer in a ballet entitled *The Elements*.

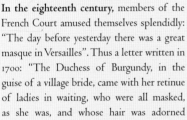

Not only did the nobility love dressing up and playing theatre. Like many of his contemporaries, painter Jean-Antoine Watteau did,

too. He was particularly taken with the characters in Italian improvised comedy, *commedia dell'arte*. They brought welcome diversion and pleasure to the poor as well. *Commedia dell'arte* originated around 1550 in Lombardy, evolving as street theatre in which improvised pieces based on stock situations were performed by troupes of specially trained actors. All that was prearranged were synopses of the plot and the sequence of scenes. Consisting mainly of clowning and jokes, the dialogue was entirely improvised. Although a couple in love belonged to the stock repertoire, the other characters were burlesque types, instantly recognisable because they always appeared in the same masks and costumes: Pantalone – an elderly Venetian merchant, the doctor, a scholar of Bologna and Arlecchino, and his crafty man-servant, whose awkward and melancholy side soon became personified as a separate character called Pedrolino.

After *commedia dell'arte* had become established in France at courts, fairs and in the streets, Pedrolino changed into a pitiable fool, who might be called either Pierrot or Gilles. This character represented the rejected lover, who was always sad. He was characterised by a distinctive white, wide-sleeved costume, a white mask and a wide white beret. Did Watteau paint his Gilles as a portrait of an

actor famous for playing the part of Gilles or Pierrot? Was this life-sized painting possibly hung in front of a café, or theatre in which the actor in question may have appeared in the role? Be that as it may, the melancholy clown, mocked, ridiculed and despised for his asinine helplessness, was a favourite with Watteau for the sole reason that he was so wretchedly sad. The mournful clown appears several times in his work. Is this a biographical clue? The painter knew all too well what it was like to have only himself for company. His final years were marred by disease and melancholy before he died at thirty-seven of tuberculosis.

Masques et Buffons: Pantalone (1550, above), Il Dottore (1653, left) and Arlecchino (1671, below), published by Maurice Sand, 1860

JEAN-ANTOINE WATTEAU
(French, 1684–1721)
**Gilles and Four Other Characters
from the Commedia dell'Arte (Pierrot)**

c. 1718/19
Oil on canvas
184 × 149 cm
Musée du Louvre, Paris

A City Rich in Gold
Venice and the sea

Venice and gondolas: An inseparable duo

He saw it once more, that landing-place that takes the breath away, that amazing group of incredible structures the Republic set up to meet the awe-struck eye of the approaching seafarer: the airy splendour of the palace and the Bridge of Sighs, the columns with a lion and saint on the shore, the glory of the projecting flank of the fairy temple, the vista of gateway and clock.

Thomas Mann, *Death in Venice*, 1912

No other city in the world has been so extravagantly praised as Venice. In 1495 the French ambassador Philippe de Commines praised it as being "the most joyously radiant city" he had ever seen. He mentioned white marble façades, apartments with gilt antechambers and sumptuously ornate fireplaces. When Napoleon conquered Venice in 1797, he thought St Mark's was "the best drawing-room in Europe and only Heaven is worthy of serving as its ceiling". Johann Wolfgang von Goethe, who stayed in the island-dotted lagoon in September 1786 while on his Italian journey, spoke with reverence of the "wonderful island city", which he "was privileged to visit" and in which he wished to reside "until I have satiated my desire to gaze on the image of this city". After endless warring with Genoa, Venice finally conquered her rival in 1380. From that date, the city was the unchallenged leader in world trade. In 1423 the Venetian Republic com-

manded a war fleet of 45 galleys specially built for combat and a merchant fleet of 300 galleys. With a population of over 200,000, Venice was one of the biggest, and certainly the richest, Western cities. Prosperity, optimism and cheerfulness reigned: "People sing in the squares, in the streets and on the canals. Merchants sing when they are prizing their wares; labourers sing when they leave their places of work; gondolieri sing when they are waiting for customers", remarked the Italian dramatist Carlo Goldoni in the eighteenth century. One wonders whether the Doge, the ruler of the Republic, sang when conducting the affairs of state.

At any rate, he had to utter the same invocation each year on Ascension Day, which was the most important event in the city calendar: "O sea, we wed thee in the sign of our true and everlasting dominion". With this incantation,

Emblems of the "floating" city

a vow renewed each year, the Venetians hoped to propitiate the primal forces of the sea to ensure their benevolence and willingness to do their share in securing the supremacy of the Republic in the Adriatic. In the days of the *veduta* painter Canaletto, the "nuptials with the sea" were staged as an opulent and colourful cavalcade. The Doge boarded his ceremonial ship, the *bucintoro*, and sailed to the Porto di Lido, the principal gateway to Venice, where the "nuptials with the sea" took place. There he poured holy water into the sea and cast a gold ring overboard. The ritual has been revived in recent years. Now, of course, something very different is at stake. No longer are the power, influence and wealth of Venice to be enhanced. The decaying city once called the Serenissima ("Most Serene Republic") must be prevented from subsiding into the sea should a raging storm unleash the forces of nature.

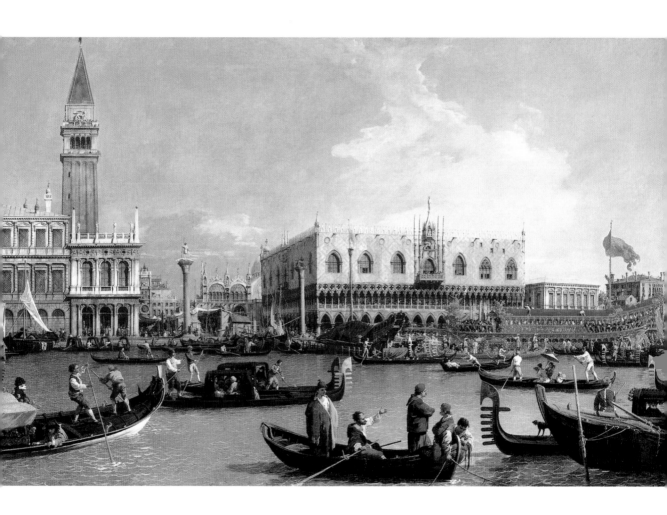

GIOVANNI ANTONIO CANALE, called CANALETTO
(Italian, 1697–1768)
The Bucintoro at the Molo on Ascension Day

c. 1732
Oil on canvas
77 × 126 cm
The Royal Collection, Windsor

A Clever Mistress
Madame la Marquise de Pompadour and Louis XV

I am always being blamed for the general wretchedness,
the Cabinet's unfounded policies, the disastrous war
campaigns and the triumphs celebrated by our enemies.
I stand accused of having sold everything, of having my
fingers in every pie, of ruling behind the scenes. One day
at dinner the King asked an old man to be so kind as to
give his compliments to the Marquise de Pompadour.
Everyone laughed at the poor man as a simpleton.
But I did not laugh.

Madame la Marquise de Pompadour (1721–1764), *Letters*, 1922

There was a small secret staircase at Versailles that led from the king's Cabinet to the second floor. There dwelled a lady named Jeanne-Antoinette Poisson, who has gone down in history as the Marquise de Pompadour. Louis XV of France, the Sun King's great-grandson and his successor, frequently climbed the steps to visit her. He is said to have preferred to disappear from Cabinet meetings for trysts with his mistress. When that happened, the ministers had to sit and wait for the king until he returned as Court etiquette forbade their leaving the room without the monarch. Thus Court lackeys could be deceived into thinking the king had spent the entire time in conference with his ministers.

Witty, cultured and beautiful, Madame de Pompadour may have been the daughter of a head-groom working on a duke's estate; her mother was a beauty in her own right. Madame de Pompadour was the fourth official royal mistress. Although married to the Polish princess Maria Leszczyńska since 1725, Louis XV seems to have embarked on his first extramarital affair in 1733. The first years of his marriage had been happy ones and six daughters and a son survived the union with Maria, who was deeply humiliated by her husband's infidelity. The first three royal mistresses to be established successively at Court from 1738 spent their time giving parties at the king's expense and behaving in a way that aroused public indignation. Years afterwards the queen was still complaining of having nightmares about her husband's dreadful mistresses.

Madame la Marquise de Pompadour was altogether different. She was unlike the others. No Bacchanalian parties took place in the private apartments of this grande dame. She gave exquisite little dinners with the king and invitations to them were coveted indeed. Moreover, Madame la Marquise was anxious to be on a good footing with the queen. She visited her every day, brought her flowers and chatted with her. The Marquise was even known to have served on occasion as an intermediary between the king and queen. When she heard one day that the queen had lost a considerable sum at gambling but was afraid to tell her husband what had happened, Madame de Pompadour asked the king for the privilege of paying the queen's debts of honour herself. Submitting to fate with gentle piety, Maria Leszczyńska allowed Madame de Pompadour to take her place at the king's side. The bourgeoise, whose paternity has never been satisfactorily established, became the power behind the throne at Versailles. When it came to appointing officials and ministers and making major decisions, Louis XV always consulted his mistress. For this reason François Boucher, once her drawing master and Court Painter to the king, painted a semi-official portrait of her. The seal and letter probably hint at her political ambition. That she was an accomplished singer is symbolised by the scores scattered at her feet. Even the little spaniel was not a prop provided by the painter. Her name was Mimi and she really did belong to Madame de Pompadour.

Louis XV, King of France (1710–1774)
Engraving by Johann Georg Wille

FRANÇOIS BOUCHER
(French, 1703–1770)
Portrait of Madame de Pompadour

1756
Oil on canvas
201 × 157 cm
Alte Pinakothek, Munich

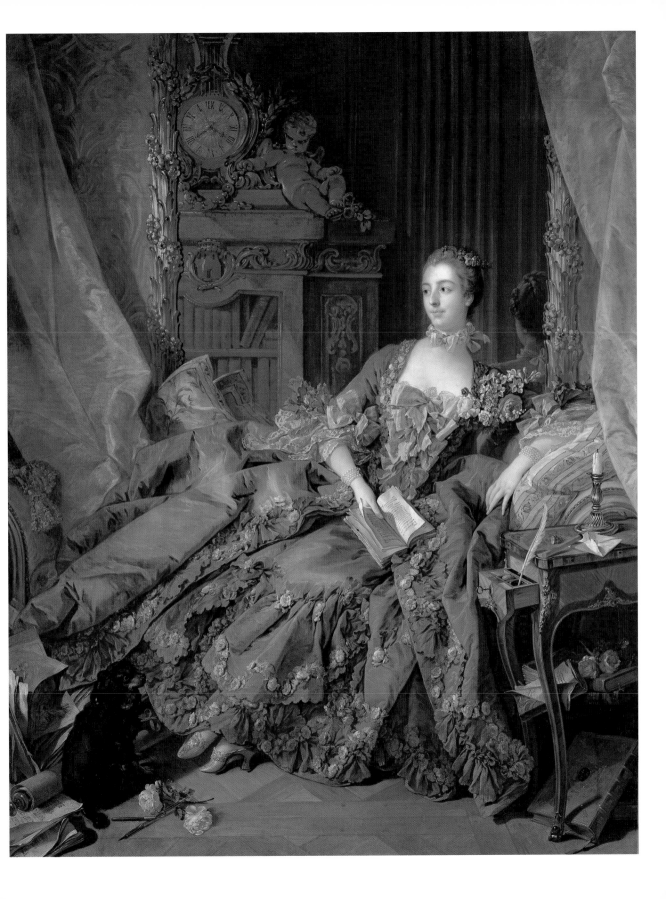

She Turns My Head
The Garden of Earthly Delights

Happy face, nymph-like girl
Eyes like cherries, seventeen
Delightful prattle
She turns my head.

Bernard, Chevalier de Bonnard (1744–1784),
Poésies diverses, published in 1791

One day in October 1766, the Parisian painter Jean-Honoré Fragonard was summoned to the hunting lodge of Baron Saint-Julien. The aristocratic treasurer of the Catholic Church pointed to his mistress and commanded: "I want you to paint Madame on a swing kept in motion by a bishop. Put me in it where I can

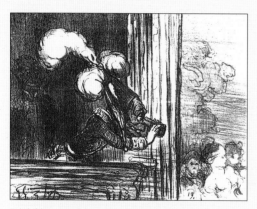

Delightful prospects; lithography by Honoré Daumier, 1859

see the legs of this pretty girl or even closer, if you want to make the picture even more pleasing." A man of the world, Baron Saint-Julien had already been turned down by a painter who was probably squeamish about the consequences of carrying out his orders – someone who had made a name for himself with representations of saints and plague victims

and felt the commission was indecent so he suggested Fragonard, who accepted. The result was *The Swing*. Fragonard had no qualms about damaging his reputation as a painter of blameless scenes by taking on this rather delicate commission. Of course Fragonard, who had been a spoilt child, was nothing if not urbane and sophisticated himself. "All his work is dedicated to women; why shouldn't his life have been so too?" asks a biographer. In 1756 the twenty-four-year-old Fragonard took advantage of a grant from the Académie de France to study works of the Old Masters in Rome. He is said to have devoted himself at least as passionately to the licentious dark-eyed beauties of Trastevere as to the paintings he had gone to Rome to study. In fact, the president of the Académie de France in Rome began to worry about his protégé. Fragonard's reputation followed him back to Paris, where all boudoirs were open to him on his return. The beauties of the day and dancers whose "hearts were not so constant" all sought the painter's attentions. Bernard, Chevalier de Bonnard advised the painters of the day to "court all lovely ladies you paint

and be sure that you are paid for your portraits in the arms of your sitters". Nothing is really known about Fragonard's love life. However, he was so highly acclaimed as a painter that he was soon provided with his own studio in the Louvre. Begrudging him his marriage because it deprived them of gossip, his biographers characterised his wife as "a peevish termagant". However, he was devoted to her, tenderly calling her "the best of all wives". Despite his reputation with the ladies, the Frenchman did show reticence in one respect: he convinced the depraved Baron Saint-Julien that it was necessary to replace the bishop, who was originally supposed to push the swing in the painting, with a courtier.

JEAN-HONORÉ FRAGONARD
(French, 1732–1806)
The Swing

c. 1767
Oil on canvas
81 × 65 cm
The Wallace Collection, London

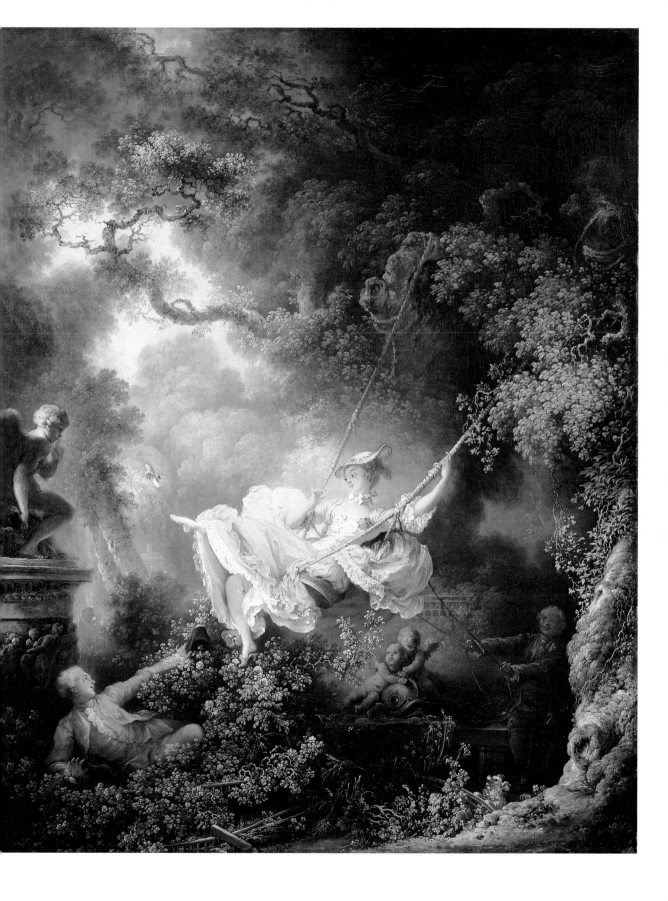

A Question of Class

English society in the eighteenth century

A Youth to Fortune

 and to Fame unknown ...

Thomas Gray, *Elegy Written in a Country Church-Yard*, 1751

Thomas Gainsborough, *Self-Portrait*, 1750/55

Who was the young man who sat for Thomas Gainsborough's *The Blue Boy*? His identity was unknown for nearly two centuries. Recent research suggests that he was Jonathan Buttall, the teenage son of a rich London ironmonger. Gainsborough is thought to have made the family's acquaintance in Bath. The city in

Few of his contemporaries were as privileged as Jonathan Buttall: children working down a coal mine in England, 1844

south-west England was renowned throughout the eighteenth and early nineteenth centuries as a fashionable spa where affluent English families went to drink the healing waters of its springs.

The ultimate in elegant watering-places, Bath was even frequented by members of the royal family when they felt jaded. Visitors to the baths were subjected to a severe regimen. Forced to get up at six in the morning, women spent an hour in the warm water of the baths dressed in long garments made of heavy material that could not cling to their bodies and reveal their contours. Men, too, bathed fully dressed. Outside the baths, the city was the place for flirtations, balls and evening card parties. There were many official functions like the Assembly-Rooms Balls and places both indoors and out where people promenaded for the purpose of meeting and keeping up with the latest goings-on. Gambling was rife and the city boasted the dubious attractions of a bevy of *demi-mondaines* to charm away the boredom of gentlemen who were not in Bath with their families. Women had to content themselves with gossip over the tea table.

The city seethed with intrigue, which is why Horace Walpole remarked it was ten times better to leave the city than to enter it. The rich visitors tended to be vain and ostentatious. This was probably the reason why the

young Thomas Gainsborough left Ipswich in the east of England to settle in Bath in 1759. The move paid off. Showered with portrait commissions from wealthy patrons, the painter was soon able to afford luxurious apartments in the beautiful and elegant Royal Circus.

However, the resort was not merely the haunt of the aristocracy. It was just as popular with rich tradesmen's and manufacturers' families. From 1750 English iron foundries and cotton mills had been flourishing and their owners could well afford to take the waters at Bath. One can imagine Gainsborough meeting Mr Buttall, the ironmonger, and his family at the Pump Room. Gainsborough had begun his career by copying and restoring Flemish paintings. It is therefore not surprising that he borrowed stylistic elements from the works of Anthony van Dyck to paint Jonathan Buttall, who is dressed in the fashion of the seventeenth century.

THOMAS GAINSBOROUGH
(English, 1727–1788)
The Blue Boy

c. 1770
Oil on canvas
177.8 × 121.98 cm
Henry E. Huntington Library and Art Gallery,
San Marino, CA

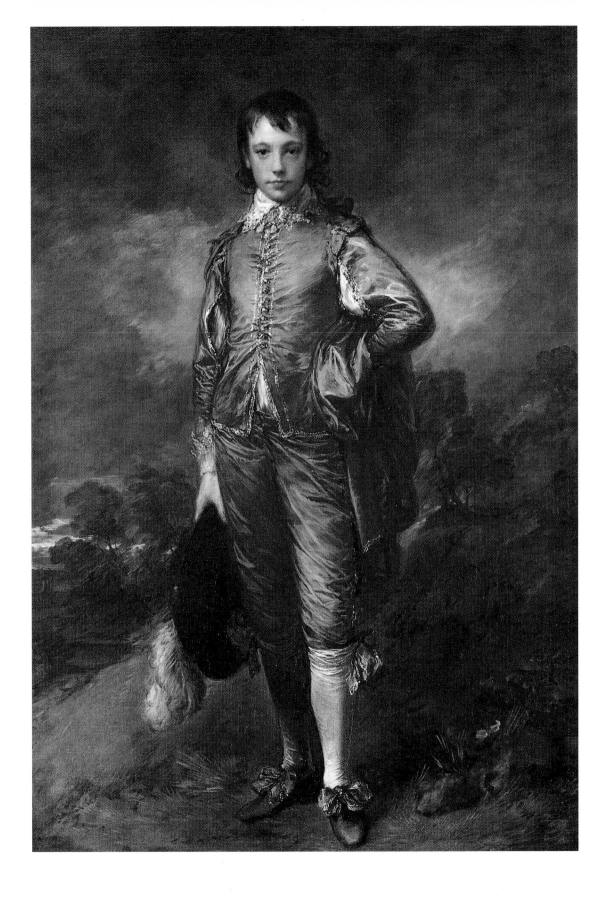

Like a Cow on a Winding Stair
A history of skating

The earliest skates were made from split and polished bones of elk, oxen and reindeer. Skaters who rubbed them with lard and poled

Out on the ice Death is waiting: *Dance macabre* by Salomon van Rusting, 1707 (above)

Lidwina von Schiedam, who took a fall on the ice in 1395, breaking one rib, was later canonised and made patron saint of sufferers; woodcut from Brugman's *Vita Lydvinae*, 1498 (top picture)

themselves along the ice could attain considerable speeds on frozen European lakes and rivers as early as 1000 BC. In winter skates may have replaced coracles and other boats in Scandinavia and Central European Neolithic pile-dwelling settlements as a convenient means of transportation. A twelfth-century chronicler described skating on the Thames in winter, relating that it kept the Thames open as an artery of travel and transport and was fun for young people, who flew like birds or the bolt of a crossbow. However, chroniclers have other tales to tell of medieval skaters who were not so breezy on the blades.

In the *Heimskringla* ("Orb of the World"), a collection of Norwegian sagas from the thirteenth century, a king's brother mocks an unknown skater: "I could skate so well that no one wanted to challenge me but you danced about on the ice like a cow on a winding stair". In 1395 Lidwina von Schiedam, who would later be canonised and venerated as a mystic and patron saint of sufferers, took a fall while skating, breaking one rib. The reason why she did not become the patron saint of skaters is that the post was already occupied. A century before she was born, Saints Crispin and Crispinian, patron saints of shoemakers, were already watching over skaters. They must have had their hands full.

A national pastime in Holland by the seventeenth century, skating was gaining popularity in England, too. The English aristocracy could be seen gliding over the canals in powdered wigs, dressed in stiff brocade after they had laboriously perfected figures

that demonstrated courtly manners and the lofty status they enjoyed. In 1742 the Edinburgh Skating Club was founded as the world's first official skating association. To be eligible for membership, aspirants to the Skating Club had to demonstrate their ability to leap on skates over three hats and execute a circle while skating on one foot. One wonders whether the Scottish painter Henry Raeburn, who must have been a member himself, has captured a test of admission to the Club in *Rev. Robert Walker Skating on Duddingston Loch*. The scene is enlivened by a fine portrait of the newly appointed Kirk of Scotland minister of Canongate Church. The portrait confirms what the Viennese writer of comedies Perinet had had to say about skating a few years before this work was painted: "The winter pastime of black-guards in the streets has actually become a slippery study of elderly cox-combs trying to cut a fine blade!"

HENRY RAEBURN
(Scottish, 1756–1823)
Rev. Robert Walker Skating on Duddingston Loch

1784
Oil on canvas
76.2 × 63.5 cm
National Gallery of Scotland, Edinburgh

A Tea Party that Led to Democracy
The American Declaration of Independence

American Revolutionaries taking revenge on a British customs official; American caricature, late 18th century

We hold these truths to be self-evident: That all men are created equal; that they are endowed by their Creator with certain unalienable Rights; that among these are Life, Liberty and the pursuit of Happiness … ; that whenever any Form of Government becomes destructive of these ends, it is the Right of the People to alter or to abolish it, and to institute a new Government, laying its foundation on such principles, and organizing its powers in such form, as to them shall seem most likely to effect their Safety and Happiness.

United States Declaration of Independence, 4 July 1776

The Boston Tea Party triggered the Revolution. In 1767 England had imposed new customs duties on her English colonies. The wrath of the colonists culminated in a boycott of English wares, which soon led to the abolition of most duties. England, insisting on a demonstration of authority, maintained the duty on tea. Ensuring the East India Company monopoly on tea and other staples, this policy left American tea merchants burdened with high duties on the goods they imported from England.

The American colonists, who had for some time considered declaring independence from England, took the duty on tea as a welcome excuse to do so. On 16 December 1773 open hostilities broke out. A group of Revolutionaries threw an entire ship's cargo of tea into the murky waters of Boston Harbor: 342 crates of tea worth 10,000 pounds sterling. Over 2,000 bystanders applauded the patriots' deed: "This is the most magnificent Movement of all. There is a dignity, a Majesty, a Sublimity, in this last Effort of the Patriots that I greatly admire. This destruction of the Tea is so bold, so daring, so firm, intrepid and inflexible, and it must have so important Consequences, and so lasting, that I cannot but consider it as an Epoch in History" was John Adams's enthusiastic

response to this remarkable demonstration of colonial assertiveness. The English government retaliated swiftly, exacting harsh penalties. The thirteen American colonies reacted with open revolt. Weary of oppression and long accustomed to self-government on parliamentary lines, the American settlers refused to surrender their economic and political freedom to the English crown, which was thousands of nautical miles away. Knit together by the events in Boston, the Americans took their first united action as a free people by convening the First Continental Congress in Philadelphia in 1774. England remained intransigent; a war was inevitable.

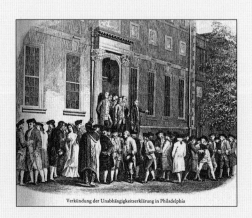

Verkündung der Unabhängigkeitserklärung in Philadelphia

While George Washington, the Commander-in-Chief of the American Continental Army, was marching his troops from one battle to the next, the Declaration of Independence was being drawn up. It was signed on 4 July 1776 in the Philadelphia State House. Among the signers were Thomas Jefferson, its author, and Benjamin Franklin. Jefferson is quoted as saying: "I am not a friend to a very energetic government", although he wholeheartedly espoused the cause of American liberty. Another fervent patriot was the painter John Trumbull, who later founded the American Academy of Fine Arts in New York and became its first president. The son of an English governor of Connecticut who supported the colonists' struggle for independence, John Trumbull served as an *aide-de-camp* to George Washington during the American Revolution. His most celebrated painting, which has become a symbol of the idealism that America stands for, depicts the signing of the Declaration of Independence as Thomas Jefferson described it to the artist.

The proclamation in Philadelphia, 1776

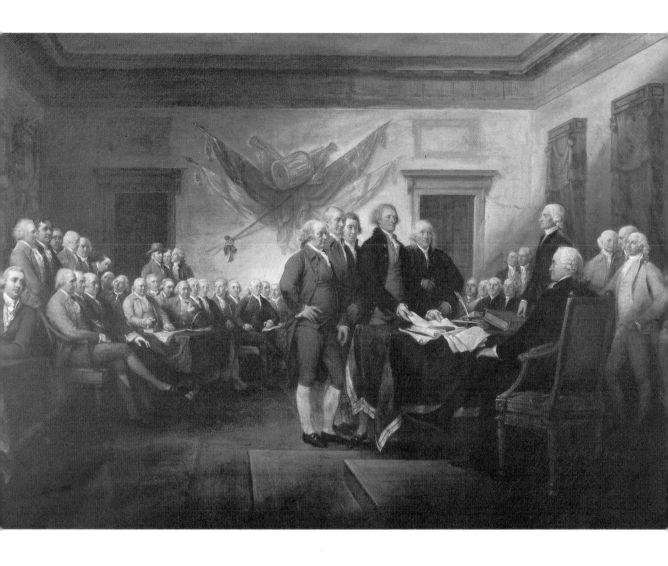

JOHN TRUMBULL
(American, 1756–1843)
The Declaration of Independence

1786–97
Oil on canvas
53.7 × 79.1 cm
Yale University Art Gallery, New Haven, CT

I Believe in Marat, the Almighty
The French Revolution, 1789

I believe in Marat, the almighty, the Creator of freedom and equality, our hope, who strikes terror into the aristocracy, who has gone forth from the heart of the nation and is revealed in the Revolution, who was murdered by the enemies of the Republic, who poured forth upon us the breath of freedom, who has descended into the Elysian Fields, whence he will one day return to judge and condemn the aristocracy.

A contemporaneous anonymous "Creed"
(July 1793 – February 1795)

Jean-Paul Marat was sitting in the bathtub when his last hour struck on 13 July 1793. A teacher of languages, a journalist and a physician, Marat had turned out to be one of the most radical demagogues the 1789 Revolution produced. He spent much time in the tub to find relief from a chronic, itchy rash. He wore compresses on his forehead to relieve headaches from which he also suffered. While he was bathing on that fateful day, he was reading a letter from Charlotte Corday, the great-granddaughter of the playwright Pierre Corneille. The young noblewoman had tried in vain to gain admittance to Marat. Now she had sent him a letter in which she slyly suggested a *tête-à-tête*. He let her in and she stabbed him. Marat died instantly.

Some contemporaries must have been pleased at the deed. Marat had been a tough customer. He had had 860 gallows erected to deal with his political enemies and had sent over 200,000 of them to the guillotine. His opponents may have considered his death a just revenge. His adherents, however, celebrated him as the martyr of a just cause. Appointed master of ceremonies at the hero's funeral, painter Jacques-Louis David was a fervent revolutionary and a personal friend of Marat. He obliged by putting Marat's corpse on canvas just as he had had it put on display: with his bare chest and wounds visible. On 15 October 1793 David presented the picture to the National Assembly. It became the symbol of the French Revolution. Copies of it were placed on church altars, smothered under billowing clouds of incense. Even in public offices copies of the painting were supposed to replace Crucifixes and royal portraits. However, before it could get out of hand, the personality cult was stopped by Robespierre's fall and the arrest of Jacques-Louis David. On 10 February the painting was removed from the chamber of the National

Assembly. Marat's heart, which had been kept in the Cordeliers Club, was burnt and the ashes scattered in the Montmartre sewer.

The guillotine, the instrument of choice for beheadings during the French Revolution, was still being used for executions this century

Down with the Bastille! The destruction of the court prison, a symbol of Bourbon despotism, by Pierre-Antoine Demachy (1723–1807)

JACQUES-LOUIS DAVID
(French, 1748–1825)
The Death of Marat

1793
Signed and dated "L'An deux"
Oil on canvas
165 × 128 cm
Musées Royaux des Beaux-Arts, Brussels

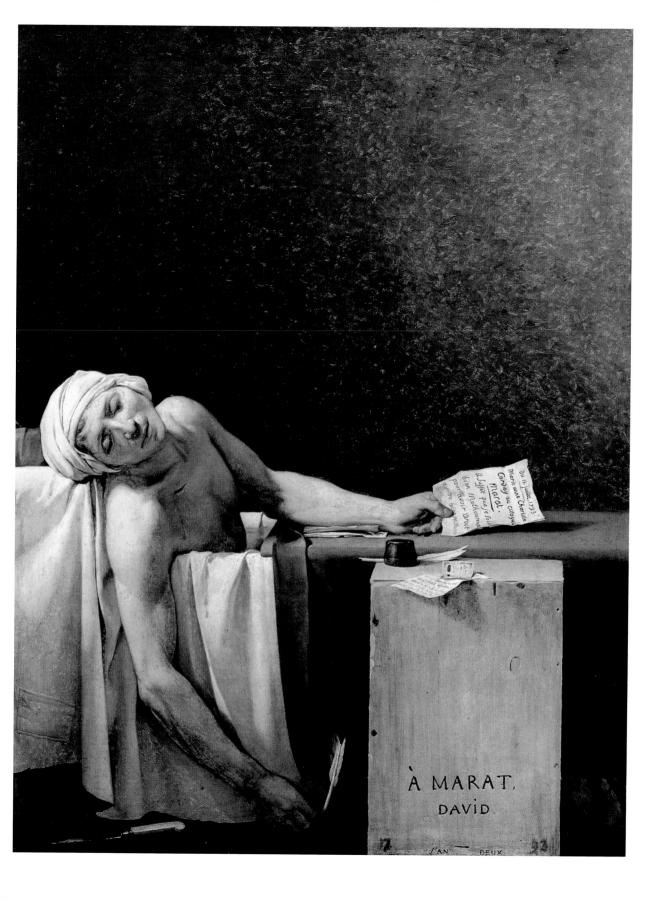

As if Carried off by the Winds
The Rise to Power of the Corsican Devil

Soldiers, you are naked and ill nourished. I shall lead you to earth's most fertile plains. Rich provinces and great cities will fall into your hands. There you shall find honour, fame and wealth.

Napoleon Bonaparte, *Speech to His Soldiers on Being Appointed General of the Republican Armies in Italy*, 1796

His French spelling was shaky indeed and his strong Corsican accent marked him as provincial. Because he pronounced his first name "Napolion", his classmates at school dubbed him "la-paille-au-nez", "straw nose". He was an average student; his German teacher even regarded him as stupid. Yet he was a voracious reader, and the books he devoured did not make easy reading: Corneille, Montaigne, Montesquieu, Plutarch and Tacitus. Moreover, he had an astonishing memory and

A STOPPAGE to a STRIDE over the GLOBE

Old England – an obstacle on Napoleon's march round the globe, late 18th century

never forgot anything. A single teacher, who must have been more percipient than the rest, saw in him "granite which a volcano is heating up". Things were still simmering on the back burner then. Born on 15 August 1769 in Ajaccio on Corsica, Napoleon Bonaparte was regarded as a taciturn, gloomy and sensitive boy. Accepted as a cadet at the Paris military academy in 1784, he was commissioned lieutenant only a year and a half later. Transferred to an artillery regiment, he flirted with the idea of revolution.

At first a fervent Corsican nationalist, he took part in a revolt against the French authorities. However in 1793, he broke with the Corsican nationalist faction and was forced to flee with his family to the French mainland. Rejoining the army, he sided with Robespierre, becoming commander of an artillery battalion. Now that his career was well launched, a short sojourn in prison after Robespierre's fall did nothing to hinder it. At the age of twenty-six Bonaparte was appointed General of the Republican Armies in Italy, and was widely admired for his brilliant tactical skills, his schooled intellect and the leadership qualities he consistently displayed. Veteran field commanders were furious. A greenhorn had been promoted over their heads, a young man of small stature with long unkempt hair. Bonaparte, however, knew where he was heading. In the campaign against Austria, he won victory after victory in northern Italy. He grew famous as a "second Alexander" who "strode like a demigod from battle to battle and victory to victory".

The painter Antoine-Jean Gros captured a scene from that period: the Battle of Arcola, a village twenty-four kilometres south-east of Verona. Between 15 and 17 November 1796, Bonaparte defeated reinforcements dispatched to the aid of the Austrian troops encircled at Mantua. France celebrated him as "Fortune's favourite in battle". The poet Friedrich Hölderlin was jubilant: "Holy vessels are poets in whom the wine of life, the spirit of heroes is held. But the spirit of that youth, that quick spirit, must it not burst the vessel that was to contain it?"

Napoleon kept cool, calm and collected. When an envoy sent by the Directoire, which was then the French government, sought him out after the victory at Arcole, he pronounced prophetically: "What I have accomplished here is a mere trifle. I am only at the beginning of my career. Do you think that I am winning laurels for my lance in Italy simply for the aggrandisement of the Directoire?" In his own words, he felt "as if he had been carried off by the winds".

ANTOINE-JEAN GROS
(French, 1771–1835)
Napoleon Bonaparte at the Bridge of Arcole, 17 November 1796

1801
Oil on canvas
74.9 × 58.4 cm
Musée du Louvre, Paris

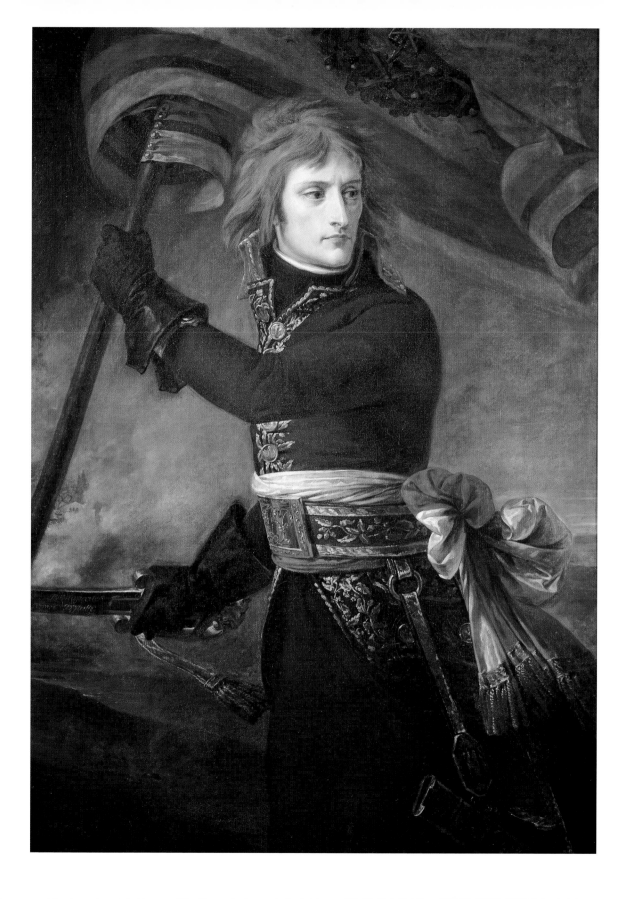

A Reflection of Horror
The Spanish Revolt against Napoleon

**No one is innocent once he has seen
what I have seen. I witnessed how
the noblest ideals of freedom and progress
were transformed into lances, sabres
and bayonets. Arson, looting and rape,
all supposed to bring a New Order,
in reality only exchanged the garrotte
for the gallows.**

Francisco de Goya, from an entry in his diary, 1808

Napoleon was furious. The "damned Spanish affair" was out of control. Early on, the power-mad Emperor of France had thought it would be a pushover. Charles IV of Spain, a weakling at best, had retreated into the background, leaving the government in the hands of his wife María Luisa and her lover Manuel Godoy. Napoleon could have won over the ambitious Godoy by making him viceroy of Spain. However, his links with Napoleon, which led to a disastrous war with Great Britain, made Godoy unpopular throughout Spain. He only barely escaped being lynched by fleeing to France.

Napoleon, cunning as he was, had always treated Spain, an ally of France, like a subject nation. He refused to admit defeat at the hands of a nation occupied by his troops. Pretending to seek reconciliation, he summoned the Spanish king and queen, with the crown prince in tow, to France. Napoleon's real intention was to keep the Spanish royals captive and put his eldest brother, Joseph Bonaparte, on the Iberian throne. When Napoleon's treachery became known, a desperate revolt broke out in Spain on 2 May 1808. Hopelessly outnumbered, a band of people armed with knives and lances attacked a powerful French cavalry force in the Puerta del Sol, a square in the heart of Madrid. Begun in blind, impotent anger, the revolt was doomed from the outset to failure. Still it signalled to the world that a conquered people had dared to stand up to Napoleon, who was then at the zenith of his power. The French Emperor exacted a terrible revenge. That same night, everyone suspected of having taken part in the rebellion executed by a French firing squad.

No one has come closer to showing the naked brutality of those events than Francisco de Goya, Court Painter to Charles IV, who had originally welcomed Napoleon's ideals. Imbued with the spirit of the French Revolution, he had not hesitated to show the Spanish royal family for what it was, painting them in a highly unflattering light. However, Napoleon turned out to be the opposite of what he had seemed to be. Although he had originally proclaimed freedom for his own and other peoples of Europe, he revealed himself as a despot. Perhaps his values had become corrupted and twisted. In any case, Goya depicted the scene with a twist: his hero is the victim who will be the next to be shot. The man in the white shirt spreads out his arms like Christ on the Cross. The wounds on his hands are like Christ's. His message is: I die that you may live. It was to take five years to drive the French out of Spain.

Barbarians! No. 38 from Goya's series of etchings, entitled *Los desastres de la guerra, c.* 1812–15

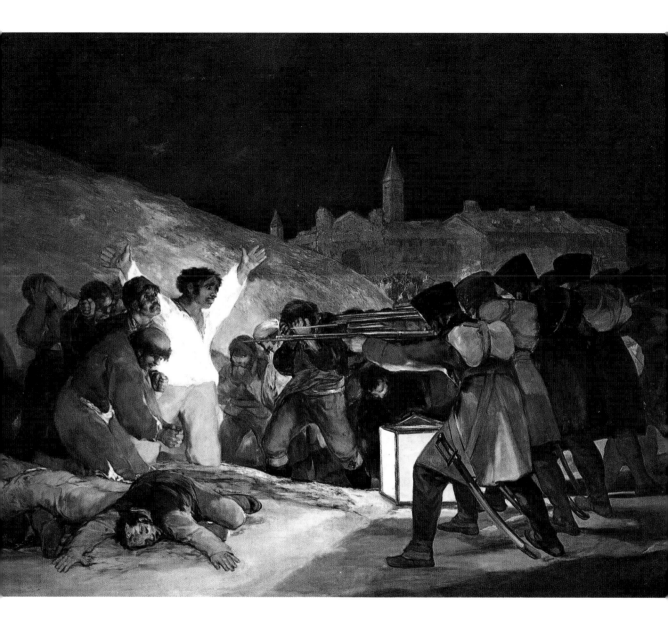

FRANCISCO DE GOYA
(Spanish, 1746–1828)
The Third of May 1808

1814
Oil on canvas
268 × 347 cm
Museo del Prado, Madrid

The Force of Nature and the Power in a Painting
On the hubris of humankind

Crushed by the weight: the wreck of the explorers' ship;
detail of Caspar David Friedrich's *The Polar Sea*

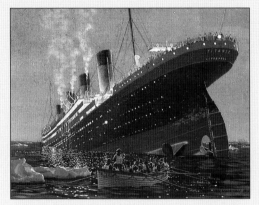

Monday, 15 April 1912, 2 a.m.: The stern of the sinking
Titanic thrusts out of the water, revealing the huge propellers

The news hit the world like a blow: "Titanic sinks four hours after collision with iceberg; 1,250 presumed dead." Thus read the *New York Times* headline of 16 April 1912. Only twenty-four hours before, an unprecedented tragedy had been enacted 400 nautical miles off Newfoundland in the Atlantic. More than half the ship's passengers had died.

Not only had a stunningly elegant ship gone down; with her sank the myth of modern times. Industrial man had believed it could dupe nature with technology: the glittering new Titanic, on her maiden voyage from Southampton to New York, was regarded as a marvel of engineering and as "unsinkable". Yet she fell victim to the vagaries of nature like so many expeditionary vessels that had sailed into perilous waters a century before.

In Caspar David Friedrich's *The Polar Sea*, the capsized ship caught in the ice may be the "Griper", which took part in expeditions to the North Pole that made the headlines in 1819–20 and 1824. British Polar explorer Sir William Edward Parry had become embroiled in a very dangerous situation whilst seeking the Northwest Passage. Caspar David Friedrich may well have been inspired by newspaper reports about Parry as well as by heavy ice floes on the Elbe in the winter of 1820–21.

The painting has occasionally been interpreted as having a religious meaning: the intransience of human life before divine eternity. There are also political interpretations: resignation in the face of the fruitless German wars of independence. And yet *The Polar Sea* remains in the first instance a symbol of the terrors of the icy wastes of the Polar regions – and of human presumption, which no longer stands in awe of nature.

CASPAR DAVID FRIEDRICH
(German, 1774–1840)
The Polar Sea

c. 1823/24
Oil on canvas
96.7 × 126.9 cm
Kunsthalle, Hamburg

Also known by the following titles:
Ideal Scene of an Arctic Sea, a Ship Foundered amongst Towering Ice Floes
(Cat. Prague 1824, where the painting was first exhibited)
The Failed North Pole Expedition (so named in Friedrich's estate)
Failed Hope ("Hope" was a popular ship's name)

One of the Wonders of the World
The mystery of Stonehenge

Constable Painting, by
Daniel Maclise, 1831

The band of silver paleness along the east horizon made even
the distant parts of the Great Plain appear dark and near;
and the whole enormous landscape bore that impress of reserve,
taciturnity, and hesitation which is usual just before day. The east-
ward pillars and their architraves stood up blackly against the light,
and the great flame-shaped Sun-stone beyond them; and the Stone
of Sacrifice midway. Presently the night wind died out, and the
quivering little pools in the cup-like hollows of the stones lay still.

Thomas Hardy, *The Wessex Novels*, vol. I, *Tess of the D'Urbervilles* (1891), 5th ed. 1896

Megaliths thousands of years old rise up against the southern English sky near Amesbury in Wiltshire. Who erected them? Did human sacrifice take place here? Was the legendary sorcerer Merlin at work here? The dressed sandstone megaliths erected to form a lintelled stone circle are approximately six metres high, some of them weighing up to forty-five tonnes. Standing on wind-swept Salisbury Plain, this mysterious monument to a world long forgotten was first called a "wonder of Britain" in the twelfth century. Since then, not a century has passed without fresh conjectures on what might have led to the building of this unique henge monument.

The Romantics were expounding lofty theories about Stonehenge when the great English landscape painter John Constable painted his famous watercolour of it based on the numerous preliminary sketches he had made on a visit in 1820. Even today the meaning of the circle of thirty uprights, some of which are still capped by massive lintels, surrounding a horseshoe arrangement of five trilithons (two upright stones connected by a lintel), is as much a mystery as ever. Archaeologists tend to believe that religious motives led to the erection of

Stonehenge. In the cold grey light of dawn, the site with its towering megaliths is a menacing, almost apocalyptic place. With the sun's first rays, the uprights cast shadows forming eerie linear patterns on the ground. One legend has it that the power of the Druids was concentrated where the shadows converge.

Within the stone circle: Pagan Druid rites reenacted

Thought to have been Celtic priests, Druids were intermediaries between the gods and humankind, soothsayers, healers and judges, and, as tutors to the sons of the aristocracy, were allegedly the real rulers of the ancient Britons. Unfortunately, however, Latin accounts of the Druids fail to shed much light

on these structures. Opponents of the theory that the Druids officiated at Stonehenge point out that the Wiltshire stone circle had already been standing for over 2,000 years before the heyday of the Celts and the Druids (100 BC – AD 78). Besides, the latter are not known to have built temples. Instead, they held their ceremonies in glades. Knowledge of the stars may have been passed down by oral tradition to the Druids, who were wiped out by the Romans on Anglesey in the year 78.

One thing is certain: the people who built Stonehenge demonstrated a knowledge of astronomy. The original approach to the site is marked by a stone over which, when viewed from the centre of the circle, the sun rises on the Summer Solstice.

The stone circle is ringed by fifty-six pits. Radiocarbon dating of one of these as well as pottery finds indicate that the earliest structure on the site dates back to late Neolithic times (roughly 2,300 BC). Whatever Stonehenge may have been, the site was more or less in continual use for thousands of years. Speculation on this most enthralling puzzle of all ancient monuments continues to abound today.

JOHN CONSTABLE
(English, 1776–1837)
Stonehenge

1836
Watercolour
38.7 × 59.1 cm
Victoria & Albert Museum, London

With Brush and Palette on the Barricades
The Revolution of 1830

Ah that great week in Paris! The courage for freedom that wafted through here has, of course, overturned the night-lights so that the red curtains on some thrones have caught fire and the gold crowns have grown hot under the glow of the night-caps. But the old catch poles are already bringing up the dowsing buckets and sniffing about all the more vigilantly.

Heinrich Heine, *English Fragments*, November 1830

Victor Hugo stayed at home. Busy researching for his novel, *The Hunchback of Notre Dame*, he did not wish to leave his wife alone, who had given birth to a daughter just four days before. The young Alexandre Dumas, on the other hand – later to achieve world renown for his swashbuckling *The Count of Monte Cristo* – bravely shouldered a double-barrelled musket, ready to risk his life for freedom with thousands of students, merchants, workers and actors.

Paris was once again on the brink of a revolution. The streets were full of agitated citizens confronting the royal guards with pistols and wooden cudgels, rifles and knives. The cause of the uproar was the citizens' fear that the old system of royal oppression, which had been abolished, was on the rise again. As early as 1814 the royal house of Bourbon had regained its former power. Louis XVIII, younger brother to Louis XVI, who had been executed during the Revolution, had been summoned from exile to rule France after the fall of Napoleon. Moderate and cautious, he had pursued liberal policies, combining the modern feeling for liberty with the principles of the *ancien régime*. When Louis XVIII died in 1824, Charles X, the youngest of the three brothers, had himself crowned at Reims with medieval pomp and circumstance. Forward-looking contemporaries found him both reactionary and foolish. Desirous of reviving pre-Revolutionary France, he intended to restore the ancient titles and privileges to the aristocracy as well as one billion francs in reparations for the property lost by the nobility during the Revolution. After Charles X issued a series of repressive decrees on 25 July 1830, abolishing freedom of the press, dissolving the legislature and depriving the majority of citizens of suffrage, things came to a head. On 28 July 1830 revolt broke out not far from Eugène Delacroix's studio. While mercenaries deployed by Charles X fought their way through the narrow streets, supporters of the revolutionaries hurled furniture, wash-tubs, roofing tiles and tool chests down on them from windows, finally dumping entire cartloads of melons on the heads of the advancing royal troops to stop their progress. The street battles raged for three days. Painter and caricaturist Honoré Daumier suffered a sabre-slash across his face during the fighting.

On 3 August 1830 the citizens were victorious, forcing Charles X to abdicate and flee into exile. Delacroix, who had observed the revolt at a safe distance, took up his brushes and palette. In a letter to his brother written in October 1830, he confessed: "Although I didn't fight, I'll at least paint for our country!" And the result was *Liberty Leading the People*, the archetype of the Revolution.

Revolution and violence on the streets of Paris in 1968

EUGÈNE DELACROIX
(French, 1798–1863)
Liberty Leading the People

1830
Oil on canvas
260 × 325 cm
Musée du Louvre, Paris

The Old World Towed by the New
The beginnings of the modern age

The devilish little steamship puffed out an odious and ghost-like stream of smoke, glowing red and ominous, while behind it the brave old ship followed at a slow pace, sad and majestic, marked by the sign of Death.

Adapted from William Makepeace Thackeray, after 1839

She had served her country well and now her day was past, and England mourned. The fighting "Temeraire", as John Ruskin and other Englishman had called her, was the symbol of heroism at sea. When the British and French fleets clashed at Trafalgar on 21 October 1805, the Temeraire was the second ship of the English line. Although Admiral Nelson, the commander of the British fleet, died of a gunshot wound on the deck of her sister ship, the "Victory", he had carried the day. Outnumbered by six ships, his fleet of twenty-seven had trounced the French. The Temeraire played an important part in the victory at Trafalgar, which was to assure British supremacy at sea for another century. She had decoyed French fire, which was aimed at Nelson and the flagship, away from the Victory and had captured a prize. At the end of the battle, as a contemporary records, she was almost hidden between two French ships secured to her mainmast and her anchor.

Some thirty years later, J.M.W. Turner was deeply moved watching the gallant old ship being towed from Sheerness to the breaker's yard at Deptford. However, the brilliant painter of atmospheric effects and moods was not just thinking of farewells. He was also looking forward to new beginnings. In 1765, ten years before Turner was born, James Watt had triggered the Industrial Revolution in England by inventing the steam engine. Turner was fascinated by the marvels of technology that were emerging all around him. He was among the first to paint pictures, dramatically experimental ones, of modern means of transportation, such as trains and steamships. Both the magnificence and the threatening aspect of such inventions are revealed in his paintings of them. An observer might find symbolism in the Temeraire's last voyage: the tugboat towing her under steam representing the New Order and all its ambivalence, the sailing vessel the Old – already transfigured in memory.

A forerunner to the inventions of James Watt: A steam-driven machine for pumping water out of mines and for operating fountains; copper-plate engraving by H. Beighton, 1717

JOSEPH MALLORD WILLIAM TURNER
(English, 1775–1851)
The Fighting Temeraire Tugged to Her Last Berth to Be Broken Up

1838
Oil on canvas
91 × 122 cm
The National Gallery, London

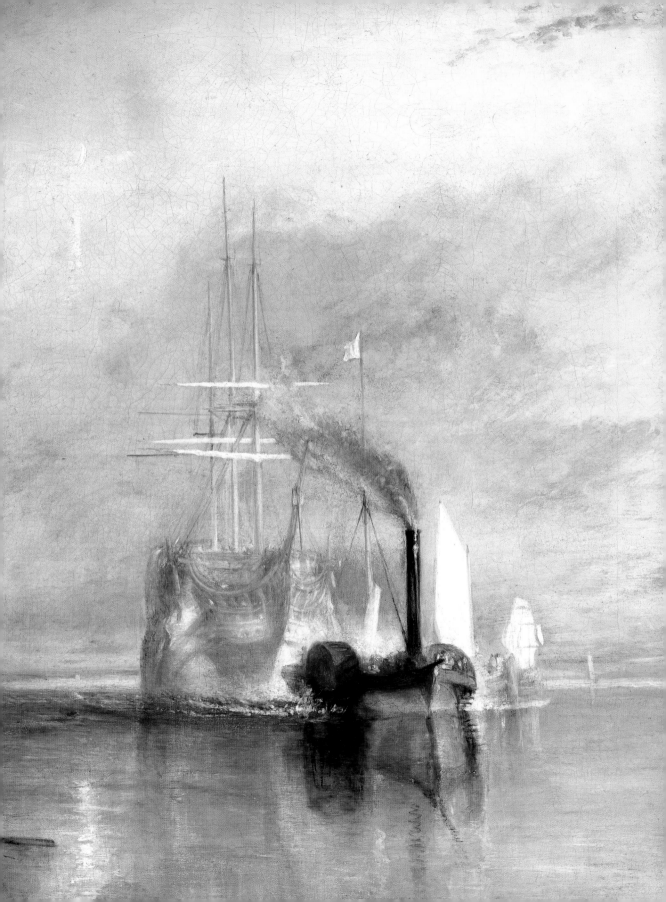

Stark Naked
The women's baths

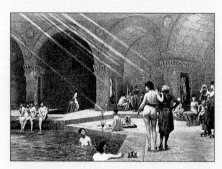

The harem's terrace, hidden from sight; photographic engraving by Jean-Léon Gérôme, 1886

I believe, in the whole, there were two hundred women …. The first sofas were covered with cushions and rich carpets, on which sat the ladies; and on the second, their slaves behind them,…. all being in the state of nature, that is, in plain English, stark naked …. There were many amongst them as exactly proportioned as ever any goddess was drawn by the pencil of … Titian,… I was charmed by their civility and beauty…. 'Tis no less than death for a man to be found in one of these places.

Lady Mary Wortley Montagu, Letter to Elizabeth Rich on her experiences in the women's baths at Sophia, dated 1 April 1717

Although the Minoans and later the ancient Greeks had bathtubs, it was the Romans who made bathing popular. The epitome of Roman civilisation, Roman thermæ, or baths, were luxurious and spacious. Pools, walls and even floors were heated. Splendid examples of urban architecture, thermæ were places where men bathed, had manicures and pedicures, took steam baths and did gymnastic exercises. They were a focal point of social and political activity. Romans are known to have made momentous decisions whilst steaming in the baths or strolling about in sandals and towels.

With the fall of the Roman empire, this glorious bath culture disappeared from the European scene. What later replaced it was certainly on a much more modest scale. Medieval Nuremberg, for instance, boasted a total of thirteen public "bathing rooms" in which huge wooden tubs were filled with hot water. There were also sometimes steam baths and resting rooms heated by tiled stoves. Such baths were not just venues for promoting body culture; they were also used as surgeries: teeth were pulled, blood was let, cupping-glasses were applied to the backs and chests of those with colds and minor operations were performed. Bathing rooms were frowned on by the Church owing to the voluptuous pleasures enjoyed in them. "Bath attendants" were licentious women who are said to have been

the reason why King Wenceslas IV of Bohemia visited the bathing establishments of Prague, his capital, more frequently than was good for his sensitive skin. In the Near East, on the other hand, the ancient bath culture survived

Wallowing in Classical life:
The Caracalla baths; painting in oil by Sir Lawrence Alma-Tadema, 1899

because going to a *hammam* (bath) is pre-scribed by Islam. Inspired by Lady Mary Wortley Montagu's account of her travels in the region, the French painter Jean-Auguste-Dominique Ingres painted the women's section of a Turkish bathhouse. The celebrated master

was eighty-three years old when he added the crowning touch to his œuvre by depicting a Turkish bath scene. Ingres made hundreds of preliminary sketches for the painting before presenting it to Prince Charles-Louis-Napoleon in December 1859. Only a few weeks later, however, the painting was returned to Ingres, allegedly because the prince's wife, Eugénie de Montijo, was scandalised by the naked ladies depicted so sensuously in this remarkable work. When *Turkish Bath* was exhibited in a second, essentially unchanged version, the nudes were what brought the painting widespread public acclaim. Critics praised it as a "tryst with Oriental coquetry" or, rather crudely, as a "feast of carnal delights" and a "still life of sensual pleasures". It certainly had an impact on Picasso and other artists, who admired it both for its composition and formal idiom. After this masterpiece, Ingres was no longer thought of as a "bloodless exponent of Neoclassicism". From now on he was a groundbreaking "revolutionary".

JEAN-AUGUSTE-DOMINIQUE INGRES
(French, 1780–1867)
Turkish Bath

1863
Oil on canvas
Diameter: 108 cm
Musée du Louvre, Paris

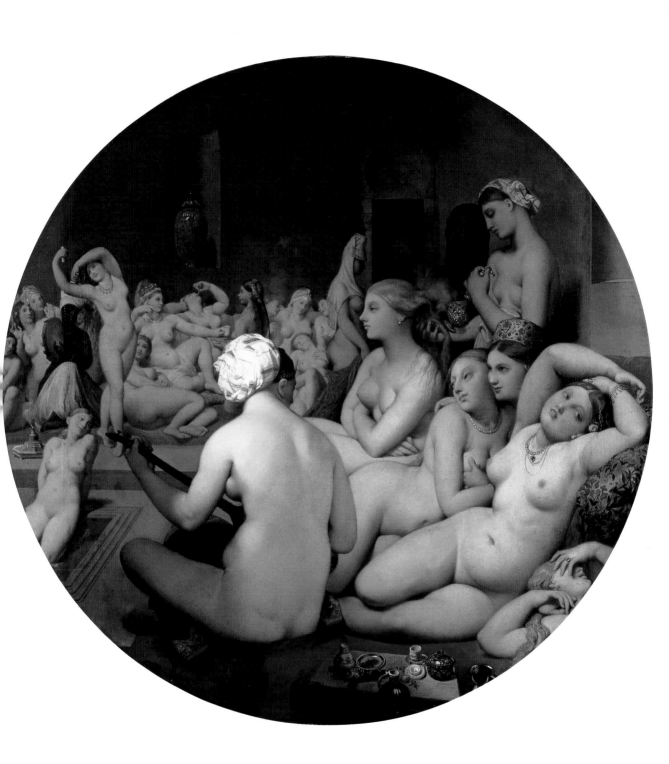

Eros Awakes to a Storm of Indignation
Paris and the "Salon des Refusés"

When one considers the shameless indecency with which he foists his *Déjeuner sur l'herbe* on respectable visitors, all that is left to say is: as a painter, Edouard Manet possesses all the qualities necessary to be rejected unanimously by all the juries on earth.

Anonymous letter to the *Gazette de France*, 1863

Emperor Napoleon III derived pleasure in being benevolent. Under his patronage, the "Salon des Refusés" was held in 1863, an exhibition of paintings that had not been considered good enough for the official Paris Salon. Nevertheless, when the Emperor entered the room, he went into a rage. Who could have painted such a monstrous thing?

Barely objectionable in this day and age: Nude sunbathing in Munich's English Garden

When he found out that the painter of the work thus stigmatised was Edouard Manet, he was not only furious, but appalled. The thirty-two-year-old painter Manet came from a hitherto respectable bourgeois family: His father was a high-ranking official in the Ministry of Justice and his mother came from a long line of diplomats. Edouard was the Prodigal Son. Although his family wanted him to study law, he failed the entrance examination. He was then sent to sea as a cadet on the "Havre et Guadeloupe" line. Life at sea did not agree with him and he was incapable of tying nautical knots. Yet he did learn some things that might prove useful to him as a painter, which was what he now intended to become. Despite his father's opposition to his plans, the family finally acquiesced.

The cause of the scandal was that the naked figure at her ease enjoying breakfast outdoors was the naturalistic figure of what could be a real woman, not an allegorical personification of "Sin" or "Lust" and certainly not recognisably mythological. The woman represented was obviously modern. She was in the company of men who were dressed in the fashion of the latter half of the nineteenth century. In fact, this was a group portrait of identifiable public figures.

Criticism of the picture was devastating. Public condemnation ranged from biting irony to malicious chuckles at the artist's expense. Only the writer Emile Zola and several other open-minded friends of the arts stood up for Manet, even daring to call him "one of the leading personalities of the age" and a "courageous man" who had lent the exhibition "brilliance, intellectual élan, wit and the appeal of the unexpectedly novel". Today one might be inclined to think that the vehement reaction to the painting stemmed from the public's annoyance at having been caught out in collective forbidden fantasies by a sharp-witted voyeur.

EDOUARD MANET
(French, 1832–1883)
Le Déjeuner sur l'herbe

1863
Oil on canvas
214 × 279 cm
Musée d'Orsay, Paris

A Look that Kills
Antiquity and the Industrial Age

**But Perseus, with the snake-haired monster's head,
That famous spoil, in triumph made his way
On rustling pinions through the balmy air
And, as he hovered over Libya's sands,
The blood-drops from the Gorgon's head dripped down.
The spattered desert gave them life as snakes,
Smooth snakes of many kinds, and so that land
Still swarms with deadly serpents to this day.**

Ovid, *Metamorphoses*, (IV. 617–24), AD 1–8

Turned to stone: The fate awaiting
whoever looked at the Gorgons.
Medusa Rondanini, a copy of a Classical
work by Phidias (5th century BC)

Even Odysseus was afraid of Medusa. This crafty Greek hero broke off his stay in the Underworld because he was afraid of being confronted by the decapitated head of the monster, whose glance turned anyone who saw her into stone. According to the Greek poet Hesiod (*c.* 800 BC), who undertook to organise the myths of the ancient Greek gods in *Theogony*, Medusa was one of the three Gorgon sisters who dwelled beyond the Mediterranean in the far West, which is where mythology located the powers of evil to be. Due to their odious appearance and the fatal effect which they had on all who saw them, the Gorgons, like the goddesses of revenge, were the horror figures of antiquity. They contemptuously mocked everyone by sticking out their tongues and were hideous to behold: round faces with baleful eyes and hair and belts made of hissing snakes. The ancients thought these sisters were immortal, except for Medusa.

Therefore, Perseus, one of Zeus's numerous offspring, was charged with killing her. He cunningly reached the home of the

Envy depicted as Medusa,
Gustav Klimt, illustration
for *Ver Sacrum*, 1899

Gorgons and, along the way, assembled the necessary tools: a helmet that made him invisible, winged shoes that let him glide above the ground and a curved sword with which he eventually decapitated the sleeping Medusa. After he succeeded in killing her, Perseus put the ghastly head into a bag as a trophy for safe keeping, where, however, it did not remain for long. On his way home from the Gorgons, he fell in love with the beautiful Andromeda in Ethiopia and defeated a sea monster in order to save her. It was then that he felt he simply had to show his beloved the head of Medusa – though only the reflection of it in water – to prove his heroism and divine descent, which obliged him to battle evil.

Intrigued by this ancient myth in the late nineteenth century, the English painter Edward Burne-Jones executed a Perseus cycle which concluded with a work entitled *The Baleful Head*. Originally intended for a church, the painter may have viewed Perseus as a forerunner to the Christian dragon-slayer St George, and the idyllic and

tranquil garden scene as a symbol of the desire for a perfect world, free of evil and the taint of industrialism, which was rapidly growing in the nineteenth century. Burne-Jones grew up in the industrial city of Birmingham at a time when the slums were increasing. His contemporary, William Morris, a writer and critic, stated in a 1891 lecture that artists in industrial society had to "look back" for inspiration: "When an artist has really a very keen sense of beauty, I venture to think that he can not literally represent an event that takes place in modern life. He must add something or other to qualify or soften the ugliness and sordidness of the surroundings of life in our generation." Against a background of retrogressive aestheticism, Burne-Jones formulated the following creed: "I mean by a picture a beautiful romantic dream, of something that never was, never will be – in a light better than any that ever shone – in a land no one can define or remember, only desire and the forms divinely beautiful." Perhaps *The Baleful Head* represents a visionary prescription for dealing with a world out of control.

EDWARD COLEY BURNE-JONES
(English, 1833–1898)
The Baleful Head

1887
Oil on canvas
155 × 130 cm
Staatsgalerie, Stuttgart

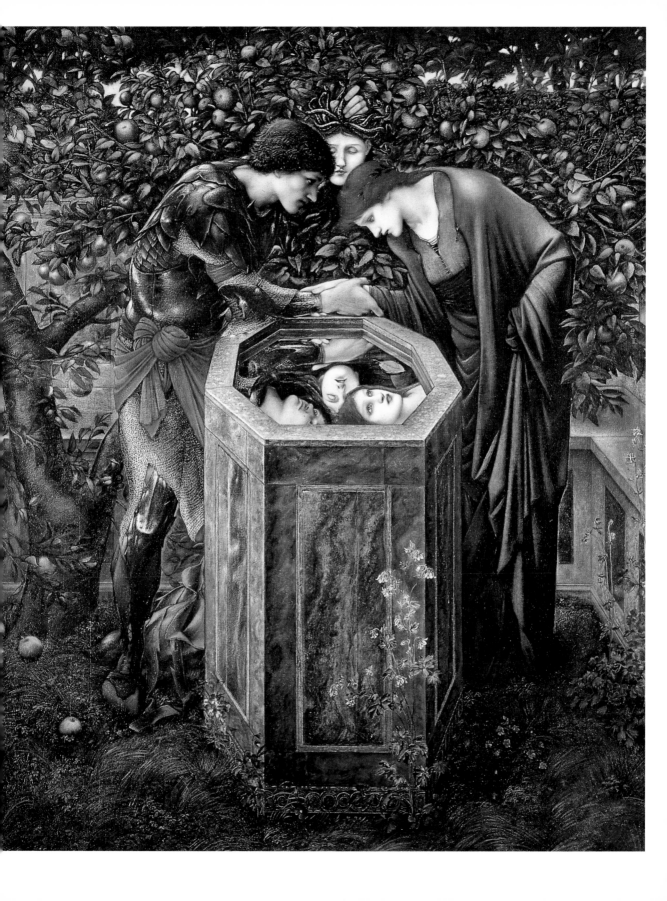

The Heat of a Summer's Day
Anyone for a swim?

Bathing in the Seine

In *Bathers at Asnières* not a cloud disturbs the relentless blue sky. The air and water shimmer in the oppressive heat, and motionless stillness smoulders. Only the boy in the water seems to be making a sound. Is he imitating the boat siren, as has been suggested by some art historians? Or is he shouting to a friend further out in the river?

Seurat was always a painter of summertime and summer light. He often travelled to the countryside to sketch men and women harvesting grain, peasants mowing fields with scythes, and labourers paving roads. Born in Paris in 1859, Seurat was one of the greatest painters of Post-Impressionism: his work shows the mark of the Impressionists' fascination with light but he took their ideas in a new direction. He developed a painting technique called Pointillism which relied on the optical mixing of colours. When a work was seen from a distance, the small dots of colour which made up the painting, blended together to create a lively, painterly surface.

It was summer when the poet Gustave Kahn visited the artist in his cramped studio in Boulevard de Clichy. Seurat was in the process of completing a painting, and Kahn observed that he "worked so energetically, despite the oppressive heat and humidity, that by the end of the day the artist was thinner than when he began". Seurat was a loner, an extremely serious and taciturn person. The artist Edgar Degas used to call him "the solicitor" because he was always formally dressed and wore a top hat. At the same time every evening "the solicitor" could be seen leaving his flat, striding purposefully towards the Boulevard Magenta to dine with his parents.

Seurat enjoyed spending time at the waterfront and was a frequent visitor to the wooded island of La Grande Jatte on the Seine, a popular outing destination for the Paris bourgeoisie. His excursions took him as far as Asnières-sur-Seine, located about five kilometres north-west of Paris. During Seurat's lifetime, factory smokestacks already marked the Asnières skyline, as can be seen in *Bathers at Asnières*, and it was far from an ideal place to bathe. As long ago as 14 February 1790, when the royal medical Counsellor Boncerf tested the water he was overcome by a "biting, pungent alkaline stench that impaired his respiratory system to such an extent that his throat and tongue swelled mightily". Until recently the Parisians' "favourite wench" was so polluted with sulphur and other toxic waste that, at a depth of one metre, divers were unable to see their hands when held directly in front of their eyes. For several years now the waste from the vast city is treated in modern sewage plants and there are hopes that Parisians might one day be able to bathe again in the Seine – enjoying it more than they did when Seurat was alive.

GEORGES SEURAT
(French, 1859–1891)
Bathers at Asnières

1883–84
Oil on canvas
201 × 301.5 cm
The National Gallery, London

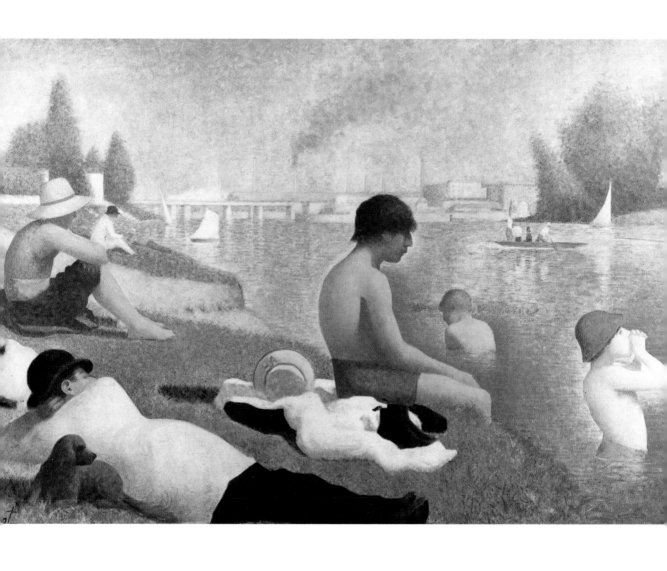

"I Think Gauguin Is Sick of Me"

How Vincent van Gogh lost part of his ear

Van Gogh left school without finishing, quit an apprenticeship and was a disaster as an itinerant preacher. He then became a painter and – as it seemed to most of those who knew him – was as unsuccessful at this as he had been at everything else, depending on his brother Theo who was an art dealer for money and becoming an out-of-control alcoholic, who spent his evenings in whorehouses. One episode of apparent madness led to his commitment. When he was discharged he shot himself: he died at the age of thirty-seven, a passionate and dreamy man.

Other painters admired him. Claude Monet thought Van Gogh's pictures were the best at the March 1890 "Salon des Indépendants", and Henri de Toulouse-Lautrec challenged an acquaintance to a duel for mocking Van Gogh's work. Yet Van Gogh was never able to make a living as a painter. The only picture he is known to have sold during his lifetime was *Red Vineyard at Arles*.

One episode has come to symbolise Van Gogh's life lived between hallucination and creative frenzy. In 1888 he moved from Paris to Arles in Provence, attracted by the southern light and the intense colours. There he shared a little yellow house with Paul Gauguin, who was already a successful painter. But Gauguin soon found that he liked neither Arles nor Van Gogh. On December 23 they quarrelled worse than ever: Gauguin felt threatened and left to spend the night at an inn. When he returned the following morning, there was a throng of spectators in front of the house, which was spattered with blood. Gauguin was arrested. It turned out that Van Gogh had returned at night alone and had cut off his own ear lobe with a razor. Then he had gone to a brothel, where he had presented the ear lobe, wrapped in newspaper, to a prostitute named Rachel: "Truly I say unto you, you will think of me." Emile Bernard, a staunch supporter of Van Gogh, admitted publicly that his friend was mad.

Van Gogh was sent to an asylum, where he painted *Self-Portrait with Bandaged Ear* which reveals the state he was in. He, who had always said he wanted to bring the sun to suffering people by painting in brilliant colours, appears as a shadow of what he had once been. When Van Gogh was young, Camille Pissaro had said: "This man will either go mad or he'll leave all the rest of us far behind." Rather than "either-or", he should have said "both-and".

Paul Gauguin in his *Self-Portrait* of 1888 (*Les Miserables*)

"Sunflowers belong to me": Vincent van Gogh wrote in a letter to his brother Theo; *Thirteen Sunflowers in a Vase*, 1888

VINCENT VAN GOGH
(1853–1890)
Self-Portrait with Bandaged Ear

1889
Oil on canvas
60 × 49 cm
Courtauld Institute Galleries, London

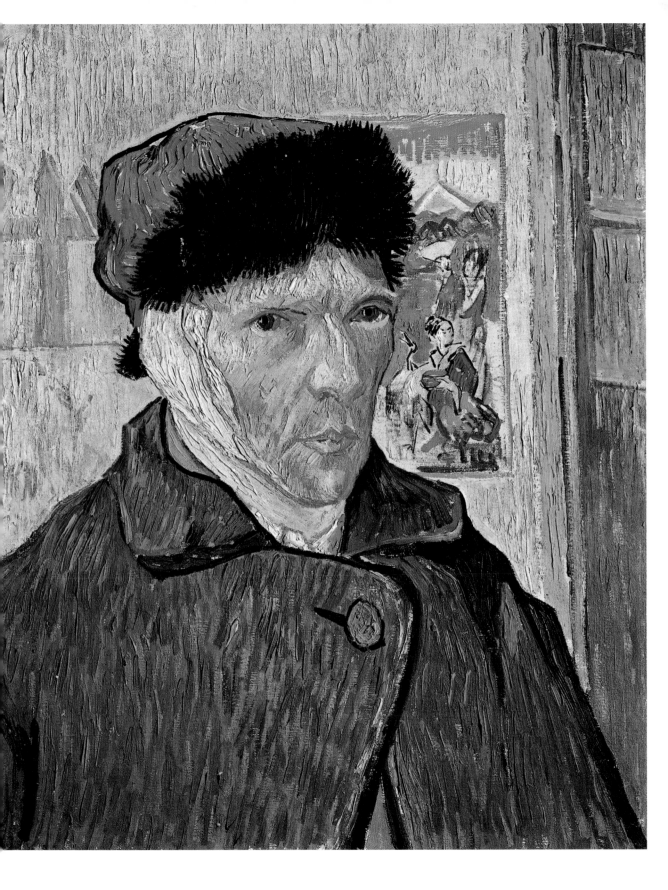

Paris: A City of Extremes
Chansons and cabaret

At the heart of Montmartre: The Moulin Rouge

One finds great luxury here and, at the same time, the greatest filth, noise, shouting, fighting and dirt – more than one can imagine. One vanishes from sight in Paris – and that is convenient because no one is interested in the life one is leading.

Frédéric Chopin, *c.* 1831

Paris, a happy-go-lucky place. The pianist and composer Frédéric Chopin came to this conclusion in 1831, shortly after arriving in the Seine metropole as a Polish émigré. "You can amuse yourself here, you can laugh – you can delight in all things. And no one gives you dirty looks, for here everyone does what they please." Half a century later, Montmartre was looked on as the centre of dissolute life in Paris. A *quartier* on the urban fringes, Montmartre had only recently become part of the city. Where pious nuns had once prayed and decent wine-growers earned an honest, hard-working wage, beggars, prostitutes and drug dealers were now in abundance. They were followed by singers, writers and penniless painters, all of them unknown. This dubious artists' colony was to turn Montmartre into a household name, even though its fame was of a decidedly dubious nature. Most of the money earned there fell into the pockets of pimps, pickpockets and streetwalkers. Montmartre was shunned by the bourgeoisie and by most successful artists.

The poet Aristide Bruant was one artist who managed to make a living there. Born in 1851, he left the local *lycée* at the age of seventeen because his family faced financial ruin. Working as a goldsmith and on the railway, he became intimately acquainted with destitution and the underworld. His experience pro-

vided the material for the many chansons he wrote and sang, making him one of the first French chansonniers as we know them today.

After founding his own cabaret in Montmartre, where his mocking of the public was met with outrage, he made the acquaintance of a young painter in 1886. A scion of the aristocracy, the twenty-two-year-old Henri de Toulouse-Lautrec was fascinated by Mont-

Outrageous and lascivious: *Chilpéric (Mlle Marcelle Lender Dansant le Pas du Bolero)*, 1896 (detail)

martre. As Bruant's friend, he became the leading chronicler of Paris nightlife. Painting in bars and brothels, dance-halls and cabarets, he also found time to draw for a gazette Bruant had launched and illustrated the poet's chansons when they were published. The public got to know Toulouse-Lautrec through his posters. He sold his first one to the Moulin Rouge music-hall. Well-founded criticism was offset by a strong resistance to Toulouse-Lautrec's style of poster. When Bruant was planning to appear at Les Ambassadeurs, a café with concerts in the centre of the city, the stage manager was appalled by the poster designed for the occasion. He considered it a cheap advertisement and a "nasty smear" on his establishment. Bruant however, already a celebrated eccentric, simply refused to appear in the café if the poster was not displayed – a poster that is now one of the most famous in the world.

HENRI DE TOULOUSE-LAUTREC
(French, 1864–1901)
Les Ambassadeurs, Aristide Bruant

1892
Coloured lithograph, poster
133.8 × 91.7 cm

"I Painted the Clouds like Real Blood"
The shadows of a bleak childhood

"Like real blood": A Norwegian sunset

One evening I was walking along a street, tired and ill, with two friends: the city and the fjord lay below us. The sun was setting and the clouds turned blood red. Then I heard the colours of nature scream – and that shrill cry echoed over the fjord.

Edvard Munch, *From My Diary*, 1929

Edvard Munch had a hard life. A doctor's son, he had a bleak childhood in Oslo. "My home was the home of illness, agony and death", he was to write in his memoirs. His mother died of tuberculosis at the age of thirty, leaving behind four children. Edvard was only six at the time. In her letter of farewell she wrote: "And now, my dear children, my sweet little ones, I say farewell to you. Your father will be able to tell you about how to get to Heaven better than I can. I'll be there waiting for you all." A pious woman who accepted her fate, all she could do was to hope for joy in the world to come – certainly not a legacy likely to inspire happiness and a zest for living in her children. Until he was thirteen, every time Edvard had a fever he was convinced that he was going to die. Influenced by his mother's negative way of viewing things, he vowed never to look forward to anything again. His father, at heart a good man, was distressing to his children. A sister of Munch's had already died of tuberculosis and, after the death of his beloved wife, Munch's father took refuge in fanatical pietism, forcing a strict regimen of prayer on his children.

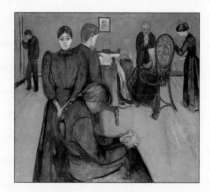

Edvard Munch, *Death in the Sick-Room*, 1893/94, painted after the deaths of his mother and sister

When he was older, Edvard argued incessantly with his father, while a second sister became a religious fanatic who was eventually declared insane.

From around 1889 onwards, Edvard became increasingly depressive, suffering from occasional fits of terror. Yet, by the age of seventeen, he had discovered another language with which to express his feelings of desperation: painting. It promised relief, consolation and hope. In a state of feverish excitement, he concluded that "the curse on mankind has become the undertone of my art – and my paintings pages in my diary". His visits to Paris and Berlin proved to be a great inspiration and, at the age of twenty-eight, he painted *The Scream* – an archetype of human experience on canvas. All the terrors of human existence seem to concentrate in the face, twisted with fear. Like so many other paintings of his, *The Scream* is, as Edvard Munch said himself, "a bitterly earnest scene – and a child of sleepless nights, which have taken their toll in blood and nerves".

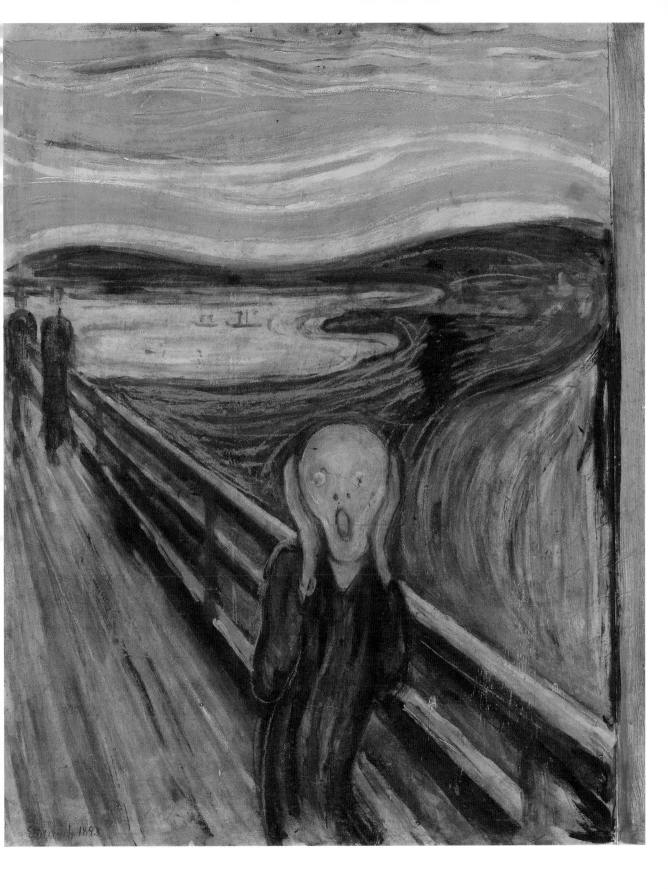

The Power of Nature
In the shadow of Mont Sainte-Victoire

On the afternoon of 15 October 1906, the clouds had finally lifted after a thunder storm lasting many hours. A broad beam of light illuminated the rising ground between the Chemin des Lauves and the rugged Mont Sainte-Victoire Range. The country road was deserted. Only a horse-drawn cart was trundling on its way to Aix-en-Provence. Suddenly it was forced to a halt: a dark figure with dirty, wet clothing lay across the road: Père Cézanne.

Kurt Leonhard, *Cézanne*, 1966

He was not dead but unconscious. The two men eventually managed to hoist him up on to their cart and take him to his residence in town, where they left him in the care of his landlady, Mme Brémond. The first thing he is said to have asked on regaining consciousness was whether the sun was shining again. He wanted to go back out of doors to finish the painting he was working on when it had started to rain. However, the artist was never able to finish it. Paul Cézanne, in his youth a friend of Emile Zola's, died seven days later. All his life he had been regarded as sickly: "Without painting he would have been nothing but a shy, introspective psychopath incapable of living a normal life – this is the image his family and the people of Aix seem to have had of him", thus one of Cézanne's many biographers. Some of the painter's eccentricities have been recorded and range from nervous irritability and a phobia of physical contact, to paranoia. Cézanne went through phases of deep depression followed by manic periods during which he grandly over-estimated himself and his abilities. Then he would write about his celebrated former colleagues in Paris, such as Manet or Renoir: "Compared to me, all my compatriots are idiots". Painting

was the only thing that kept the unpredictable Provençal, whose world was as unsteady as a damaged ship floundering in heavy seas, on a fairly even keel.

Cézanne preferred to paint out of doors. However, because he could not bear having anyone look over his shoulder while he was painting, he fled town and sought the solitude of nature in the surrounding countryside. Cézanne was obsessed with Mont Sainte-Victoire. He drew and painted more than sixty versions of this massive limestone escarpment, which looms a thousand metres above the flat

Paul Cézanne on the hill Les Lauves, *c.* 1905

country fifteen kilometres east of Aix. Here, he was alone and could forget all his troubles with the municipal authorities, who, he felt, had ruined the city with pavements, hideous promenades and gas lights. A further advantage of the mountains was that they were serenely static. Always squabbling with someone about something when he was not painting, Cézanne concentrated so hard on his still lifes that the fruit was invariably rotten before he had finished. It once took him 115 sittings to complete a portrait and he was known to have burst into a terrible rage at sitters who altered their expression. It was ideal for him that the face of Mont Sainte-Victoire only changed with the varying light and the seasons of the year. The "Sacred Mountain of Provence", as Mont Sainte-Victoire is sometimes called, became the leitmotif of Cézanne's work. Under its shadow began and ended the life of a painter who hardly exchanged a word with others, yet stirred the world with his groundbreaking pictorial language.

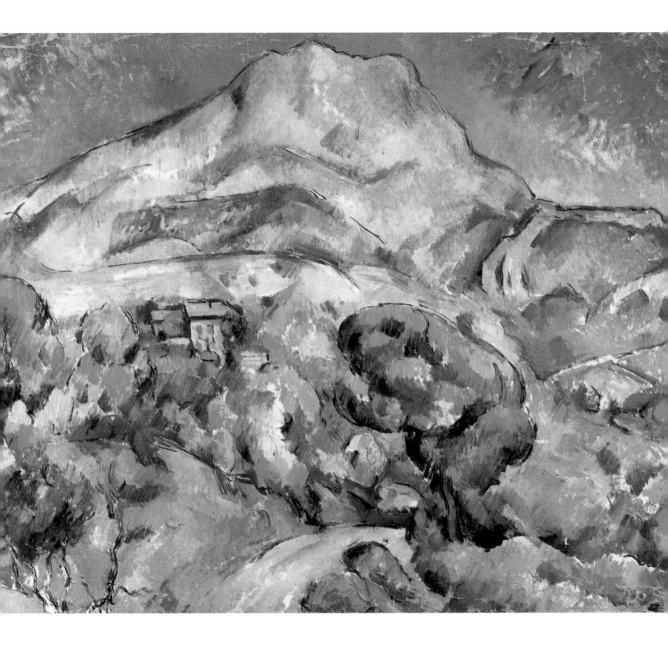

PAUL CÉZANNE
(French, 1839–1906)
Mont Sainte-Victoire

c. 1900
Oil on canvas
78 × 99 cm
Hermitage, St Petersburg

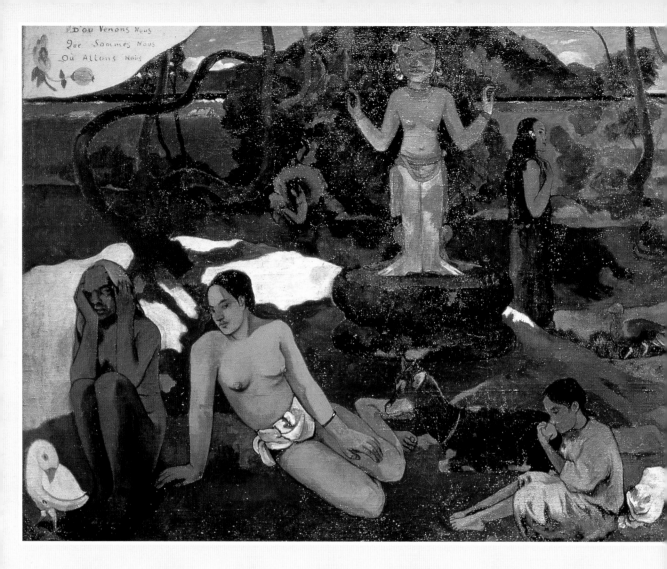

I Couldn't Care Less!
Another Eden in the South Seas

The people of Tahiti have invented a word:
"No artu", which means "I couldn't care
less!" Here it means pretty much the same
as complete serenity and naturalness.
You cannot imagine how I have grown
accustomed to this word. I often say it –
and I understand it.

Paul Gauguin, Letter to Georges Daniel de Monfroid,
7 November 1891

Coconut palms, pristine white beaches,
crystal-clear azure waters, natives leading
modest but happy lives in peace and harmony
and colourful tribal festivities. In the early
twentieth century a great many people in
the Old World dreamt of the South Seas.
Burgeoning industrialisation and increasing
traffic were beginning to infringe on the peace
of the cities and the countryside alike, creat-
ing unnecessary stress and a hectic way of life.
The sparsely populated islands dotting the
Tropic of Capricorn were viewed as a verit-
able paradise in comparison. There, weary
Europeans thought they might find the un-
spoilt natural beauty of the Garden of Eden

and a people living in serene harmony in such
an earthly paradise. That at least was Paul
Gauguin's vision.

The Frenchman had spent several years at
sea before embarking on a brilliant career as a
stockbroker. At the age of thirty-four he de-
cided to give up everything thinking, mis-
takenly as it turned out, that he could live
from his painting. His circumstances grew in-
creasingly difficult. He first moved to Rouen,
then to Brittany, before settling in Arles with
Vincent van Gogh, only to return to Brittany
shortly afterwards. His nomadic life inspired
creativity, but led to a destitute existence,
ultimately causing an irreparable rift between

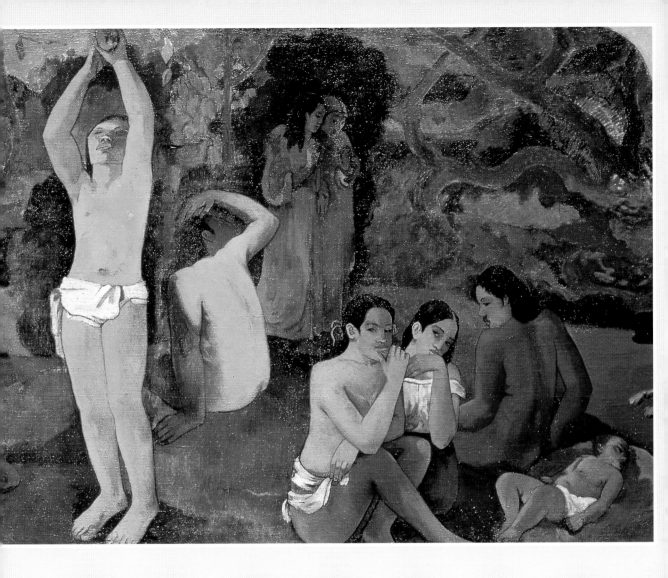

him and his family. Finally, he abandoned his wife and children. The prospect of leaving everything far behind may have sparked his love of adventure, for soon he was on his way to Tahiti: "The future will belong to the painters of the tropics because no one has yet painted them, and we always need novelties for the general public, the stupid purchasers of art." On 8 July 1891 Gauguin arrived at Papeete, the capital of the Tahitian Islands. However, the paradise of "noble savages", which he had thought might be free of the temptations, vices and defects of European life, turned out to be a delusion. The light, the lush vegetation and natural beauty, the exotic customs and friendliness of the natives did not disappoint him. Daily life, on the other hand, was rife with the corruption and oppression that accompanied French colonial rule, leaving a grey veil over the brilliant colours of his South Seas Arcadia. Gauguin married a Tahitian, settled down in a typical Tahitian house and was soon in conflict with the French colonial authorities. Beset by ill health and chronic poverty, he was forced to return to Paris in 1893. Two years later he fled to the South Seas again, first to Tahiti and then to the Marquesas Islands, where he died in 1903 in a hut he had decorated with his paintings. Although his dreams of paradise

PAUL GAUGUIN
(French, 1848–1903)
**Where are we?
Who are we?
Where are we going?**

1897
Oil on canvas
139 × 375 cm
Museum of Fine Arts, Boston

had not been fulfilled, Gauguin painted powerful pictures full of joy and serenity while in the South Seas. In one of his letters he declared: "Life is so delightful here and my work so salutary that it would be madness to seek this anywhere else."

Freezing Every Gesture
Light and effects

I speak of the past, for it seems to me that everything is growing older in me – except my heart. And even my heart has something artificial about it. The dancers have sewn it into a pink silk sachet, slightly faded pink silk, like their ballet slippers.

Edgar Degas, letter to the sculptor Albert Bartholomé, 17 January 1886

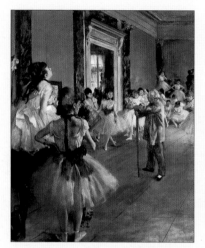

The Dance Class, 1873

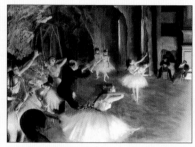

The Rehearsal on Stage, 1874

Built between 1862 and 1865 near the Madeleine, the Paris Opéra – then, the world's largest opera house – covers an area of 11,000 square metres. Behind an exuberant façade, decorated with allegorical figures, the auditorium seats 2,200. The artist Edgar Degas, who lived three streets away near rue Le Peletier, did not require a season ticket. By the 1860s, this witty and entertaining painter, who could also be stubbornly intransigent when he so desired, had discovered ballet as his genre. Because he knew several members of the orchestra, he had access to the sacrosanct world backstage. Nearly every day the Frenchman sat on or behind the stage. Early on he had become interested in motifs drawn from urban life, painting workaday scenes of women ironing, passers-by in the streets and men in bars, as well as the pleasures of the Parisian racecourse or circus scenes. However, Degas, who was the son of an aristocratic

banker of Italian descent and a New Orleans creole, found *artistes* and prostitutes common but intriguing. What the Moulin Rouge was to Toulouse-Lautrec, the rehearsal room with its ballerinas was to Degas.

In those days the Paris Opéra Ballet – not to mention more illustrious names – was waning in the firmament of the Parisian cultural scene. Choreographers were running out of ideas and the public was not satisfied with what the Opéra Ballet had to offer. But the quality of the productions was of no consequence to Degas, who was concerned with movement, speed and the enchantment of ballet. In his paintings, he captured the elegance and delicate grace of ballet with an unprecedented keenness of observation. Tragically, by 1870, his eyesight was beginning to fail. As if to record as much as he could on canvas before it was too late, Degas painted ever more feverishly to freeze every gesture, every pose of his

ballerinas: dancing on points, performing *pas de deux* or taking their curtain call, their tutus a froth of effervescence. He was even more fascinated by what went on behind the scenes. The pictures in which he captured ballerinas pulling up their tights, or fiddling with the laces of their slippers, are like snapshots taken by a hidden camera. He was not above depicting the darker side of dancing: ballerinas at the bar rubbing their ankles because they hurt or resting their heads on their arms in sheer exhaustion. Degas knew how to make even such moments of weariness enchanting. He introduced yet another first to painting: the effects of modern lighting. He was the first painter to study and exploit the effects of the mixture of natural and artificial light, like that of the setting sun and gas lanterns. The result was a painted twilight as it had never been seen before.

EDGAR DEGAS
(French, 1834–1917)
Behind the Scenes

c. 1898
Pastel on paper
60 × 67 cm
State Pushkin Museum
of Fine Arts, Moscow

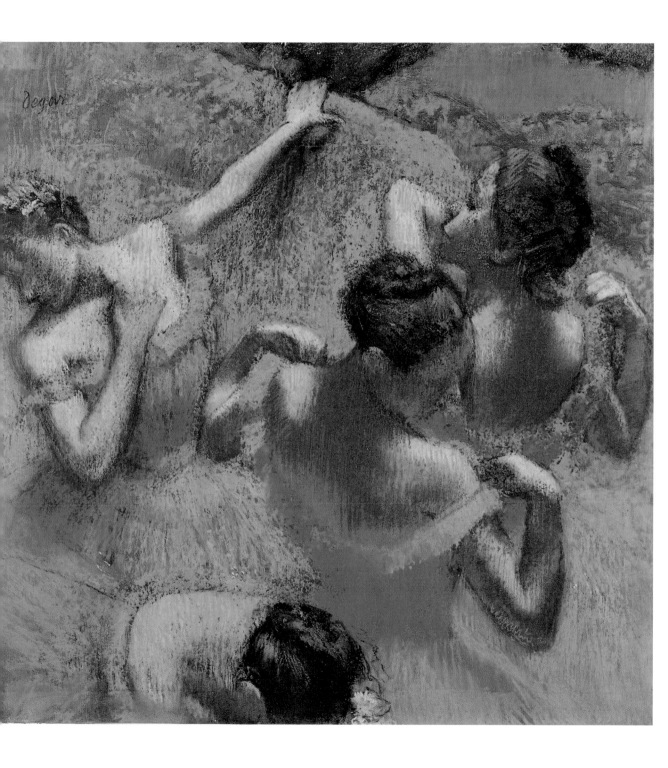

A New World Stage
Fin-de-siècle in Vienna

Constantin Brancusi's *Kiss*, 1907, was
executed at the same time as Klimt's work
of the same name

I love those first timid caresses,

half questioning, yet already
half trusting,

they crackle with red sparks
of seduction

and shoot sheaves of gold
into the fiery night.

Stefan Zweig, from *Silver Strings*, 1901

In 1900 Vienna was the glittering hub of the
Austro-Hungarian Empire and the world
capital of *fin-de-siècle* culture. Tradition reigned
supreme in the city of waltzes and coffee-
houses. Mozart, Beethoven and Schubert, the
immortal three in music, had lived here.
Since the Habsburgs had made it their capital
centuries before, all the currents of European
culture and civilisation converged in Vienna.
A harmony of contrasts, "It was lovely to live
here", wrote Stefan Zweig, "for, unconsciously,
every person in the city became a sophisticate, a
cosmopolitan". The charm of turn-of-the-
century Vienna worked its magic on poets
and authors, musicians and artists; the city
was full of famous faces such as Hugo
von Hofmannsthal, Arnold Schönberg and
Gustav Mahler, who all adored it. Yet, an era
was drawing to a close, overshadowed by the
decline of the Austro-Hungarian Empire.
Still elegant, the boulevards of Vienna were
growing shabby. The clouds of war were
gathering on the horizon. The flower of
Viennese Jugendstil was in late bloom and the
golden age was fading.

Gustav Klimt was regarded as the leading
Viennese painter of his day. A goldsmith's
son, he founded the "Vienna Secession" in
defiance of academic painting. As eclectic as

the city itself, Klimt's aesthetic embraced such
superficially disparate elements as *fin-de-siècle*
elegance and sensuousness and Byzantine
icons and mosaics. Moreover, he incorporated
elements of East Asian and ancient Egyptian
art in his work. He lavishly bestowed sym-
bolic ornament and decoration on his works,
making the surfaces of his pictures glitter

The Secession building in Vienna, a home to the art of
Klimt and his friends

with the colours of jewels – cornflower
sapphires and amethysts, alexandrites and
pearls on a rich gold ground.

Influenced by the writings of his fellow
Viennese, Sigmund Freud, Klimt painted
sensuous and sumptuous pictures, which
aroused the ire of the critics. His work was
condemned as "obscene", yet, all he did was
revel in luxury and beauty with a suggestion
of the physical pleasures in life, freed from
the constraints of nineteenth-century inhib-
itions. His masterpiece, *The Kiss*, is a cele-
bration of beauty and eroticism. Some might
view it as a manifesto of decadence. In retro-
spect, Klimt's œuvre seems to reflect one
of the last dreams of innocence before the
horrors of war set in.

GUSTAV KLIMT
(Austrian, 1862–1918)
The Kiss

1907/08
Oil on canvas
180 × 180 cm
Österreichische Galerie Belvedere, Vienna

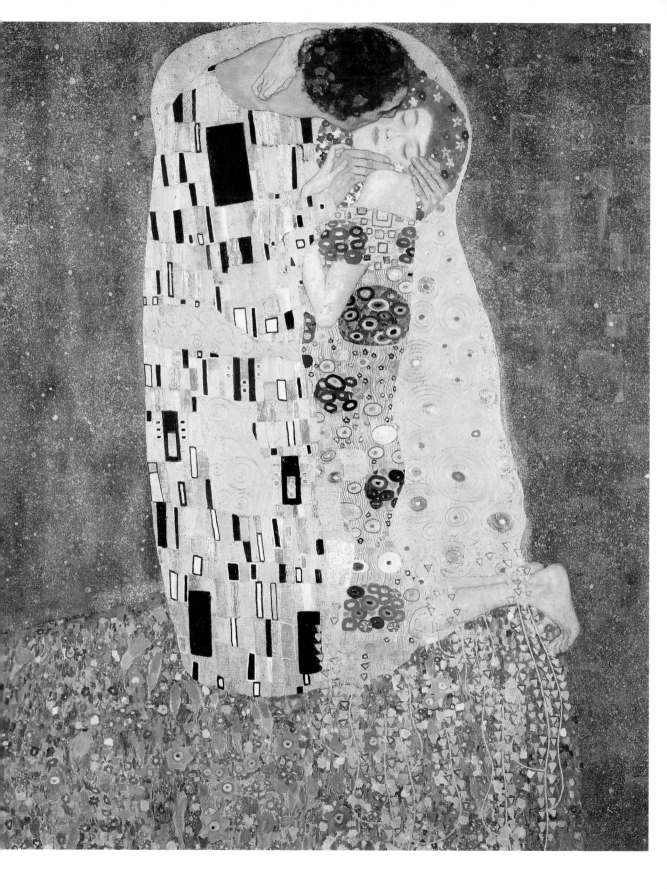

Hewn with an Axe
Delight in distortion

You remember, don't you, that the picture was at first called *The Brothel at Avignon*. And do you know why? Avignon is a name that is linked to my life in Barcelona. There I lived only a few steps away from the Calle d'Avignon. That is where I always used to buy my paper and paints under the gaze of prostitutes.

Pablo Picasso, *Word and Confessions*, 1954

The newborn baby was blue and made no sound. The midwife thought it was dead, but not Don Salvador, both its uncle and doctor, who was reading his newspaper in the next room. He had the presence of mind to blow a whiff of cigar smoke into the face of the nearly suffocated baby. It began to draw in breaths of air and to scream. Thus Pablo Picasso encountered and conquered death in

The fascination of a distant continent: Picasso sitting amongst African and Oceanic artefacts in his Paris studio, 1908

the first moments of his long life. What would there be left for him to fear? The world admired his impressive vitality, his passion for sheer hard work and the overwhelming self-confidence displayed by the brilliant artist, who had exhibited his first picture by the time he was fourteen. Picasso, who lived to be nearly ninety-two, was celebrated for his talent all his life. At the age of eighteen in Barcelona, he used to meet the city's intellectual avant-garde in the "The Four Cats", an artists' café. The youngest of the artists who frequented the café, he was soon the most popular: "He exerted such a powerful charisma that he became the leader of the entire group", related a contemporary.

In 1904 Picasso moved to Paris. He is said to have burned drawings to keep the stove ablaze – and to have painted the walls of his empty room with furniture. All this may be the stuff of legends, but it does reflect the conditions in which he lived at that time. Because he had broken with academic convention, preferring instead to paint the down-and-out, clowns and prostitutes, he had to struggle to earn his livelihood in his youth. Even among friends his work remained controversial. The biggest scandal caused by the young firebrand erupted over the painting entitled *Les Demoiselles d'Avignon*. Not long before its completion, he had visited Henri Matisse and, in his flat, had picked up the first African sculpture he had ever seen. "He didn't put it down all evening. And when I arrived at his studio the next morning, the floor

was covered with sheets of paper. They all bore the same motif: the head of a black woman. The same woman then emerged on his canvases; sometimes there were two of them, sometimes three. Suddenly there was *Les Demoiselles d'Avignon*, a picture as big as a wall", recalls the poet Max Jacob.

The writers and artists of the nineteenth century had depicted distant lands as being like paradise, exotically transfiguring and glamourising reality. Picasso, on the other hand, was interested solely in the aesthetics of exoticism. His defiance of convention in *Les Demoiselles d'Avignon*, which was decried as being "aggressively erotic", set off shock waves. Contemporaries thought the figures' faces looked "as if they had been hewn with an axe". Construed as the artist's homage to the shrill world of deformation and deconstructed myth, it was widely interpreted as a general attack on the ideals of European art. In retrospect, however, this picture, with its synchronicity of different perspectives, represents the beginning of a new era for painting – a break with the past and a challenge for the future.

PABLO PICASSO
(Spanish, 1881–1973)
Les Demoiselles d'Avignon

1907
Oil on canvas
244 × 233.7 cm
The Museum of Modern Art, New York

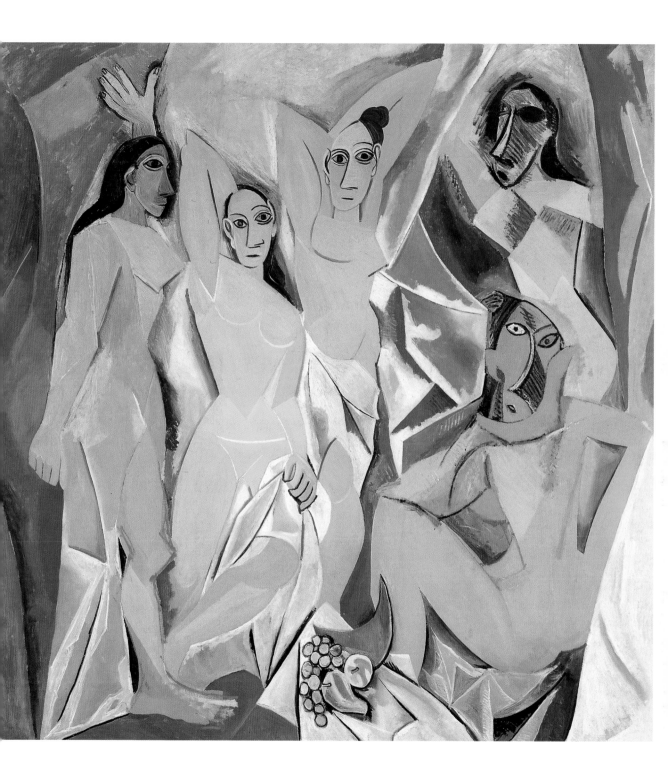

The Calming Effect of Colour
The blue of the Côte d'Azur

Matisse in his studio in Vence

The French artist Henri Matisse delighted in painting the blue of his beloved Côte d'Azur, the green umbrella pines and the rows of elegant white villas lining the coast. He revelled in capturing the essence of leisurely life on canvas: men playing *boules* in the shade of the trees, people relaxing and enjoying quiet, carefree days in the sun, yachts bobbing on a gentle swell in the harbour accompanied by the balmy breezes of the mistral. Colours, for him, were like the harmony of music. He was convinced that contemplating sunlit colours induced profound inner calm. In *Dance* he explores the calming effect of colour. This is not the only occasion on which he consciously acted as a painterly pastor, a priest of the easel, who exuded an almost religious feeling for life. In 1908 he expressed the hope that people might find peace and tranquillity in his paintings. He loved life's sensuous pleasures, the beauty of the models who sat for him and the lushness of nature. Painting was his way of sharing his own zest for life with others from all walks of life. He certainly succeeded. The Italian painter Renato Guttuso called Matisse's work a "feast

for the senses" and "a design for a paradise-like world". With the joyous serenity depicted in his paintings, Matisse superbly "exempli-

fied a love of life and trust in its beauty". The French writer Louis Aragon, like Matisse a member of the French Communist Party, raved about the artist's work. His paintings showed "the victorious smile of our times, since mankind has begun to turn away from darkness and, with just this smile, triumph-

antly confronts the days that are for ever bright and peaceful". In Matisse's paintings the sun is almost always shining and the people he portrays appear carefree. The lightness of being also imbues the five men and women suspended in dreamy abandon between heaven and earth in *Dance*. Later, Matisse designed sets and costumes for Sergei Diaghilev's *Ballets Russes* in Paris, for he also loved ballet. Dance represented life and rhythm, sparkling with vitality and the freshness of youth. In 1905 Matisse is said to have watched Catalan fishermen dancing the Sardana, an old round dance with abrupt changes of beat and tempo, on the beach at Collioure. Perhaps the memory of this scene is lent expression in *Dance*. Although Matisse frequented the Paris café, Moulin de la Galette, where people danced on Sunday afternoons, he was not sufficiently inspired by the ambience there to paint it. What most likely captured his imagination at the Paris café were the intriguing steps of the farandole, an ancient Provençal dance, whose insistent rhythms seem to have underscored his painting.

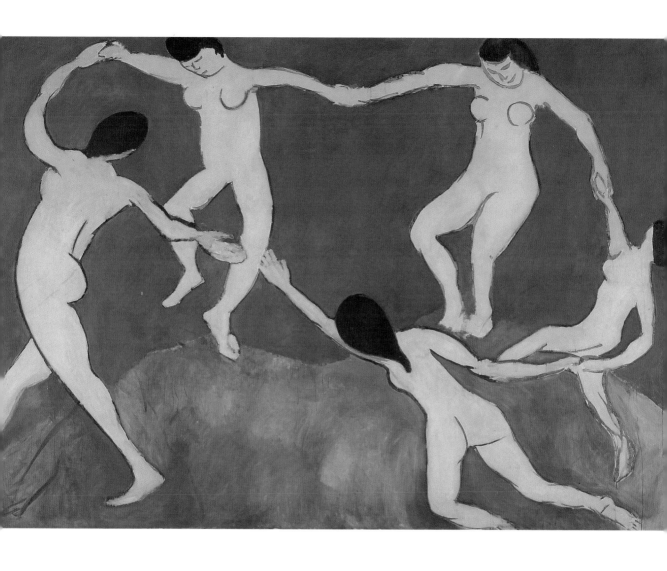

HENRI MATISSE
(French, 1869–1954)
Dance (first version)

1909
Oil on canvas
259.7 × 390.1 cm
The Museum of Modern Art, New York

Blue Horses and Yellow Cows
Munich in 1911: The art capital

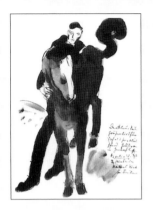

Franz Marc,
"The Blue Rider presents
his Blue Horse", illustrated
letter to Else Lasker-Schüler,
December, 1912

The Blue Rider is here – a lovely sentence, five words –
nothing but stars. I'm now thinking like the moon.
Am dwelling in the clouds, especially in the evenings
when no one else is in the streets....
My eyes hurt as if your sweet horse had kicked up
a cloud of dust. Come to me, you and your spouse,
Blue Rider, that I may love you.

The lyric poet Else Lasker-Schüler in a letter to Franz Marc,
9 December 1912

In 1911 a full tankard of beer in the Bavarian royal capital of Munich cost 30 pfennigs. In those days the city on the Isar boasted cultural attractions on a scale that dwarfed the "Okto-ber Fest". Thomas Mann was writing *Death in Venice* in his flat in Schwabing, the artistic and cultural hub of Munich. Bruno Walter was conducting the world première of Gustav Mahler's *Songs of the Earth* at the Conservatory. Munich gleamed as the centre of the arts. As the lyric poet Else Lasker-Schüler remarked: "Munich is like paradise.... Listening to friends playing the accordion; strolling past the windows of the reverent old stores; old masters, tasteful jewellery, wild weapons from the tombs of biblical potentates, and every-where the blue eyes of King Ludwig!... One can muse so effortlessly in Munich, and recline in comfort on well-upholstered memories. Here it feels good to be oneself."

However, even the disgruntled Munich of conventional wisdom found plenty to jolt it out of its stolidity. A performance staged by the nude dancer Via-Villany made the chamois tufts that Bavarian men wear on their loden hats wag with indignation. In a former shop in Tuerken Strasse two men could be seen through the window painting decidedly offensive pictures. One of them, Franz Marc,

was defiantly brandishing the picture of a horse – painted blue! Loud protests were heard. The police who rushed to the scene had no legal right to make the painters stop what they were doing so they contented themselves

Wassily Kandinsky, final design for the cover of
the Blue Rider almanac, 1911

with patrolling the area around the shop to keep public wrath from erupting. Marc and his colleague Wassily Kandinsky were com-mitted to encouraging a dialogue between painting, literature and music with the pur-pose of "radically widening the bounds of

expressive creativity". In 1912 they published an almanac that caused a sensation. It con-tained nineteen articles and quoted passages, three musical scores and 141 reproductions of pictures, including folk art and children's paintings and drawings, "primitive, Roman and Gothic art", "twentieth-century art" and Egyptian shadow-play figures. By bringing together this jumbled mixture of artworks they hoped to encourage other artists to venture in new directions. The almanac bore the title "Blauer Reiter" (Blue Rider). "We thought up the name round the coffee table in the shade of Marc's garden", Kandinsky said, adding: "We both loved blue, Marc – horses, and I – riders. The name came of its own accord". Soon afterwards, the Blue Rider had their first exhibition. Never tightly organised, the group consisted of a circle of artists around Marc and Kandinsky. Marc found animals "purer" than human beings. In his work, blue stood for masculinity, astringency and intellect. The horse was the attribute of the popular saints Martin and George, who as celestial riders conquered evil and materi-alism. Marc and Kandinsky contrived to emulate them in art. The Blue Rider did not last long; it dissolved in 1916 after Franz Marc was killed in action at Verdun.

FRANZ MARC
(German, 1880–1916)
Blue Horse I

1911
Oil on canvas
112.5 × 84.5 cm
Städtische Galerie im Lenbachhaus, Munich

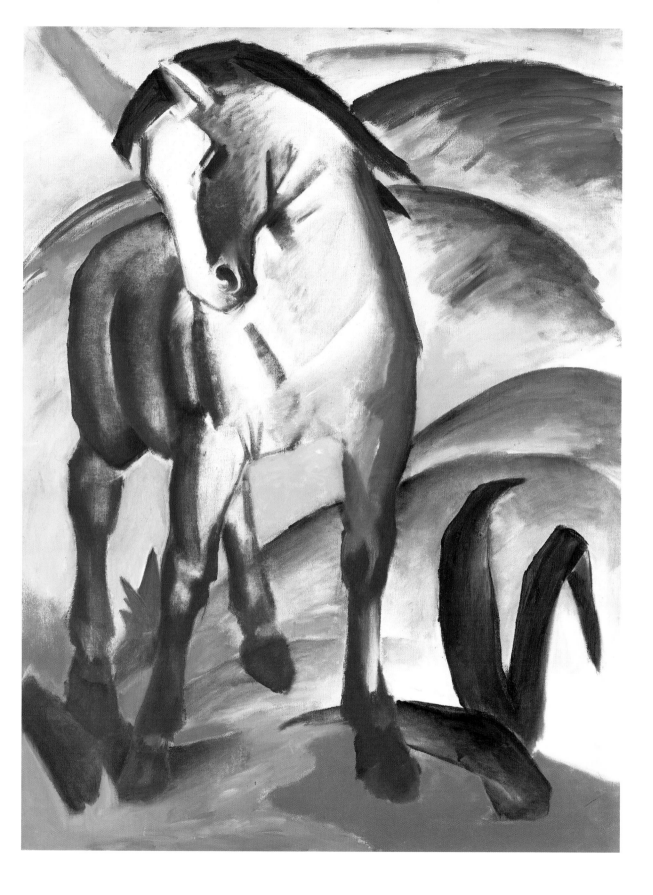

Painting Music
From the visible world to an abstract symphony of colours

The colours of Moscow:
St Basil's Cathedral on Red Square

The sun is melting Moscow down to a mere speck which, like a tuba gone mad, is making the whole inner being, the whole soul vibrate…. It is only the final chord of the symphony that heightens colours to their most vivid…. Pink, purple, yellow, white, pistachio-green, flaming red houses, churches – each a song unto itself – the shrill green lawn, the deep drone of the trees…. Painting this hour, I thought, would represent the artist's most unlikely and loftiest happiness.

Wassily Kandinsky, 1912, in *Collected Writings I*, 1980

One evening in 1910 Wassily Kandinsky entered his Munich studio, noticed a canvas that had been accidentally hung upside down and was enraptured. He had suddenly comprehended that this was a picture "of extraordinary beauty, glowing with an inner radiance". At that time, as the Russian émigré would say later, he had, in a flash of insight, understood what abstraction really meant. In connection with art, "abstraction" did not mean "anything that could be perceived by the senses; it meant trying to represent the intellectual content of something". This did not mean depicting a couple embracing, for instance, but instead expressing their feelings of joy, love and security solely by means of a non-representational approach.

The discussion waxed loud and long as to who had been the first to paint an abstract picture and who should therefore be regarded as the founder of abstract painting. All his life, Kandinsky would remain convinced that the honour should have gone to him. Today it is a well-known fact that other artists, such as Hans Schmithals, painted abstract pictures before Kandinsky did. Nevertheless, Kandinsky deserves full credit for the pioneering way he allowed colour and form to become autonomous in his compositions.

Kandinsky had refused a university chair in law to become a painter. His progress towards abstraction was long and arduous. At the beginning of his artistic career, any type of

Inside the Kremlin walls

painting that did not correspond to reality left him bewildered. At the age of thirty he saw an exhibition of French Impressionists in Moscow and stood for hours before Monet's *Haystack*, jotting down notes: "It was only when I read the catalogue that I realised it was a haystack. I couldn't pick it out. I was embarrassed about not being able to do so. I also felt that the painter had no right to paint so indistinctly. I numbly sensed that the real subject of the painting was missing." Then Kandinsky became more familiar with the painting and noted happily "that the picture not only seizes one, it imprints itself indelibly on one's memory to hover, always unexpectedly, before one's eyes in all its detail…. Painting has assumed magical power and magnificence. Unconsciously, however, the subject has been discredited as an unavoidable element of the picture. I had the general impression that a tiny particle of my sun-drenched fairy-tale Moscow already had an existence of its own on canvas."

Despite his allegiance to abstraction, Kandinsky drew his inspiration solely from the visible world, starting with carvings on Russian peasants' houses and extending to African masks and Upper Bavarian votive tablets. It was not his aim to represent nothingness with his abstract renderings; he endeavoured to reveal the primal chaos from which the creative force emerged, the force that once formed the world. *Composition VII*, Kandinsky's most important work from the period before the First World War, does not attest to destruction, but carries the message of a creative beginning.

WASSILY KANDINSKY
(Russian-born, 1866–1944)
Composition VII (Third Version)

1913
Oil and tempera on canvas
90.2 × 125.2 cm
Städtische Galerie im Lenbachhaus, Munich

Down the Garden Path
Water-lilies at Giverny

The former French president and statesman Georges Clemenceau described one of the water-lily pictures painted by his friend Claude Monet as "a water-meadow covered with flowers and leaves, ignited by the torch of the sun and glittering in the play of light between the sky and the surface of the water". Clemenceau had successfully co-ordinated French political and military efforts towards the end of the First World War and made a major contribution to the Allied victory. He raved about Monet's water-lily pictures calling them a "revelation". Between 1915 and 1924 he made it possible for Monet to paint eight enormous water-lily murals on the walls of the Orangerie in the Tuileries as a gift to the nation. Despite such encouragement, however, Claude Monet was not surrounded by distinguished promoters and patrons from the outset. On the contrary, his work entitled *Impression, soleil levant* inspired the critic Louis Leroy to coin the derogatory term "Impressionists" for an entire group of painters whose work he did not like. For decades Monet was almost destitute. Not until art dealer Theo van Gogh, Vincent's brother, managed to sell one of his paintings for 10,350 Francs – then an almost unheard of price for a work of contemporary art – was Claude Monet able to live fairly comfortably. Already middle-aged, he began to reap the fruits of his success.

CLAUDE MONET
(French, 1840–1926)
Water-Lilies

1916
Oil on canvas
200.5 × 201 cm
The National Museum of Western Art, Tokyo

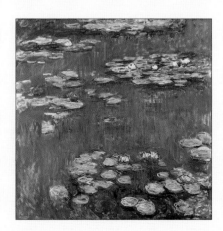

Monet was even able to make a life-long dream come true. For seven years he had rented a country house in Giverny; now he was able to buy it and lay out a garden of flowers and shrubs. In 1895 and 1896 he successfully negotiated the purchase of several neighbouring plots of land – including a pond – which he planted with a profusion of weeping willows, irises, rhododendrons and water-lilies. An avid landscape gardener, he was inspired by Japanese woodcuts, which were by now sought after on the European art market, especially in France and England. Monet was so fond of his estate that his chief preoccupation for the remaining thirty-six years of his life was painting views of his gardens. As a young man he had always painted out of doors to capture the light and atmosphere and the interplay of colour and reflection. The six gardeners Monet employed in old age took care of his paradise, leaving him free to paint it and touch up the paintings in his studio. Water-lilies were his obsession: between 1903 and 1908 he painted forty-eight pictures of them, which he exhibited in Paris in 1909. He sought eternity in painting, or so his fleeting glimpse of it would seem to intimate.

Spectres Are Born
Giorgio de Chirico and World War I

I for my part believe that a place that paralyzes and freezes the brightness of noonday hides more secrets than a dark room in which someone is holding a séance.

Giorgio de Chirico, in a letter to a friend, January 1919

Seldom had spring brought forth more flowers than in 1914: the days were blue and soft and the air balmy. Inhabitants of the European capitals enjoyed the coffeehouses and parks. At seaside resorts crowds danced under chestnut trees to the strains of promenade concerts. And in their offices the diplomats were calculating and worrying. In the Balkans the vital interests of the Austrian, Russian and Turkish Empires were balanced: but it was an unstable balance and many nationalists were convinced that their nation would benefit from its overthrow. When the Austrian Archduke was assassinated in Sarajevo by a Slav nationalist the Austrian government calculated that it was then or never for their interests in the Balkans. Encouraged by their German allies, who believed that a war

A possible source of inspiration? The arcades bordering the palace gardens in Munich where Giorgio de Chirico studied between 1906–09

with the French was nearly inevitable and that Germany's chances were better in 1914 than they would be in 1918, the Austrians issued the Serbs a humiliating ultimatum. But the Russians had appointed themselves the protectors of the Serbs and were closely allied to the French. No one knew how seriously the British took their alliance to the French....

The pressure rose slowly at first, but then rapidly. The levy of a war tax on one side was answered with the lengthening of the term of military service on the other; partial mobilization on one side was answered on the other by full mobilization. The German commanders were convinced that to prevail against France and Russia they would have to destroy France quickly before the slow Russians could assemble their armies. But that meant they had to strike first: they could not allow the Russians to mobilise. Human will seemed powerless in the face of unfolding events, long-determined plans, strategic necessities, the requirements of national prestige – for the most terrifying thing about this, the most bloody war Europe had ever known, was that no one had wanted it.

In Paris the twenty-six-year-old painter Giorgio de Chirico was filled with the sense of the meaninglessness and madness of life.

Giorgio de Chirico, *Self-Portrait*, 1924

The son of an Italian railway engineer, he was born in Greece and grew up familiar with ancient legends, with myth, tragedy and a strong sense of fate. He believed in signs and in predestination, magical places and the astrology and studied ancient Greek religion. He was also a student of Nietzsche and Schopenhauer.

De Chirico's feelings about the senselessness and terror of his time were worked through these symbols and ideas. He was one of the most truly "disturbing" of modern painters. De Chirico conjures up menacing Italian piazzas which seem to conceal the key to a looming catastrophe. His colonnade-lined facades seem to be the surface of an isolated world; to reflect the hot light of a shuttered noon. The purpose of his "Metaphysical Painting" was to reveal invisible forces, fears, emotions and shadows concealed behind the world of visible things. He played with allusions and like the ancients delighted in riddles and enigmas, such as the Sphinx, the oracle at Delphi and the Sybilline Books. What is the significance of the painting of 1914, *Mystery and Melancholy of a Street*? Could it signify anonymity, the solitude and menace of a great city? The work seems to evoke a mood which many of us have sensed before, of doom and evil, and of the senseless and unavoidable, bearing down on us. It is difficult for us not to see the work as a prophecy of what at the time was called "The Great War".

GIORGIO DE CHIRICO
(Italian, 1888–1978)
Mystery and Melancholy of a Street

1914
Oil on canvas
87 × 71.5 cm
Private Collection

The Poetic Nude
Absinthe and transfiguration

Wouldn't you like to rest? With these words her gestures assumed a new softness so that I trembled in the innermost fiber of my being as if to a voice never heard and indefinable. She felt me, and over her eyes descended a heavy veil and I fell on my knees and with my eager hand on her body, she stood up, her body taut and quivering like a living harp.

Gabriele d'Annunzio, *Intermezzo*, V 111–117 (1883)

His name stood for scandal. Amedeo Modigliani was a wild aesthete after the manner of his time. He loved Nietzsche, Baudelaire, Oscar Wilde and Gabriele D'Annunzio, smoked hashish, drank absinthe, danced naked on the tables of third-rate cafés, fought with the police and spent many an odd night locked up. He is supposed to have been intimate with many waitresses, painter's models and prostitutes. Once a model schoolboy, he was also tubercular and the English writer Beatrice Hastings left him when he decided to find his happiness and health in alcohol and drugs. She was fed up with getting up early every day to write the articles and poetry that put food on their table – while he slept until noon.

The young Italian, who had moved to Paris in 1910, forgot her soon enough. He met the love of his life at Mardi Gras: a girl fourteen years younger than himself, Jeanne Hébuterne. Friends warned him to keep away from her because she came from a family which had sired celebrated clerics. Her parents would

find him a disgusting character. But Modigliani was not to be deterred. The tragic aesthete who, despite the excesses of his Paris

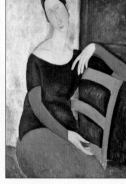

Plagued by misfortunes: Modigliani's *Self-Portrait* of 1919, and his wife *Jeanne Hébuterne*, 1918

life, still retained at thirty-three the beauty of his youth, had fallen deeply in love. He found in her the incarnation of the "lady with the swan-like neck" whom he had painted many hundreds of times. It was love at first sight for both of them and the power of love removed all obstacles. Jeanne defied her family to be

Modigliani's permanent model. His fame grew, chiefly due to the series of paintings of which *Nude with Necklace* is one. The critic Francis Carco wrote in 1919 on the series: "Animal suppleness, waiting motionless in abandonment of self, in delicious languor, has never been more tellingly interpreted by a painter." Others praised Modigliani's poetic nudes as "hymns to a sensitive beauty".

The elegiac melancholy of these paintings reflects the tragedy and uncertainty of their creator's own life. For the first time he had enough money to live on, yet his health was collapsing. He died of meningitis on 24 January 1920. He was thirty-six and an incurable alcoholic. Jeanne Hébuterne, who was nearly nine months pregnant, committed suicide the following morning by jumping out of a window of her parents' fifth-floor flat.

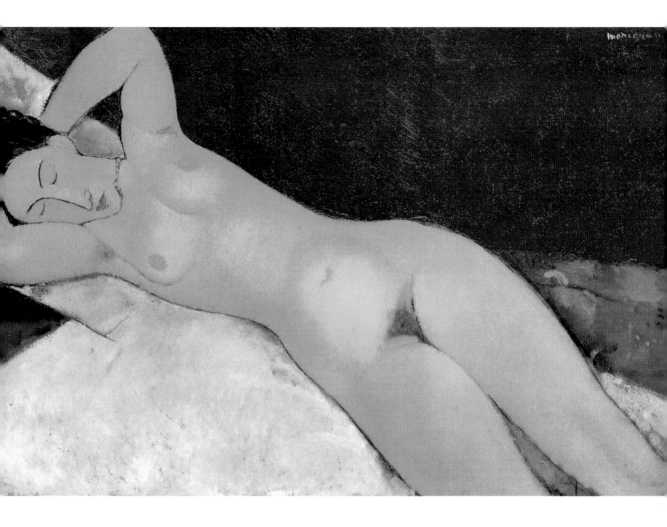

AMEDEO MODIGLIANI
(Italian, 1884–1920)
Nude with Necklace

1917
Oil on canvas
73 × 116 cm
Solomon R. Guggenheim Museum, New York

The Fiddler on the Roof
Folklore, music and persecution

Stage scene from
Jerome Robbins's
production of
Fiddler on the Roof with
Paul Lipson and
Peg Murray

**Airy beings in flight as transient phenomena
are at the heart of Marc Chagall's lyrical
interpretation of Sholem Aleichem. The Jew
floating over the rooftops is anywhere but
on firm ground. And he proves that he is an
acrobat solely by surviving nimbly in a world in
which he is not at home. He is a strange creature
who lives in books and dreams. In order to
survive, he is always inventing new fantasies
and dreams of riches and power so he doesn't
perceive the wretchedness and hopelessness
of his situation.**

Avram Kampf, *Chagall in the Moscow Yiddish Theatre*, 1991

Marc Chagall's painting of a melancholy violinist has become world famous as "the fiddler on the roof". The musical of that name, adapted from a set of tales by the Russian Jewish writer Sholem Aleichem, premiered on 22 September 1964 at the Imperial Theater in New York City and was sold-out to theatres for years. The story is set in Anatevka, a little Jewish *shtetl* in the Russian Ukraine, shortly before the revolutionary turmoils of 1905. Tevye, a milkman who owns a lame nag, lives together with his wife Golde and their five daughters in a cramped peasant cottage; they live in bitter poverty and constant fear of pogroms. Yet Tevye drives a desperate but quick-witted bargain with God and turns the tables on tragedy by the sheer volubility of his wit.

As Maurice Samuel wrote: "Life gets the better of him but he comes off better in debate with it." At first Tevye has something to hold on to: "Without tradition our lives would be just as insecure as the fiddler up there on the roof." But then nothing turns out the way one expects. His daughters refuse to let their father choose their husbands and marry as they please. Heartbreaking scenes, being disowned by their father and the depths

of despair are the consequences. An edict of the Tsar's puts an end to it all. Tevye and his wife Golde are rejected by their daughters. Denied the descendants they long for, they

Poster for *Fiddler on the Roof*, for the world premiere in
New York City, 1964

and all the other Jews of Anatevka are expelled from their homes.

Chagall was born in 1887, the son of a Jewish fishmonger in Liozno near the White Russian provincial capital of Vitebsk. His early life was remarkably like that which is enacted in the musical. At the age of thirty-three he had his first experience of scene painting and directing plays at the Moscow Yiddish Theatre.

In 1941 he emigrated – like Sholem Aleichem had twenty-five years earlier – to the United States, where he again worked in the theatre.

The musical *Fiddler on the Roof* goes back to a pre-Surrealist image of Chagall's. It was 1920 when he first painted this image on the wall of the auditorium of the Moscow Yiddish Theatre as a symbolic representation for music. Thus Chagall's colourful, opulent realm of motifs, nurtured in the soil of Jewish myth and Russian folklore, was transformed into theatre. And this theatrical reality recalls the centuries-old fate of a people who have always been driven from place to place. In the face of such hardship, often the only thing left to fall back on is faith together with irony, humanity and wit.

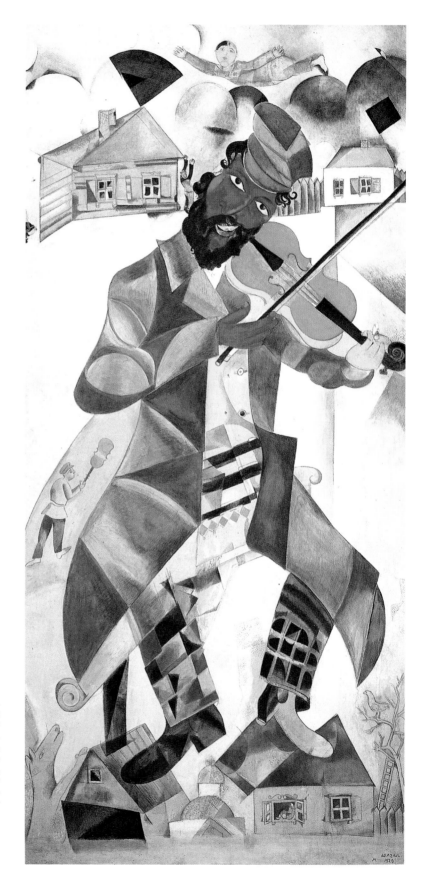

MARC CHAGALL
(Russian-born, 1887–1985)
The Green Fiddler

1920
Mural from the
Moscow Yiddish Theatre,
Tempera and gouache on canvas
213 × 104 cm
Tretyakov Gallery, Moscow

The Fat Frog at Her Side
The destiny of a woman painter

Diego. Beginning
Diego. Builder
Diego. my child
Diego. my bridegroom
Diego. Painter
Diego. my lover
Diego. my husband
Diego. my friend
Diego. my father

Diego. my mother
Diego. my son
Diego. I
Diego. Universe.
Diversity in unity.
Why do I call him my Diego?
He never was, nor will he ever be, mine.
He is his own.

Frida Kahlo, from a diary entry

The Mexican painter Diego Rivera was working on a mural when a gifted young painter came by to show him some of her work. The twenty-one-year-old Frieda Kahlo (who later changed the spelling of her name to Frida) was of multicultural descent, with a German father and a Mexican mother. She wanted to know what Rivera thought of her work. A friend of Pablo Picasso's, Rivera had lived in Paris (1911–1921) and later returned to Mexico, becoming one the most important artists of the Social Realist movement. He told Kahlo that he found her work to be expressive, sensuous and of a style distinctly her own. Rivera later said that it was immediately obvious to him that this woman was exceptionally talented. He advised her to continue painting and visited her frequently. They fell in love. In 1929 Kahlo married Rivera, who was twenty-one years her senior.

The "delicate dove and fat frog" were now a pair although their life together was tempestuous. The first strains of their marriage became apparent during a three-year stay in the United States. Rivera was fascinated by the country and its people but Kahlo soon had enough of the Americans. After their return to Mexico, Rivera engaged in several extramarital affairs. In 1935 he fell in love with Kahlo's sister Cristina, who had been his model for two murals. Deeply hurt, Kahlo left

Rivera, revenging herself on him by having affairs of her own with men and women. In 1939 Kahlo and Rivera divorced. However, they were still drawn to each other and remarried a year later in San Francisco.

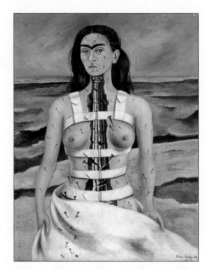

Frida Kahlo, *The Shattered Column*, self-portrait in a steel corset, 1944

The way Kahlo remembered her first wedding is captured in *Frieda and Diego Rivera*. All her paintings similarly reflect the events of her stormy life, which was overshadowed not only by her unhappy marriage. Kahlo was

dogged by ill health all her life. In 1913 polio left her with a crippled right foot which later had to be amputated. In 1925 fate struck again when she was riding a bus that collided with a tram and Kahlo sustained serious injuries to her lower abdomen and spine, forcing her to wear a corrective corset. These illnesses and misfortunes wore heavily upon her and she made her own psychological and physical pain the subject of many of her works. Stylistically she was influenced by Mexican folk art, particularly votive paintings. While she was a professor at the La Esmeralda Art School, she talked more about personal feelings than about art with her students. With her health declining rapidly, she wanted to commit suicide – "only Diego keeps me from doing it". Kahlo died a week after her forty-seventh birthday and her last diary entry reads: "I await the end joyfully. And I hope never to return."

FRIDA KAHLO
(Mexican, 1907–1954)
Frieda and Diego Rivera

1931
Oil on canvas
100 × 79 cm
Museum of Modern Art, San Francisco

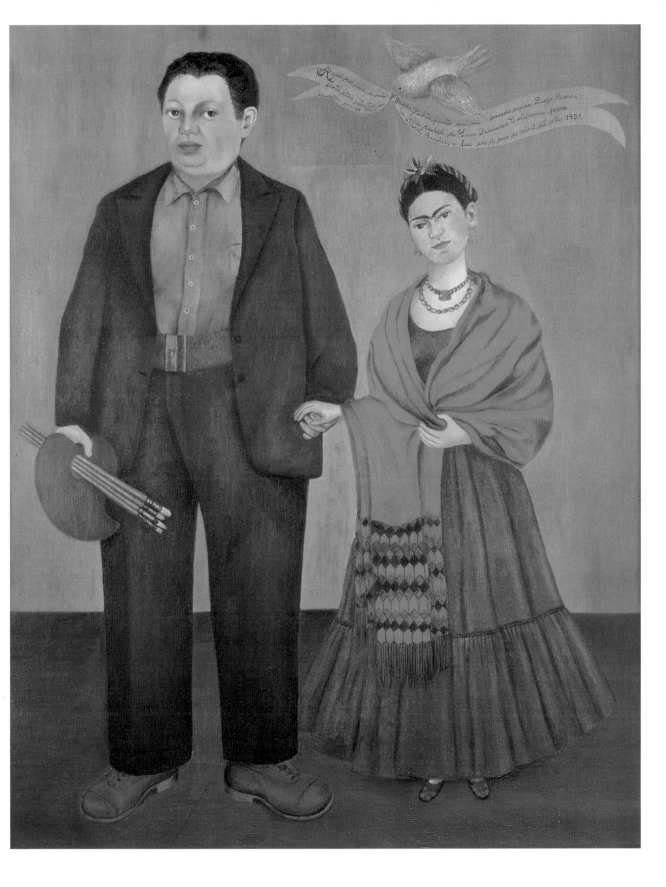

The Paranoid-Critical Camembert
Into the subconscious with Salvador Dalí

Dalí moustache, photograph by Philippe
Halsman, 1954

**You can be sure that my famous
soft watches are nothing other than
the affectionate, extravagant, lonely,
paranoid-critical Camembert of
time and space.**

Salvador Dalí, *The Conquest of the Irrational*, 1935

A ghost which can be used as a table, a skull
copulating with a concert grand piano, fried
eggs riding or a mournful mirror: the world
that appears in Salvador Dalí's pictures is cer-
tainly bizarre. He has been criticised for this,
frequently and severely. He was regarded as
neurotic, perverse and mad. One of the more
harmless epithets applied to him "an eroto-
maniac eccentric". None of this bothered
him in the least.

At twenty-five, the eccentric Catalonian
fell in love with Elena Diakonova. He called
her "Gala" and, no less scandalous than he,
she shared the rest of his life. He found
ingenious ways of wooing her: he cut his best
shirt so short that his navel showed, turned
his trousers inside out, died the hairs in his
armpits bright blue and smeared his body
with a mixture of fishpaste, goat dung and
aspic. Just before Gala entered the house, he
washed off the stinking mess, changed his
clothes and collapsed at her feet, laughing
hysterically. She found him repulsive, but by
the end of that year she vowed: "My little
boy! We'll never leave each other!"

Dalí – a boy who never grew up. Spoilt by
his permissive mother, he conducted sadistic
experiments, and his school reports were so
bad that, as a biographer relates, his parents
were devastated. However, all these ploys safe-
guarded his boundless creativity, which drew
on an inexhaustible imagination, from outside
intervention. He became one of the great
visionaries of the Surrealist movement and
modern painting.

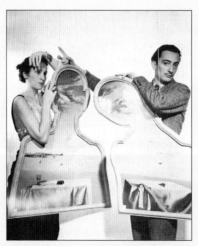

Heads in the clouds: Gala and Salvador Dalí, photograph
by Cecil Beaton, 1936

Influenced by Freudian psychology and in-
spired by his own subconscious, he captured
the irrational world of his dreams, visions and
hallucinations on canvas with meticulous
objectivity. Making a fetish of detail, he wrote
books about everything he was doing and
created ballet sets and film scenarios teeming
with his grotesque motifs. Dalí was certainly a
self-obsessed megalomaniac and a choleric
one at that. He was both an anarchist and an
admirer of monarchy, and has been accused
of having fascist tendencies. He publicly pro-
claimed his right to be insane. Yet he is sup-
posed to have drawn on mundane reality for
at least some of his inspiration. The story has
it that he painted *The Persistence of Memory* after
having eaten Camembert.

SALVADOR DALÍ
(Spanish, 1904–1989)
The Persistence of Memory

1931
Oil on canvas
26.3 × 36.5 cm
The Museum of Modern Art, New York

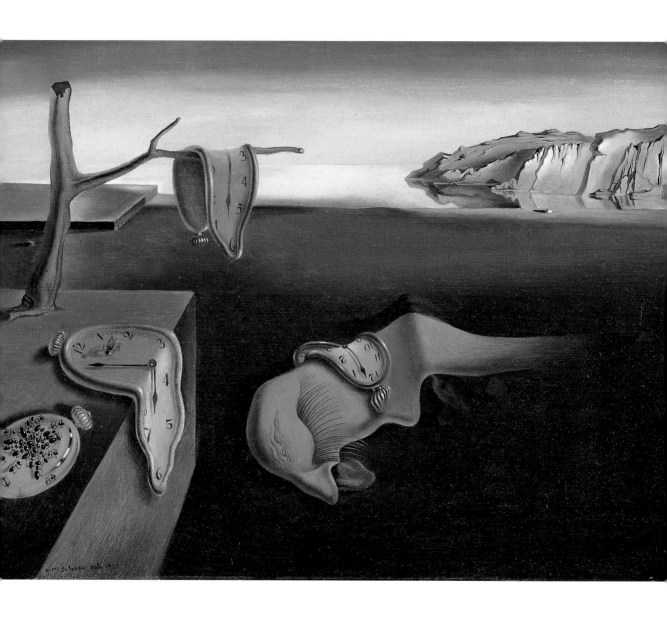

Man's Inhumanity to Man
Europe in turmoil

The painting which I did after the defeat of the Republicans was *L'ange du foyer* (Fireside angel). This is, of course, an ironic title for a clumsy figure devastating everything that gets in its way. At the time, this was my impression of what was happening in the world, and I think I was right.

Max Ernst, from his writings, 1948

Sergeant Yoldi was appalled: "There was nothing to be heard but the crackle and roar of flames. No one spoke and even the cattle trotting aimlessly through the streets made no noise. We were all dumb with horror. I had known Guernica before the war – there was nothing left of it. It had been a little town with red-roofed, white-walled houses. Now its streets were strewn with charred animal carcasses." On 26 April 1937, just twenty-four hours before Sergeant Yoldi arrived in Guernica, the town had been bombed by the German Condor Legion. This became the most famous of the Spanish Civil War atrocities, horrifying a world which had not yet grown used to air attacks on defenceless cities.

The war began in July 1936, when General Francisco Franco led a revolt against the Spanish Republic. The Spanish Left had won a parliamentary majority but was unable to restrain those among them who were determined that their turn in power should be used to destroy the Right. Franco's revolt became a civil war, and Franco received the support of Mussolini's Italy and Hitler's Germany, which went so far as to send troops – using the Spanish war to try out new weapons and tactics. The Republicans were supported by volunteers from all over the world, as well as by Stalin's Soviet Union. Horrifying and sadistic atrocities were committed by both sides – Pablo Picasso, who was a Spaniard, made Guernica the subject of one of his most famous paintings. After Franco's victory the German painter Max Ernst created his spectral *L'ange du foyer* (Fireside angel), an apocalyptic monster bursting with destructive energy, a King-Kong-like Angel of Death spreading fear and terror.

Ernst was born in 1891 at Brühl near Cologne, and as a painter he was quite "degenerate": or this is how he was described by the propagandists of the Third Reich. In 1921 Ernst moved to Paris, where he threw himself into sculpture, print-making and film as well as painting. There he became a participant in the French Dada movement, a short-lived movement from 1916 to about 1922 which declared that all established values, morals and aesthetics had been rendered meaningless by the catastrophe of World War I. Later, in 1924, Ernst became a member of the Surrealist movement which followed Dada and was considered one of its most innovative members. The Surrealists still touted the importance of chance in their work, as did the Dadaists, but added to it more control and theories borrowed from psychoanalysis, emphasising the subconscious and the importance of dream imagery.

In 1937, the year he painted *L'ange du foyer*, Ernst learned that the National Socialists had confiscated his early work, which he had left behind in Germany. It was soon destroyed in the National Socialist effort to "purify" German art. We may suppose, then, that when he painted this work, Spain was not the only thing worrying him. When World War II began, the French interned Ernst at Aix-en-Provence as an "enemy alien", but friends interceded for him. He was released and ordered to leave France. He went to the United States of America with the help of the art connoisseur and collector Peggy Guggenheim, who he later married.

The scene of destruction: The Basque town of Guernica y Luno after the bombing of 26 April 1937

MAX ERNST
(German, 1891–1976)
**L'ange du foyer
(Fireside angel)**

1937
Oil on canvas
114 × 146 cm
Private Collection

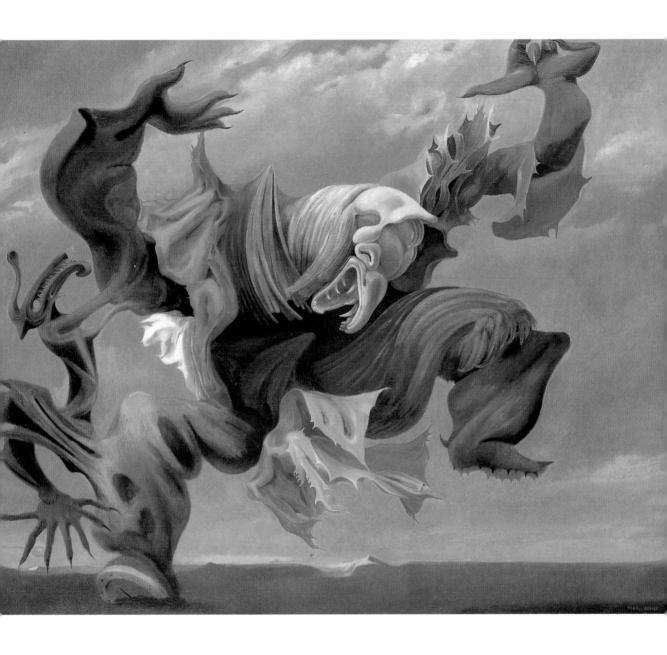

The Silent Observer
An American dream

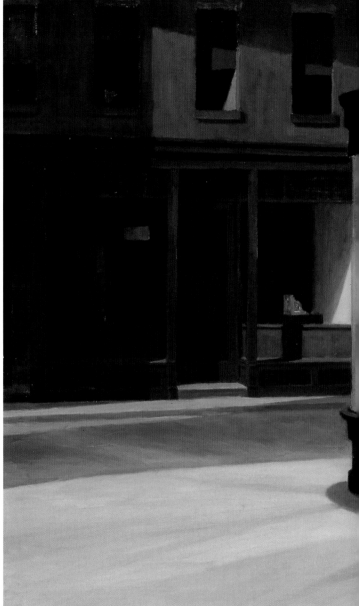

Dusk gently smoothes crispangled streets.
Dark presses tight the steaming asphalt
city, crushes the fretwork of windows and
lettered signs and chimneys and water-
tanks and ventilators and fire-escapes
and moldings and patterns and corrugations
and eyes and hands and neckties into blue
chunks, into black enormous blocks.
Under the rolling heavier heavier pressure
windows blurt light. Night crushes bright
milk out of arclights, squeezes the sullen
blocks until they drip red, yellow, green into
streets resounding with feet. All the asphalt
oozes light. Light spurts from lettering on
roofs, mills dizzily among wheels, stains
rolling tons of sky.

John Dos Passos, *Manhattan Transfer*, 1925

In Edward Hopper's urban pictures there are no skyscrapers. Nor are there any massive high-way systems, sprawling strip-malls, factories or slums. African-Americans, Hispanics or Asians are also absent from his city scenes. Hopper, a native New Yorker, studied commercial art, attended art school and made several tours of Europe before starting out as a commercial artist with an advertising firm. He only painted middle-class white America, with occasional references to its mechanical civilisation: a deserted filling station or an abandoned typewriter. Still he is regarded as the greatest Realist painter of his generation.

Hopper's paintings record everyday American life, circa 1920–1960, but he particularly emphasised its dreariness. He refused to sing paeans of praise to the "land of unlimited possibilities". He thought America "hideous-ly chaotic" and directed his attention to the everyday philistines, those who did not start

off washing dishes or would not end up millionaires on Long Island. Portraying the mundane and seemingly joyless activities of their daily lives, he eschewed overt technical brilliance and painterly precision. There is always a tragic, paralyzing monotony, a creep-ing anxiety, whether he is hinting at endless unpopulated expanses behind the trees along a deserted road or the grim dinginess of Man-

hattan tenements viewed in the glare from an elevated railway. Hopper often sketched his figures against the backdrop of New York City, where 3.5 million anonymous lives were already swallowed up by the early twentieth century.

Few paintings are more haunting than *Nighthawks*. Hopper himself said that the work showed a restaurant at an intersection of

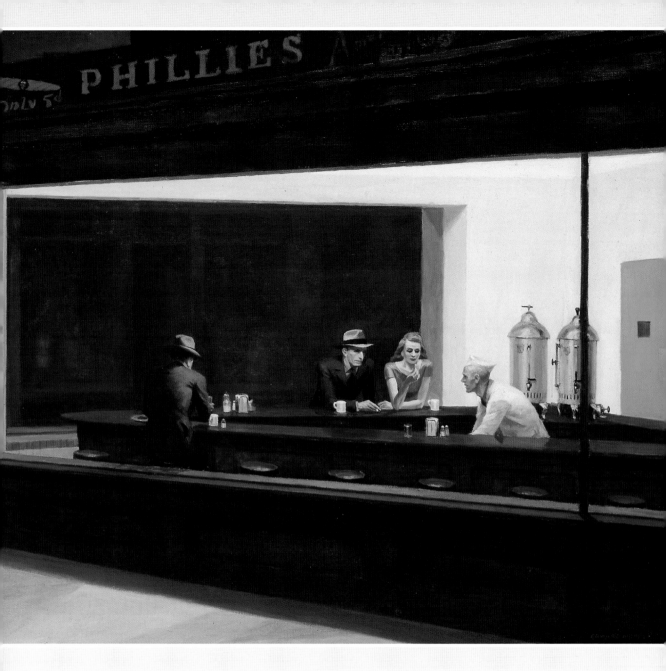

Greenwich Avenue. He had simplified the melancholy scene and enlarged the restaurant. He reflected that he had more or less instinctively tried to paint the loneliness of a big city.

The starkness of Hopper's approach may well have been inspired by Ernest Hemingway. Hopper found Hemingway's short story, *The Killers*, written in the 1920s, to be refreshingly different from what one usually encountered when leafing through an American magazine. The authenticity of Hemingway's work contrasted sharply with the pretentious, sugary pap churned out by his contemporaries. Hopper thought Hemingway refused to make concessions to popular taste, never deviating from the truth and offering no delusive hopes at the end. Like Hemingway, Hopper never sugar-coated anything.

EDWARD HOPPER
(American, 1882–1967)
Nighthawks

1942
Oil on canvas
76.2 × 144 cm
The Art Institute of Chicago

Claustrophobic Fear
Francis Bacon and the pope

Francis Bacon, April 1992

I have always been very moved by the movements of the mouth and the shape of the mouth and the teeth. People say that these have all sorts of sexual implications.... I like, you may say, the glitter and colour that comes from the mouth, and I've always hoped in a sense to be able to paint the mouth like Monet painted the sunset.

David Sylvester, *Interviews with Francis Bacon: 1962–1979*, 1975

Shot in the eye: A still from Sergey Eisenstein's film *The Battleship Potemkin*, 1925

Pope Innocent X was a magnanimous prince of the Church and a discerning lover of the arts but was said to have less influence over the Vatican Curia than his brother's widow, whose intercession was sought out by cardinals and ambassadors. Yet Innocent X was thought to be a good Pope – especially in Spain. He had taken the Spanish side in some royal quarrels and his portrait was painted in 1650 by the court painter of King Philip IV, Diego Velázquez (1599–1660). Nearly 300 years later, Velázquez's portrait became the fascination of a very modern artist. In 1909 Francis Bacon was born to English parents living in Dublin, but his fascination for this portrait did not develop until 1949: "I think it is one of the greatest portraits that has ever been made, and I became obsessed by it. I buy book after book with this illustration in it of the Velázquez *Pope [Innocent X]*, because it haunts me, and it opens up all sorts of feelings …".

Bacon executed over twenty-five variations on Velázquez's work, among them *Head VI*. Bacon said that he had intended to work over the picture plane to make it look like "the skin of a hippopotamus", though in other respects the picture was painted to be "like Velázquez". Yet Bacon had never seen Velázquez's original portrait, which hangs in the

Galleria Doria Pamphili in Rome. Bacon claimed that for nearly two or three years he was so entranced by this portrait, that he attempted to paint a work equal to it. Bacon speculated that it was partly due to the magni-

The pope setting an example: Diego Velázquez, *Pope Innocent X*, 1650

ficent handling of colour which intrigued him. Or the high office of Innocent X, who surveyed the world from a sovereign's throne. Pope Innocent X had the appearance of a tragic hero. This is what Bacon wanted to portray, but, unlike Velázquez, he tore off the official facade to reveal the inner man. Bacon's *Pope Innocent X* does not look at us *ex cathedra*.

He is a private person, a solitary being whose sufferings, brought on by loneliness, are wrenched from him in a scream – as if his isolation had induced claustrophobic fear.

Head VI may remind us of Albert Camus's *The Stranger*, Jean-Paul Sartre's *No Exit* or perhaps even Sergey Eisenstein's *Battleship Potemkin*. Eisenstein's film of the 1925 Russian revolution contains a brutal close-up: a screaming woman is being hit in the eye by a bullet, losing control of the pram she has been pushing. The scene is a distillation of existential fear; a still photo of it was hanging in Bacon's studio when he painted *Head VI*.

FRANCIS BACON
(English, 1909–1992)
Head VI

1949
Oil on canvas
93 × 77 cm
Arts Council Collection and
Hayward Gallery, London

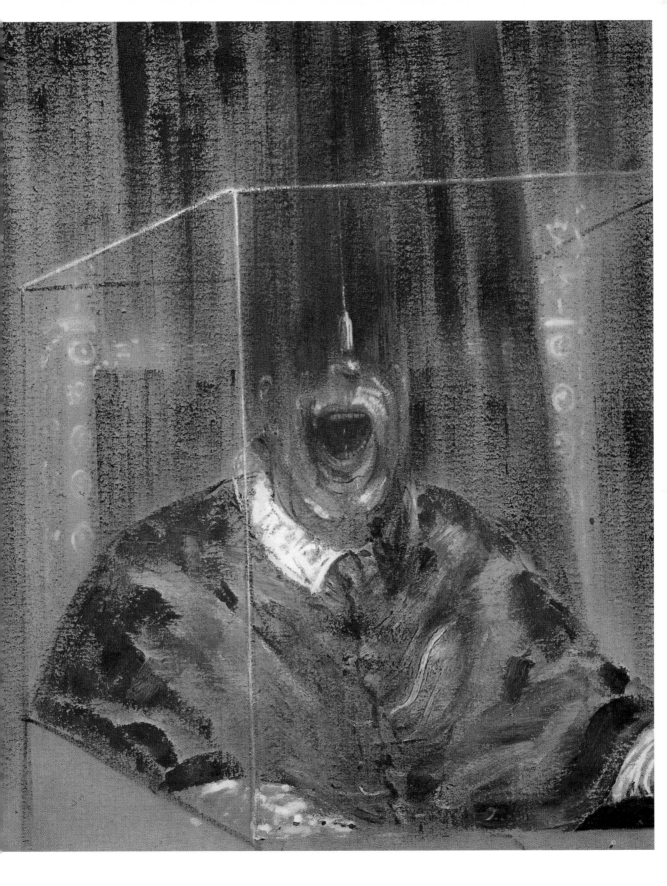

Making Myths
Film and art

On honeymoon, with Arthur Miller, Englefield Green, Surrey, 1956

She acted out her life under the devouring gaze of a gigantic audience, one that couldn't get enough of her: Marilyn, the enchanting child-woman, the breathtaking sex-symbol, the unattainable goddess of film. She was unforgettable in *Gentlemen Prefer Blondes*, *Some Like It Hot*, and *The Seven-Year Itch*. She was wildly acclaimed, dominated the headlines, filled the gossip columns and incarnated the dreams of a decade. Behind the glitz, glamour and the luscious smile which enthralled the world was a vulnerable and immature woman. Did America know it all along? Was that the secret source of her mystique? She had a terrible childhood. She said that she was probably a mistake, that her mother hadn't wanted to have her at all. She never knew her father and was bounced between her mother's home and a series of adoptive families; her mother had a nervous breakdown and Marilyn spent two years in an orphanage. She never graduated from high school and married at sixteen, perhaps to avoid being sent back to an orphanage. She was later to comment that her marriage wasn't unhappy; but it wasn't happy either. She and her husband just didn't have much to say to each other.

Her discovery was all part of the war effort. While her husband was fighting in World War II Marilyn was in a factory checking parachutes. Ronald Reagan sent David Conover, a twenty-five-year-old army photographer, to photograph cheerful young

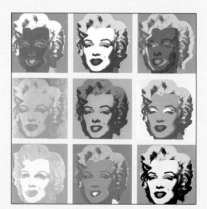

Marilyn Monroe, 1967

munitions-factory workers. Conover took notice of this girl who could make more out of a pose than anyone he had ever seen. The publicists took his discovery and created "Marilyn Monroe", the icon of post-war Hollywood. She was oddly detached and alienated, saying she always had the feeling that she was not real, that she was something like a well-made counterfeit. She was sure that everyone had similar feelings from time to time but in her case things had gone so far that she sometimes thought she was completely synthetic. She died on the night of 4 August 1962 under mysterious circumstances, but her legend lived on and even grew.

Andy Warhol, the son of Czech immigrants, began his artistic career in advertising, moved on to film-making and became high-society's favourite portrait artist. He ended up a cult figure, probably *the* cult figure, of Pop Art. His *Marilyn Monroe* is a twentieth-century icon of art. He wrote of his work that, whether or not his loud colours made her into a symbol was irrelevant, and if the colours were beautiful, it was because *she* was; beauty calls for beautiful colours. Marilyn Monroe was commercialised beauty, quite artificial and quite misunderstood.

ANDY WARHOL
(American, 1928–1987)
Marilyn Monroe

1967
Detail
Silk-screen prints on paper
Each 91.5 × 91.5 cm
Private Collection

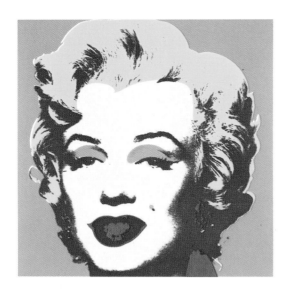
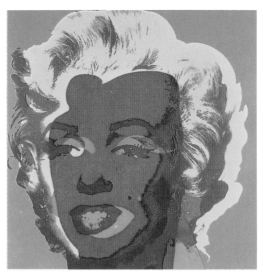
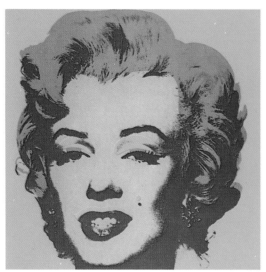
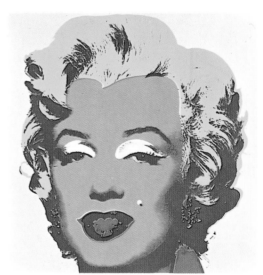

Suggested Reading

Prehistoric Art that Made the World Think Again
Bornefeld, Hans W.: *The Keys to the Caverns*. Kiel, 1994.
Rand, Paul: *From Lascaux to Brooklyn*. New Haven, CN, 1996.
Ruspoli, Mario: *The Cave of Lascaux: The Final Photographs*.
 New York, 1987.

The Pharao's Curse
Aldred, Cyril: *Tutankhamen's Egypt*. New York, 1972.
Carter, Howard: *The Tomb of Tutankhamen*. London, 1972.
Carter, Howard and A.C. Mace: *The Discovery of the Tomb of
 Tutankhamen*. New York, 1977.
Germer, Renate: *Mummies: Life after Death in Ancient Egypt*.
 Munich/New York, 1997.
Macdonald, Fiona: *The World in the Time of Tutankhamen*.
 Parsippany, NJ, 1997.
Vassilika, Eleni: *Egyptian Art*. Cambridge/New York, 1992.

Fertile Beginnings
Bremmer, Jan (ed.): *Interpretations of Greek Mythology*.
 Totowa, NJ, 1986.
Graham, James W.: *The Palaces of Crete*. Princeton, NJ, 1987.
Homer: *Odyssey*. Cambridge, 1964.
Martin, Roland: *Greek Architecture: Architecture of Crete, Greece,
 and the Greek World*. New York, 1988.
Nagy, Gregory: *Greek Mythology and Poetics*. Ithaca, NY, 1990.
Willetts, Ronald F.: *Everyday Life in Ancient Crete*.
 Amsterdam, 1988.

What Would Life Be Without Music?
Macnamara, Ellen: *The Etruscans*. Cambridge, MA, 1991.
Phillips, Tom: *Music in Art Through the Ages*.
 Munich/New York, 1997.
West, M.L.: *Ancient Greek Music*. Oxford/New York, 1992.

Everyday Life Freezes into Burning Darkness
Guillaud, Jacqueline: *Frescoes in the Time of Pompeii*.
 Paris/New York, 1990.
Kraus, Theodor: *Pompeii and Herculaneum: The Living Cities
 of the Dead*. New York, 1975.
Mau, August: *Pompeii, its Life and Art*.
 New Rochelle, NY, 1982.
Richardson, Lawrence: *Pompeii: An Architectural History*.
 Baltimore, MD, 1988.

"Upon this Rock I Will Build My Church"
Gough, Michael: *The Origins of Christian Art*. London, 1973.
Milburn, Robert: *Early Christian Art and Architecture*.
 Berkeley, CA, 1988.
Verbrugge, Verlyn D.: *Early Church History*.
 Grand Rapids, MI, 1998.

From Brothel to Court
Bovini, Giuseppe: *Ravenna. Its Mosaics and Monuments*.
 Ravenna, 1970.
Browning, Robert: *Justitian and Theodora*. New York, 1987.
Corrick, James A.: *The Byzantine Empire*.
 San Diego, CA, 1997.

"Which Was, and Which Is, and Which Is to Come"
McGinn, Bernard: *Visions of the End: Apocalyptic Traditions
 in the Middle Ages*. New York, 1979.
Meehan, Bernard: *The Book of Kells: An Illustrated Introduction
 to the Manuscript in Trinity College, Dublin*. New York, 1994.
Megaw, Ruth and Vincent: *Celtic Art: From its Beginnings to
 the Book of Kells*. New York, 1989.
Simms, George Otto: *Exploring The Book of Kells*.
 Dublin, 1988.

Idle Hands Are the Devil's Workshop
Carletti, Giuseppe: *Life of St. Benedict*. Freeport, NY, 1971.
De Waal, Esther: *A Life-Giving Way: A Commentary on the
 Rule of St. Benedict*. London 1995.
Fry, Timothy (ed.): *The Rule of St. Benedict in English*.
 New York, 1988.

Ten-Sixty-Six and All That
Bates, David: *William the Conqueror*. London, 1989.
Bell, G.: *The Bayeux Tapestry: History and Description*.
 St. Claire Shores, MI, 1971.
Gameson, Richard (ed.): *The Study of the Bayeux Tapestry*.
 Rochester, 1997.
Grape, Wolfgang: *The Bayeux Tapestry*.
 Munich/New York, 1994.
May, Robin: *William the Conqueror and the Normans*.
 New York, 1984.
Rud, Mogens: *The Bayeux Tapestry and the Battle of Hastings, 1066*.
 Copenhagen, 1992.

The Court and the Church: The Great Divide
Bevan, Bryan: *Henry IV*. New York, 1994.
Ullmann, Walter: *The Papacy and Political Ideas in the
 Middle Ages*. London, 1976.

Medieval Medical Matters
Flanagan, Sabina: *Hildegard of Bingen, 1098–1179: A Visionary
 Life*. London/New York, 1989.
Schipperges, Heinrich: *Hildegard von Bingen: Healing and the
 Nature of the Cosmos*. Princeton, NJ, 1996.
Strehlow, Wighard and Gottfried Hertzka: *Hildegard of
 Bingen's Medicine*. Santa Fe, NM, 1988.
Ulrich, Ingeborg: *Hildegard of Bingen: Mystic, Healer, Companion
 of the Angels*. Collegeville, MN, 1993.

Fate and the Entire Cosmos of Medieval Life
Carmina Burana: cantiones profanae. Original text with intro-
 duction, facing vocabularies, translations and essays
 by Judith Lynn Sebesta. Wanconda, IL, 1996.
Liess, Andreas: *Carl Orff*. London, 1966.
Saliba, Konnie K.: *Accent on Orff: An Introductory Approach*.
 Englewood Cliffs, NJ, 1991.
Waldburg Wolfegg, Christoph Graf zu: *The Medieval
 Housebook*. Munich/New York, 1998.

The Art of Falconry
Abulafia, David: *Frederick II: A Medieval Emperor*.
 New York, 1992.
Chamerlat, Christian Antoine de: *Falconry and Art*.
 London/New York, 1987.
Oswald, Allan: *The History and Practice of Falconry*.
 St. Helier, 1982.

How a Poor Little Man Put the World Right
Bucci, Mario: *Giotto*. New York, 1989.
Lunghi, Elvio: *The Basilica of St Francis at Assisi: The Frescoes
 by Giotto, His Precursors and Followers*. London, 1996.
Moleta, Vincent: *From St. Francis to Giotto:
 The Influence of St. Francis on early Italian Art and Literature*.
 Chicago, 1983.
Smart, Alastair: *The Assisi Problem and the Art of Giotto:
 A Study of the Legend of St. Francis in the Upper Church of
 San Francesco, Assisi*. Oxford, 1971.

Thou Art Mine and I Am Thine
Hall, Clifton and Samuel Coleman: *Walther von der Vogelweide:
 A Complete Reference Work*. Niwot, CO, 1995.

Idle Hands Are the Devil's Workshop
McMahon, James V.: *The Music of Early Minnesang*.
 Columbia, SC, 1990.
Scheibe, Fred Karl: *Walther von der Vogelweide, Troubadour of the
 Middle Ages: His Life and His Reputation in the English-speaking
 Countries*. New York, 1969.

A Useful Thing, Peace!
Hook, Judith: *Siena, a City and its History*. London, 1979.
Southard, Edna Carter: *The Frescoes in Siena's Palazzo pubblico,
 1289–1539*. New York, 1979.
Starn, Randolph: *Ambrogio Lorenzetti: The Palazzo pubblico, Siena*.
 New York, 1994.

God Moves in Mysterious Ways
Cruz, Joan Carroll: *Relics*. Huntington, IN, 1984.
Jarrett, Bede: *The Emperor Charles IV*. New York, 1935.

Kings and Peasants in Miniature
Beckett, Wendy: *The Duke and the Peasant: Life in the Middle Ages*.
 Munich/New York, 1997.
Chamberlain, Lydia: *Très riches heures*. Lanham, MD, 1992.
Cazelles, Raymond and Johannes Rathofer:
 *Illuminations of Heaven and Earth: The Glories of the Très riches
 heures du duc de Berry*. Foreword by Umberto Eco.
 New York, 1988.
Schacherl, Lillian: *Très Riches Heures: Behind the
 Gothic Masterpiece*. Munich/New York, 1997.

To You Have I Given Myself
Châtelet, Albert: *Van Eyck*. Woodbury, NY, 1980.
Hall, Edwin: *The Arnolfini Betrothal: Medieval Marriage and the
 Enigma of Van Eyck's Double Portrait*. Berkeley, CA, 1994.
Seidel, Linda: *Jan Van Eyck's Arnolfini Portrait: Stories of an Icon*.
 Cambridge/New York, 1993.

"In this Sign Thou Shalt Conquer"
Bertelli, Carlo: *Piero della Francesca*. New Haven, CN 1992.
Grant, Michael: *Constantine the Great: The Man and His Times*.
 New York, 1994.
Lightbown, Ronald: *Piero della Francesca*. New York,1992.

The Pagan Dragon
Borsi, Franco: *Paolo Uccello*. New York, 1994.
McCreless, Patrick: *Wagner's "Siegfried": Its Drama, History
 and Music*. Ann Arbor, MI, 1982.
Passes, David: *Dragons: Truth, Myth, and Legend*.
 New York, 1993.
Uccello, Paolo: *All the Paintings of Paolo Uccello*.
 New York, 1969.

A Lesson in Perspectives
Carr, Dawson W.: *Andrea Mantegna: The Adoration of the Magic*.
 Los Angeles, 1997.
Boorsch, Suzanne: *Andrea Mantegna*.
 Cat., London/Milan/New York, 1992.
Lightbown, Ronald: *Mantegna, With a Complete Catalogue
 of the Paintings, Drawings and Prints*. Oxford, 1986.

Venus: The Evening Star
Dunn-Mascetti, Manuela: *Aphrodite: Goddess of Love*.
 San Francisco, 1996.
Lightbown, Ronald: *Sandro Botticelli: Life and Work*.
 New York, 1989.
Rose, H.J.: *A Handbook of Greek Mythology*.
 London/New York, 1991.
Zöllner, Frank: *Botticelli: A Tuscan Spring*.
 Munich/New York, 1998.

Myths and Medicine

Curley, Michael J.: *Physiologus*. Austin, TX, 1979.
Erlande-Brandenburg, Alain: *The Lady and the Unicorn*.
Paris, 1979.
Freeman, Margaret B.: *The Unicorn Tapestries*.
New York, 1976.

Thus God Created Man in His Image

Brion, Marcel: *Dürer: His Life and Work*. New York, 1960.
Lüdecke, Heinz: *Albrecht Dürer*. New York, 1972.
Ripley, Elizabeth: *Dürer, a Biography*.
Philadelphia, PA, 1958.

Heaven and Hell

Harris, Lynda: *The Secret Heresy of Hieronymus Bosch*.
Edinburgh, 1995.
Linfert, Carl: *Hieronymus Bosch*. New York, 1989.
Mearns, Rodney (ed.): *The Vision of Tundale*.
Heidelberg, 1985.
Snyder, James: *Hieronymus Bosch: The Man and His Paintings*.
New York, 1980.

The Demonic Enchantment of a Smile

Eissler, Kurt Robert: *Leonardo da Vinci: Psychoanalytic
Notes on the Enigma*. New York, 1961.
Galli, Letizia: *Mona Lisa: The Secret of the Smile*.
New York, 1996.
MacDonald, Fiona: *The World in the Time of Leonardo da Vinci*.
Parsippany, NJ, 1998.
McLanathan, Richard: *Leonardo da Vinci*. New York, 1990.

"And the Lord God Called unto Adam, and Said unto Him, Where Art Thou?"

Bull, George: *Michelangelo: A Biography*. New York, 1996.
Eliot, Alexander: "The Sistine Cleanup: Agony or
Ecstasy?", in: *Harvard Magazine* 89/4 (1987). p. 28–38.
Gilbert, Creighton: *Michelangelo: On and off the Sistine Ceiling*.
New York, 1994.
Michelangelo: The Sistine Chapel. New York/Avenel, NJ, 1992.

Queen of Angels and Men

Beck, James H.: *Raphael*. New York, 1994.
Gillette, Henry S.: *Raphael: Painter of the Renaissance*.
New York, 1967.
Levey, Michael: *Florence: A Portrait*. Cambridge, MA, 1996.
Müntz, Eugène: *Raphael, His Life, Works and Times*.
Boston, MA, 1977.

Money Makes the World Go Round

Fryde, E.B.: *Studies in Medieval Trade and Finance*.
London, 1983.
Silver, Larry: *The Paintings of Quentin Massys with catalogue
raisonné*. Montclair, NJ, 1984.

Plagued to Death

McGowen, Tom: *The Black Death*. New York, 1995.
Mellinkoff, Ruth: *The Devil at Isenheim: Reflections on Popular
Belief in Grünewald's Altarpiece*. Berkeley, CA, 1988.
Monick, Eugene: *Evil, Sexuality, and Disease in Grünewald's
Body of Christ*. Dallas, TX, 1993.

"When Shall We Three Meet Again"

Dukes, Eugene D.: *Magic and Witchcraft in the Dark Ages*.
Lanham, 1996.
Kors, Alan Charles and Edward Peters:
Witchcraft in Europe, 1100–1700; A Documentary History.
Philadelphia, PA, 1972.
Levack, Brian P. (ed.): *Witch-Hunting in Continental Europe:
Local and Regional Studies*. New York, 1992.
Shakespeare, William: *Macbeth*.
Cambridge/New York, 1997.

A Battle that Changed the World

Bosworth, A.B.: *Conquest and Empire: the Reign of Alexander
the Great*. Cambridge/New York, 1988.
Roisman, Joseph (ed.): *Alexander the Great:
Ancient and Modern Perspectives*. Lexington, MA, 1995.
Stoneman, Richard: *Alexander the Great*.
London/New York, 1997.
Wood, Christopher S.: *Albrecht Altdorfer and the Origins of
Landscape*. Chicago, 1993.

A Hotbed of Crime and Fornication

Dickens, A.G.: *Martin Luther and the Reformation*.
London, 1967.
Fearon, Mike: *Martin Luther*. Minneapolis, MN, 1986.
Friedländer, Max J. and Jacob Rosenberg:
The Paintings of Lucas Cranach. Ithaca, NY, 1978.
Schade, Werner: *Cranach, a Family of Master Painters*.
New York, 1980.

Give Yourself Body and Heart to Me

Fraser, Antonia: *The Wives of Henry VIII*. New York, 1994.
Ridley, Jasper: *Henry VIII*. New York, 1985.
Rowlands, John: *Holbein: The Paintings of Hans Holbein
the Younger*. Oxford, 1985.
Warnicke, Retha M.: *The Rise and Fall of Anne Boleyn:
Family Politics at the Court of Henry VIII*. New York, 1989.
Williams, Neville: *Henry VIII and His Court*. London, 1971.

Who Has Ever Read in His Soul?

Biadene, Susanne: *Titian: Prince of Painters*. Munich, 1990.
Grant, Neil: *Charles V, Holy Roman Emperor*. New York, 1970.
Hope, Charles: *Titian*. London, 1980.
Rady, Martyn C.: *The Emperor Charles V*.
London/New York, 1988.
Ridolfi, Carlo: *The Life of Titian*. University Park, PA, 1996.

Let Us Build a Tower to the Heavens

Delevoy, Robert L.: *Bruegel*. New York, 1990.
Stechow, Wolfgang: *Pieter Bruegel the Elder*. New York, 1990.
The Tower of Babel: An Anthology. West Burke, VT, 1975.

Cowards Don't Go to Heaven

Cervantes, Miguel de: *Don Quixote*. New York, 1981.
Close, Anthony J.: *Miguel de Cervantes, Don Quixote*.
Cambridge/New York, 1990.
Franzoi, Umberto: *The Doge's Palace in Venice*. Venice, 1973.
Paulson, Michael G.: *Lepanto: Fact, Fiction, and Fantasy*.
Lanham, 1986.
Rosand, David: *Painting in Sixteenth Century Venice*.
Cambridge, 1997.

Blessed Be the Fruits of Culture

Barthes, Roland: *Arcimboldo*. Milan, 1980.
Holzer, Hans: *The Alchemist: The Secret Magical Life of Rudolf
von Habsburg*. New York, 1974.
Hulten, Pontus: *The Arcimboldo Effect:
Transformations of the Face from the 16th to the 20th Century*.
New York, 1987.
Kaufmann, Thomas DaCosta: *The School of Prague:
Painting at the Court of Rudolf II*. Chicago, 1988.
Maiorino, Giancarlo: *The Portrait of Eccentricity: Arcimboldo
and the Mannerist Grotesque*. University Park, PA, 1991.

Only a Storm Brewing?

Bronstein, Leo: *El Greco*. New York, 1990.
Tomlinson, Janis: *From El Greco to Goya: Painting in Spain,
1561–1828*. New York, 1997.

Expanding Horizons

Alexander, Michael (ed.): *Discovering the New World.
Based on the Works of Theodore de Bry*. New York, 1976.

Barden, Renardo: *The Discovery of America: Opposing Viewpoints*.
San Diego, CA, 1989.
Chrisp, Peter: *Voyages to the New World*. New York, 1993.
Sale, Kirkpatrick: *The Conquest of Paradise: Christopher
Columbus and the Columbian Legacy*. New York, 1991.

Love Rules the World

The Age of Caravaggio. Catalog of an exhibition at the
Metropolitan Museum of Art, New York,
February–April 1985. New York, 1985.
Friedlaender, Walter F.: *Caravaggio Studies*. New York, 1969.
Gash, John: *Caravaggio*. New York, 1994.

Tempestuously Voluptuous

Alpers, S.: "Manner and Meaning in some Rubens
Mythologics", in: *Journal of the Warburg and Courtauld
Institute* 30 (1967). p. 272ff.
Downes, Kerry: *Rubens*. London, 1980.
Warnke, Martin: *Peter Paul Rubens: Life and Work*.
Woodsbury, NY, 1980.
White, Christopher: *Peter Paul Rubens: Man and Artist*.
New Haven, CN, 1987.

May God Only Keep Thee, Thou Juice of the Grape

Knuttel, Gerhardus: *Adrien Brouwer, the Master and His Work*.
The Hague, 1962.
Reynolds, E.J.: *Some Brouwer Problems*. Lausanne, 1931.

Wherever We Look there Is Fire, Plague and Death

Ahnlund, Nils: *Gustav Adolf the Great*. Westport, CN, 1983.
Asch, Ronald G.: *The Thirty Years War: The Holy Roman Empire
and Europe, 1618–48*. New York, 1997.
Parker, Geoffrey: *The Thirty Years' War*.
London/New York, 1997.

A Painting Well Guarded

Haverkamp-Begemann, Egbert: *Rembrandt, The Nightwatch*.
Princeton, NJ, 1982.
Hijmans, Willem and others: *Rembrandt's Nightwatch:
The History of a Painting*. Alphen aan den Rijn, 1978.
Schwartz, Gary: *Rembrandt: His Life, His Paintings*.
London/New York, 1991.

Landscapes, Light and Legends

Jamie, Kathleen: *The Queen of Sheba*.
Newcastle upon Tyne, 1995.
Langdon, Helen: *Claude Lorrain*. Oxford, 1989.
Russell, Diane H.: *Claude Lorrain, 1600–1682*.
Washington, DC, 1982.

Behind the Scenes

Hume, Martin Andrew Sharp: *The Court of Philip IV*.
New York, 1927.
López-Rez, José: *Velásquez*. London, 1980.
Stradling, R.A.: *Philip IV and the Government of Spain,
1621–1665*. Cambridge/New York, 1988.
Sutton, Denys: *Diego Velásquez*. New York, 1967.

Everyday Scenes Transformed Into Poetry

Arasse, Daniel: *Vermeer, Faith in Painting*.
Princeton, NJ, 1994.
Wheelock, Arthur K.: *Vermeer: The Complete Works*.
New York, 1997.
Wheelock, Arthur K.: *Vermeer and the Art of Painting*.
New Haven, CN, 1995.

L'état c'est moi!

Ashley, Maurice Percy: *The Age of Absolutism, 1648–1775*.
Springfield, MA, 1974.
Bernier, Olivier: *Louis XIV: A Royal Life*.
Garden City, NY, 1987.

Lewis, W.H.: *The Splendid Century: Life in the France of Louis XIV.* New York, 1971.

Pierrot and other Clowns
Jones, Louisa E.: *Pierrot – Watteau: A Nineteenth-Century Myth.* Tübingen/Paris, 1984.
Lee, Kathleen Marguerite: *Italian Popular Comedy: A Study in the Commedia dell'arte, 1560–1620.* New York, 1962.
Shakespeare, William: *A Midsummer Night's Dream.* Oxford/New York, 1996.
Wine, Humphrey: *Watteau.* London/New York, 1992.

A City Rich in Gold
Baker, Christopher: *Canaletto.* London, 1994.
Levey, Michael: *Painting in XVIII Century Venice.* London, 1959.
Mann, Thomas: *Death in Venice.* New York, 1970.
Steer, John: *Venetian Painting: A Concise History.* London, 1970.

A Clever Mistress
Ananoff, Alexandre: *François Boucher.* Lausanne, 1976.
Hunter-Stiebel, Penelope: *Louis XV and Madame de Pompadour: A Love Affair with Style.* New York, 1990.
McInnes, Ian: *Painter, King & Pompadour: François Boucher at the Court of Louis XV.* London, 1965.

She Turns My Head
Ashton, Dore: *Fragonard in the Universe of Painting.* Washington, DC, 1988.
Cronin, Vincent: *Louis and Antoinette.* New York, 1995
Rosenberg, Pierre: *Fragonard.* New York, 1988.
Sheriff, Mary D.: *Fragonard: Art and Eroticism.* Chicago, 1990.

A Question of Class
Cormack, Malcolm: *The Paintings of Thomas Gainsborough.* Cambridge, 1991.
Gray, Thomas: *Elegy Written in a Country Church-Yard.* London, 1955.
Lindsay, Jack: *Gainsborough: His Life and Art.* London/New York, 1981.
Woodall, M.: *The Letters of Thomas Gainsborough.* London, 1963.

Like a Cow on a Winding Stair
Brown, Nigel: *Ice-skating: A History.* New York, 1959.
Heller, Mark F. (ed.): *The Illustrated Encyclopedia of Ice Skating.* New York, 1979.
Larrington, Carolyne (ed.): *The Poetic Edda.* Oxford/New York, 1996.
Raeburn, Henry: *The Art of Sir Henry Raeburn, 1756–1823.* Edinburgh, 1997.

A Tea Party that Lead to Democracy
Cooper, Helen A.: *John Trumbull, the Hand and Spirit of a Painter.* New Haven, CN, 1982.
Fryatt, Norma R.: *Boston and the Tea Riots.* Princeton, NJ, 1972.
Jaffe, Irma B.: *John Trumbull, Patriot-Artist of the American Revolution.* New York/Boston, 1975.
Labaree, Benjamin Woods: *The Boston Tea Party.* London/New York, 1975.

I Believe in Marat, the Almighty
Brookner, Anita: *Jacques-Louis David.* London, 1980.
Huet, Marie Hélène: *Rehearsing the Revolution: The Staging of Marat's Death, 1793–1797.* Berkeley, CA, 1982.
Roberts, Warren E.: *Jacques-Louis David, Revolutionary Artist: Art, Politics and the French Revolution.* Chapel Hill, NC, 1989.

As if Carried off by the Winds
Lyons, Martyn: *Napoleon Bonaparte and the Legacy of the French Revolution.* New York, 1994.

Prendergast, Christopher: *Napoleon and History painting: Antoine-Jean Gros's La Bataille d'Eylean.* Oxford/New York, 1997.

A Reflection of Horror
Goya, Francisco: *The Disasters of War.* New York, 1967.
Hilt, Douglas: *Ten against Napoleon.* Chicago, 1975.
Horwitz, Sylvia L.: *Francisco Goya, Painter of Kings and Demons.* New York, 1974.
Pérez Sánchez, Alfonso E. and Julián Gállego: *Goya: The Complete Etchings and Lithographs.* Munich/New York, 1995.
Rollins, Leighton: *Disasters of War.* Santa Barbara, CA, 1981.
Thomas, Hugh: *The Third of May, 1808.* London, 1972.

The Force of Nature and the Power in a Painting
Eaton, John P.: *Titanic: Destination Disaster: The Legend and Reality.* Wellingborough, 1987.
Koerner, Joseph Leo: *Caspar David Friedrich and the Subject of Landscape.* New Haven, CN, 1990.
Siegel, Linda: *Caspar David Friedrich and the Age of German Romanticism.* Boston, MA, 1978.
Winocour, Jack (ed.): *The Story of the Titanic, as Told by its Survivors.* New York, 1960.

One of the Wonders of the World
Constable, Freda: *John Constable: A Biography – 1776–1837.* Lavenham, 1975.
Fowles, John: *The Enigma of Stonehenge.* New York, 1980.
Hardy, Thomas: *Tess of the d'Urbervilles.* Boston, MA, 1998.
North, John David: *Stonehenge: A New Interpretation of Prehistoric Man and the Cosmos.* New York, 1996.
Parris, Leslie and Ian Fleming-Williams (ed.): *Constable: Paintings, Watercolors and Drawings.* London, 1976.

With Brush and Palette on the Barricades
Goodwin, Albert: *The French Revolution.* New York, 1966.
Hannoosh, Michele: *Painting and the Journal of Eugène Delacroix.* Princeton, NJ, 1995.
Kates, Gary: *The French Revolution: Recent Debates and New Controversies.* London/New York, 1998.
Roberts, J.M.: *The French Revolution.* Oxford/New York, 1997.
Wilson-Smith, Timothy: *Delacroix: A Life.* London, 1992.

The Old World Towed by the New
Brown, David Blayney: *The Art of J.M.W. Turner.* London, 1990.
Egerton, Judy: *Turner: The Fighting Temeraire.* London, 1995.
Gage, John (ed.): *Collected Correspondence of J.M.W. Turner.* Oxford, 1980.
Harold, Inge: *Turner on Tour.* Munich/New York, 1997.
Ritchie, L.: *The Works of William Makepeace Thackeray.* 26 vols. New York, 1910–1911.
Rodner, William S.: *J.M.W. Turner: Romantic Painter of the Industrial Revolution.* London/Berkeley, CA, 1997.

Stark Naked
Fein, Richard J.: *At the Turkish Bath.* Towson, MD, 1994.
Ockman, Carol: *Ingres's Eroticized Bodies: Retracing the Serpentine Line.* New Haven, CN, 1995.
Rosenblum, Robert: *Jean-Auguste-Dominique Ingres.* New York, 1990.
Vigne, Georges: *Ingres.* New York, 1995

Eros Awakes to a Storm of Indignation
Brombert, Beth Archer: *Edouard Manet: Rebel in a Frock Coat.* Boston, MA, 1996.
Cachion, Françoise: *Manet: The Influence of the Modern.* New York, 1995.
Düchting, Hajo: *Edouard Manet: Images of Parisian Life.* Munich/New York, 1995.

Tucker, Paul Hayes: *Manet's Le déjeuner sur l'herbe.* Cambridge/New York, 1998.

A Look that Kills
Ash, Russell: *Sir Edward Burne-Jones.* New York, 1993.
Evslin, Bernard: *Medusa.* New York, 1987.
Hodges, Margaret: *The Gorgon's Head: A Myth from the Isles of Greece.* Boston, MA, 1972.
Ovid: *Metamorphoses.* London/Cambridge, MA, 1984.

The Heat of a Summer's Day
Gould, C.: *Seurat's Bathers. Asnières and the Crisis of Impressionism.* London, 1976.
Leighton, John: *Seurat and the Bathers.* London, 1997.
Smith, Paul: *Seurat and the Avant-Garde.* New Haven, CN, 1997.

"I Think Gauguin Is Sick of Me"
Arnold, Wilfred Niels: *Vincent van Gogh: Chemicals, Crises, and Creativity.* Boston, MA, 1992.
Gogh, Vincent van: *The Letters of Vincent van Gogh.* London, 1996.
Nemeczek, Alfred: *Van Gogh in Arles.* Munich/New York, 1995.
Peres, Cornelia and others: *A Closer Look: Technical and Art-Historical Studies on Works by Van Gogh and Gauguin.* Zwolle, 1991.
Walther, Ingo F.: *Vincent van Gogh: The Complete Paintings.* Cologne, 1993.

Paris: A City of Extremes
Adriani, Götz: *Toulouse-Lautrec: The Complete Graphic Work.* New York, 1988.
Gauzi, François: *My Friend Toulouse-Lautrec.* London, 1957.
Heller, Reinhold: *Toulouse-Lautrec: The Soul of Montmartre.* Munich/New York, 1997.
Toulouse-Lautrec, Henri de: *Unpublished Correspondence.* Edited by Lucien Goldschmidt and Herbert Schimmel. London, 1969.
Zévaès, Alexandre: *Aristide Bruant.* Paris, 1949.

"I Painted the Clouds like Real Blood"
Be, Alf: *Edvard Munch.* New York, 1989.
Eggum, Arne: *Edvard Munch: Paintings, Sketches, and Studies.* New York, 1984.
Heller, Reinhold: *Munch: His Life and Work.* Chicago, 1984.
Heller, Reinhold: *Edvard Munch: "The Scream."* New York, 1973.
Torjusen, Bente: *Words and Images of Edvard Munch.* Chelsea, VT, 1986.

The Power of Nature
Adriani, Götz: *Cézanne Paintings.* New York, 1995.
Cahn, Isabelle: *Paul Cézanne: A Life in Art.* London, 1995.
Cézanne, Paul: *Paul Cézanne, Letters.* New York, 1984.
McLeave, Hugh: *A Man and His Mountain. The Life of Cézanne.* London, 1977.

I Couldn't Care Less!
Brettell, Richard R.: *The Art of Paul Gauguin.* Washington, DC, 1988.
Gauguin, Paul: *Noa Noa: The Tahiti Journal of Paul Gauguin.* Edited by John Miller. San Francisco, 1994.
Gauguin, Paul: *Gauguin: Letters from Brittany and the South Seas: The Search for Paradise.* New York, 1992.
Hollmann, Eckhard: *Paul Gauguin: Images from the South Seas.* Munich/New York, 1996.

Freezing Every Gesture
Ash, Russell (ed.): *Degas' Ballet Dancers.* New York, 1992.
Kendall, Richard: *Degas Dancers.* New York, 1996.

Schacherl, Lillian: *Edgar Degas: Dancers and Nudes*.
 Munich/New York, 1997.
Thomson, Richard: *The Private Degas*. London, 1987.

A New World Stage
Dean, Catherine: *Klimt*. London, 1996.
Fleck, Robert: *Vienna Secession, 1898–1998:*
 The Century of Artistic Freedom. Munich/New York, 1998.
Masini, Lara-Vinca: *Art Nouveau*. London, 1984.
Nielsen, Erika: *Focus on Vienna 1900: Change and Continuity*
 in Literature, Music, Art, and Intellectual History.
 Munich, 1982.
Vergo, Peter: *Art in Vienna, 1898–1918: Klimt, Kokoschka,*
 Schiele and their Contemporaries. London, 1993.

Hewn with an Axe
Bradley, Fiona: *Perspectives on Picasso*. London, 1994.
Gedo, Mary M.: *Picasso, Art as an Autobiography*.
 Chicago, 1980.
Picasso, Pablo: *Picasso: In His Words*. Edited by Hiro Clark.
 San Francisco, 1993.
Rubin, William Stanley: *Les Demoiselles d'Avignon*.
 New York, 1994.
Spies, Werner: *Picasso's World of Children*.
 Munich/New York, 1996.

The Calming Effect of Colour
Benjamin, Roger: *Henri Matisse*. New York, 1992.
Benjamin, Roger: *Matisse's "Notes of a Painter": Criticism, Theory,*
 and Context, 1891–1908. Ann Arbor, MI, 1987.
Flam, Jack D.: *The Dance*. Washington, DC, 1993.
Flam, Jack D.: *Matisse, the Man and His Art, 1869–1918*.
 Ithaca, NY, 1986.
Matisse, Henri: *Matisse on Art*. Edited by Jack D. Flam.
 Berkeley, CA, 1995.

Blue Horses and Yellow Cows
Kandinsky, Wassily and Franz Marc: *The Blaue Reiter*
 Almanac. Edited by Klaus Lankheit. New York, 1989.
Rosenthal, Mark: *Franz Marc*. Munich/New York, 1989.
Städtische Galerie München (ed.): *The Blue Rider*.
 New York, 1971.
Vogt, Paul: *The Blue Rider*. Woodbury, NY, 1980.
Zweite, Armin: *The Blue Rider in the Lenbachhaus Munich:*
 Masterpieces by Franz Marc, Wassily Kandinsky, Gabriele Münter,
 Alexei Jawlensky, August Macke, Paul Klee.
 Munich/New York, 1989.

Painting Music
Grohmann, Will: *Wassily Kandinsky: Life and Work*.
 New York, 1958.
Hoberg, Annegret: *Wassily Kandinsky and Gabriele Münter*.
 Munich/New York, 1994.
Kandinsky, Wassily: *Kandinsky, Complete Writings on Art*.
 Boston, MA, 1982.
Overy, Paul: *Kandinsky: The Language of the Eye*. New York,
 1969.
Weiss, Peg: *Kandinsky in Munich: The Formative Jugendstil Years*.
 Princeton, NJ, 1979.

Down the Garden Path
Gwynn, Stephen Lucius: *Claude Monet and His Garden:*
 The Story of an Artist's Paradise. New York, 1934.
Joyce, Claire: *Monet at Giverny*. New York, 1975.
Koja, Stephan: *Monet*. Munich/New York, 1996.
Russell, Vivan: *Monet's Garden: Through the Seasons at Giverny*.
 New York, 1995.
Sagner-Düchting, Karin: *Monet at Giverny*.
 Munich/New York, 1994.
Tucker, Paul Hayes: *Claude Monet: Life and Art*.
 New Haven, CN, 1995.

Spectres Are Born
De Chirico, Giorgio: *De Chirico: The New Metaphysics*.
 Buffalo, NY, 1996.
De Chirico, Giogio: *The Memoirs of Giorgio de Chirico*.
 Coral Gables, FL, 1971.
Gimferrer, Pere: *Giogio de Chirico*. New York, 1989.
Helwig, Werner: *De Chirico: Metaphysical Paintings*.
 London, 1962.

The Poetic Nude
Hall, Douglas: *Modigliani*. New York, 1990.
Kruszynski, Anette: *Amedeo Modigliani: Portraits and Nudes*.
 Munich/New York, 1996.
Modigliani, Jeanne: *Modigliani: Man and Myth*.
 New York, 1958.
Wittlin, Tadeusz: *Modigliani: Prince of Montparnasse*.
 Indianapolis, IN, 1964.

The Fiddler on the Roof
Chagall, Marc: *My Life*. New York, 1960.
Chagall, Marc: *Marc Chagall and the Jewish Theater*.
 New York, 1992.
Chagall, Marc: *Daphnis and Chloe*. Munich/New York, 1994.
Compton, Susan: *Marc Chagall: My Life, My Dream*.
 Munich/New York, 1990.
Kamenskitni, Aleksandr Abramovich: *Chagall: The Russian*
 Years, 1907–1922. New York, 1989.

The Fat Frog at Her Side
Herrera, Hayden: *Frida Kahlo*. New York, 1992.
Kahlo, Frida: *The Diary of Frida Kahlo: An Intimate Self-Portrait*.
 New York, 1995.
Kettenmann, Andrea: *Frida Kahlo, 1907–1954:*
 Pain and Passion. Cologne, 1993.
Oles, James: *Frida Kahlo, Diego Rivera and Mexican Modernism*.
 San Francisco, 1996.
Tibol, Raquel: *Frida Kahlo: An Open Life*.
 Albuquerque, NM, 1993.

The Paranoid-Critical Camembert
Ades, Dawn: *Dalí and Surrealism*. New York, 1982.
Dalí, Salvador: *Conquest of the Irrational*. New York, 1935.
Etherington-Smith, Meredith: *The Persistence of Memory:*
 A Biography of Dalí. New York, 1992.
Schiebler, Ralf: *Dalí: Genius, Obsession and Lust*.
 Munich/New York, 1996.

Man's Inhumanity to Man
Camfield, William: *Max Ernst — Dada and the Dawn of*
 Surrealism. Munich/Houston, TX, 1993.
Ernst, Max: *Beyond Painting and other Writings by the Artist*
 and His Friends. New York, 1948.
Ernst, Max: *Max Ernst: A Retrospective*. New York, 1975.
Gimferrer, Pere: *Max Ernst*. New York, 1984.
Legge, Elizabeth M.: *Max Ernst: The Psychoanalytic Sources*.
 Ann Arbor, MI, 1989.

The Silent Observer
Hobbs, Robert Charleton: *Edward Hopper*. New York, 1987.
Levin, Gail: *Edward Hopper: An Intimate Biography*.
 New York, 1995.
Levin, Gail: *Edward Hopper: The Art and the Artist*.
 New York/London, 1980.
Lyons, Deborah: *Edward Hopper and the American Imagination*.
 New York, 1995.
Schmied, Wieland: *Edward Hopper: Portraits of America*.
 Munich/New York, 1995.

Claustrophobic Fear
Alphen, Ernst van: *Francis Bacon and the Loss of Self*.
 London, 1992.

Domino, Christophe: *Francis Bacon: Painter of a Dark Vision*.
 New York, 1997.
Schmied, Wieland: *Francis Bacon: Commitment and Conflict*.
 Munich/New York, 1996.
Sylvester, David: *Interviews with Francis Bacon*. London, 1980.
Sinclair, Andrew: *Francis Bacon: His Life and Violent Times*.
 London, 1993.

Making Myths
Garrels, Gary (ed.): *The Work of Andy Warhol*. Seattle, 1989.
Guiles, Fred Lawrence: *Norma Jean; The Life of Marilyn Monroe*.
 New York, 1969.
Mailer, Norman: *Marilyn, a Biography*. New York, 1973.
Spoto, Donald: *Marilyn Monroe: The Biography*. New York,
 1993.
Tretiack, Philippe: *Andy Warhol*. New York, 1997.
Warhol, Andy: *The Andy Warhol Diaries*. New York, 1989.

Index of the Artists

Photo Credits